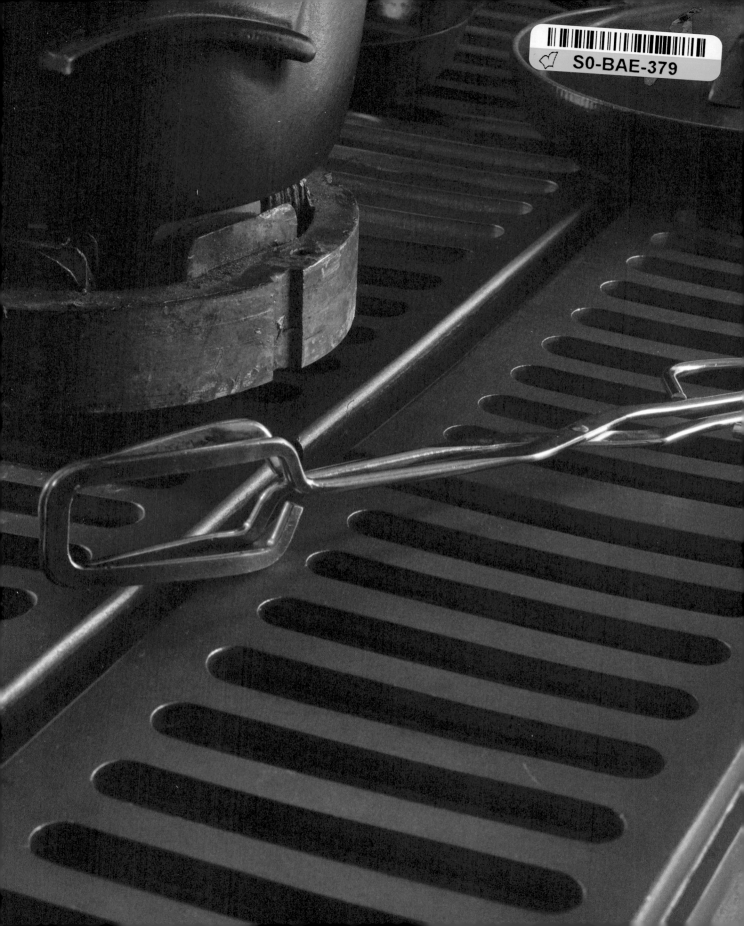

STAR WARS™

GALAXY'S EDGE

THE OFFICIAL BLACK SPIRE OUTPOST COOKBOOK

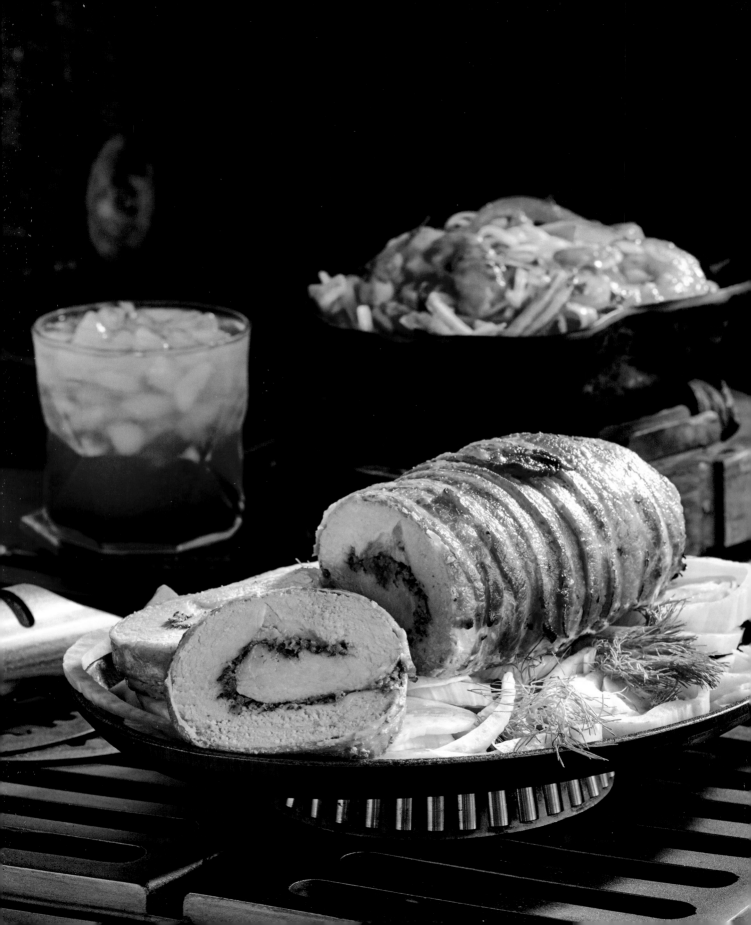

STAR WARS™
GALAXY'S EDGE

THE OFFICIAL BLACK SPIRE OUTPOST COOKBOOK

BY CHELSEA MONROE-CASSEL
AND MARC SUMERAK

PHOTOGRAPHY BY TED THOMAS

INSIGHT
EDITIONS

San Rafael · Los Angeles · London

CONTENTS

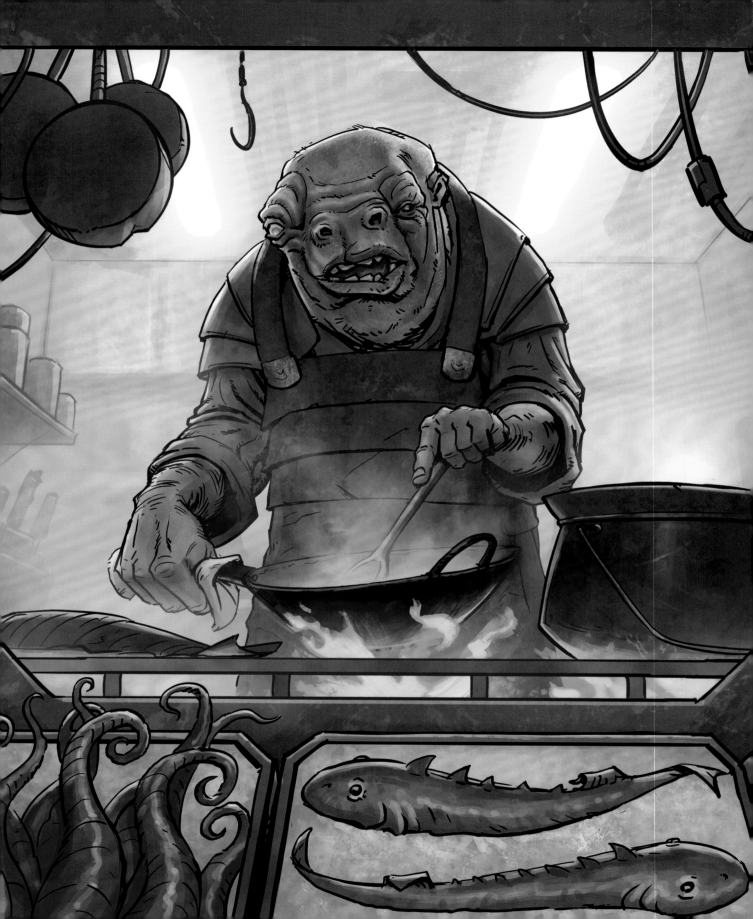

INTRODUCTION

Food is art. Sure, maybe it don't seem that way when you're chompin' on a ronto wrap in a busy spaceport. Right then, food is probably nothin' more than fuel to you. But take a moment to stop and think about how a pinch of sikoroot can transform a hideous beast of burden into a tantalizin' treat, and you might start to see food the way I do.

My name's Strono Tuggs. But you can call me Cookie. Everyone else does.

If you've ever been to Takodana, you might recognize me. Or at least my work. See, I spent the last century as the head chef in Maz Kanata's castle. It was my job to fill the bellies of her esteemed—and not-so-esteemed—guests. Nothin' made me happier than watchin' the gravy drip off some Quarren smuggler's tentacles as he eagerly scarfed down a meal I'd prepared. Jedi or outlaw, it didn't matter much to me who sauntered in, as long as they were hungry. And they always were. Ah, those were the days . . .

The good times ended, though, when the First Order reduced Maz's castle to a pile of rubble, and my kitchen was one of the casualties. For a moment there, I figured I'd served my last dish. Turns out, it was just the start of a whole new course.

But I'm gettin' ahead of myself. I should know better than to bring out the entrée ahead of the soup! Before you dig in to the details of where I'm at today, you probably oughta know where I came from. We all got stories, after all. And mine is plenty tasty.

My people, the Artiodac, ain't never made the list of the prettiest species in the galaxy. And I'll be the first to admit that my visage is particularly unsettlin', even by our standards. Bein' the ugliest of the ugly, well, that was never an easy dish for me to swallow. But I always believed there was beauty somewhere out there in the galaxy. Knew I wouldn't find it in the mirror, but never would've guessed I'd find it on a plate instead.

Back in my younger days, I had the good fortune of stumblin' across some ancient holovids of a chef named Gormaanda. If you ain't never heard of her, she was this four-armed force of nature who could take somethin' plain—even somethin' ugly—and turn it into somethin' exquisite. If she could do that for food, maybe she could do it for me, too. From the moment I started watchin' her, I knew what I was s'posed to be. I'd finally found the beauty I'd been searchin' for.

So I followed her example and started travelin' the Outer Rim in search of new flavors, all the while creatin' my own recipes and honin' my skills. Each world that I visited added new ingredients and techniques to my ever-expandin' menu. I studied every local delicacy I could find, from salads on Savareen to desserts on D'Qar. Not all of 'em were winners, mind you. Some worlds have native cuisines that I'm not sure even a rathtar could digest. But even the worst dishes taught me somethin' new about how to combine flavors—or, in some cases, how not to.

After a few years explorin' the gastronomic galaxy, I was ready to serve the people. Sadly, the people wasn't quite ready for me to serve them. Let's just say my presence in the dinin' room didn't exactly inspire an appetite. But I didn't let that hinder me. Cookin' was in my blood. (And sometimes, when usin' particularly feisty ingredients, my blood was in the cookin' too.)

Wasn't until I met ol' Maz that someone was finally willin' to look past me and let my food speak for itself. She gave me my big break, puttin' me in charge of her kitchens and trustin' me to keep her patrons fed. So I stepped up and cooked like my life depended on it. (And considerin' the types of folks that frequented her establishment, it often did.) Thanks to her, I spent the next century doin' what I love most. And then it was all over, just like that. The castle was destroyed and my sous-chefs were fleein' for their lives.

Might've lost my kitchen, but I still had my recipes and my passion. As long as I had those two things, it didn't matter if I was cookin' in a fancy castle on Takodana or in a tiny hut on Tatooine. After all, before Maz hired me, I'd been scourin' the whole blasted galaxy while learnin' my craft. Maybe this was just a chance to go back to my culinary roots and expand my horizons some more.

So I bought me a nice food freighter—a Sienar-Chall Utilipede Transport—and filled it up with everythin' I could salvage. Some of my custom equipment survived the castle's fall, but the food was a complete loss. (A shame, too—had some nice gornt steaks in the freezer that I'd been savin' for a special occasion.) Seems natural that a fresh start might as well come with fresh ingredients, though, right? So I set out gatherin' some old favorites from all those planets I'd visited back durin' my early days. And even some strange new spices, meats, and veg from worlds I'd never visited before.

As I filled my pantry with exotic foods from dozens of systems, I was fillin' my head with excitin' new recipe ideas. Now all I needed was someone to cook 'em all for. I was just as shocked as anyone to discover that all my years cookin' for Maz had earned me quite a reputation on the Outer Rim. Seemed like folks on every planet had heard legends about that fabled old castle, and they all wanted a taste of Takodana. It was an opportunity I hadn't expected but one I was mighty glad to have.

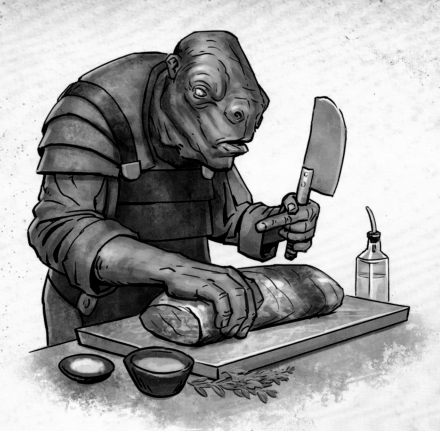

And that's how I got here. My food freighter helps me deliver a carefully curated selection of my favorite dishes—or as I like call it, Tuggs' Grub—to spaceports and dockin' bays from Bespin to Batuu. Some stops are longer than others, dependin' on how friendly—and hungry—the locals are. Once my supplies run dry, I'm off to the next planet to gather more ingredients and fill more eager bellies. But I always try to leave a little piece of my kitchen behind on every world I visit. And that's what you're holdin' in your hands right now.

See, a long time ago, I learned how important it was for a chef to share their recipes with the galaxy. If Gormaanda hadn't made those holovids, after all, there's no way I'd be out here cookin' today. Plus, I've seen a few great chefs get themselves butchered for keepin' their sauces too secretive, so I'm givin' my menu away . . . for an extremely reasonable price!

Like I said before, food is art. So maybe, if you're lucky, you'll look through this here book and find the same thing I found on my plate all those years ago—somethin' beautiful. And if not, well, hopefully you'll at least find yourself a full belly.

GET READY TO DIG IN!

COOKIE

BLACK SPIRE OUTPOST

Been to plenty of worlds on the Outer Rim and beyond. Ain't many that I like visitin' more than Batuu. Yeah, maybe food tastes the same no matter what planet you eat it on, but there's a reason you don't notice many folks enjoyin' a fine meal under the smoggy skies of Corellia. Location matters, and this is one that's been overlooked for too long.

Even in the old days, way back before I started workin' for Maz, Batuu was known as a frequent stop for travelers like me who were passin' through the Outer Rim lookin' to trade or refuel. When new hyperspace routes bypassed the planet, though, Batuu quietly fell off the maps for most folks. Because of that fact, Batuu's ports soon found themselves bustlin' with a whole new type of visitor. The type who was tryin' hard not to get noticed.

Now, Batuu's outposts have become the perfect getaway for those lookin' to escape the watchful eye of the First Order—or maybe just hopin' to hide out until their debts to the Hutts are forgotten. The locals have become an unsavory lot, that's for certain. But if I learned anythin' about smugglers and thieves durin' my time at Maz's castle, it's that they always have an appetite. That makes Batuu the perfect kinda place for me to set up shop.

When I dock on Batuu, it's always at Black Spire Outpost. It's the planet's largest population center and has everythin' I need for an extended stay. There's easy access to fresh crops and exotic meats from the surroundin' rural zones, and if there's a rare spice I ever find myself missin', my pal Dok-Ondar from the local antiquities shop has a knack for acquirin' it. Plus, it's one of the few places I can stock up on gold dust—a native species of golden lichen that elevates just about any dish with its spicy bite. But most importantly, Black Spire Outpost is full of hungry customers eager to sample Tuggs' Grub.

Since my last visit to Black Spire, the First Order arrived and occupied one of the port's dockin' bays. Heard they're lookin' for some kinda Resistance post hidden somewhere in the ruins beyond the outpost. Their presence has made my regular patrons a bit skittish, to say the least. I'll admit, I ain't so thrilled to see 'em either after what they did to my kitchen on Takodana. Still, if they've got the credits, I'll gladly serve 'em just the same as any other customer. (Probably gonna garnish their dishes with a little less gold dust, though.)

Even with stormtroopers patrollin' the market, I can't help but love Black Spire Outpost. It's got this rustic charm that more civilized worlds lost long ago, and I always feel welcome. I've made friends here, and sure, even a few enemies. But there's somethin' special about this place that keeps drawin' me back time and again. Know plenty of folks who feel the same.

In fact, I've been thinkin' about extendin' my current stay on Batuu beyond my usual limited-engagement status, but only if I can find a way to keep my pantry full enough. Good thing I happen to know where I can find a few smugglers . . .

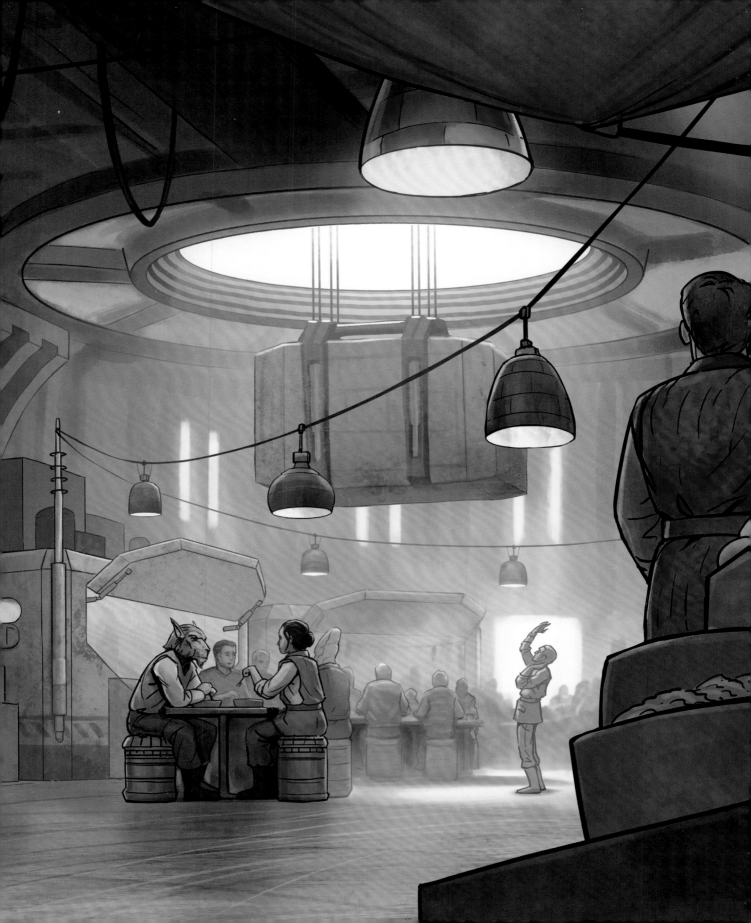

DOCKING BAY 7
FOOD + CARGO

Sure, it might not look like much on the outside, but this converted cargo hold on the edge of Batuu's market is the perfect place for me to set up shop at Black Spire Outpost. Of course, it helps that I'm already used to working in unorthodox cookin' spaces. My kitchen at Maz's place on Takodana was nothin' more than a repurposed storeroom, after all, so I learned early in my career how to turn jogans into jogan-ade.

Dockin' Bay 7's assortment of converted cargo pods contains all the basics a visitin' chef could ask for—includin' a full kitchen setup and places for hungry guests to chow down. It's also got pods where local vendors can hawk their wares, givin' me access to fresh, local ingredients and my guests somethin' interestin' to gawk at while they dine. There's even a pod where folks can place their orders, with fancy displays showin' off my menu. Lets patrons have a glimpse of what they're gettin' and lets me focus on what I do best: cookin'.

As ready for service as Dockin' Bay 7 may be, every chef wants to add their own personal flair to the dinin' experience. So one of my favorite features of this particular location is that I can land my trusty food freighter right on top of the hangar. From there, I can lower down my own cargo pods containin' just about everythin' a chef like me could need to whip up some quality vittles—from fresh ingredients to specialized cookin' gear.

Makes some guests a mite uncomfortable havin' one of those massive containers danglin' over their heads while they eat, but I say it adds to the thrill of the experience. Of course, if the hangar's bustlin' interior ain't quite their speed, folks are always welcome to go and sit outside in a nice shaded courtyard adjacent to the hangar.

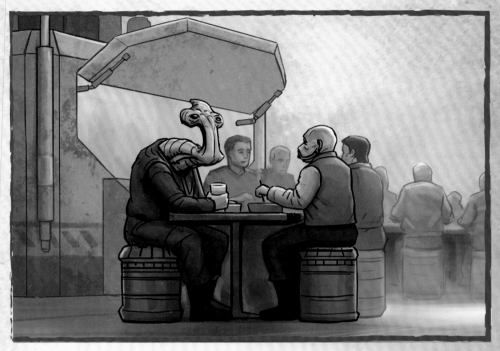

While I always bring along my own team of galaxy-class sous-chefs to staff the kitchen, I've come to rely on Batuu natives to run service in the front of the house. Thankfully, these locals are pros. They've seen plenty of food freighters come and go over the years, so they know how to adapt quick to new menus and big personalities. They're some of the most efficient and courteous folks I've ever worked with, and they always treat my customers with the same respect that they show me. (Maybe they know that I'd have words with 'em if they didn't.)

A sign outside the bay advertises its ever-changin' food freighter of the week. When it's my turn to blast off, another chef will take my place to feed the next batch of hungry locals without ever missin' a meal. But like I said before, this place is really growin' on me. Might be worth seein' if they'd change the sign to somethin' a bit more permanent.

SIENAR-CHALL UTILIPEDE TRANSPORT

After workin' in the same kitchen for a century or so, it's been nice to get out and see a few systems. As I mentioned, my current center of culinary operations—a modified Sienar-Chall Utilipede Transport—is the key to makin' that possible. The ship wasn't specifically designed to be a food freighter, but some minor modifications have turned my baby into a fully operational mobile kitchen and restaurant that allows me to take my signature dishes to any world I choose. I've come to think of it as a "travelin' diner for diners travelin'." Has a nice ring, don't it?

The best thing about this particular vessel is how versatile it is. Its modular cargo cradle can be stocked to the brim with everythin' I could ever need for cookin' on the fly. I've currently got three cargo pods of my own, each servin' a special purpose. I use one as my freezer, while another works as my pantry for fresh items. And, of course, I've got a cargo pod that carries all the personal cookin' equipment I've gathered over the years.

And unlike most cargo containers, each of my pods has built-in life-support systems, allowin' me the luxury of transportin' live ingredients across the Outer Rim with maximum freshness and unlimited variety. That means folks that ain't never had fresh tip-yip or yobshrimp before finally get the chance to taste 'em without the fear of gettin' poisoned. It's given me a chance to share not just a taste of Takodana but an entire galaxy of flavors.

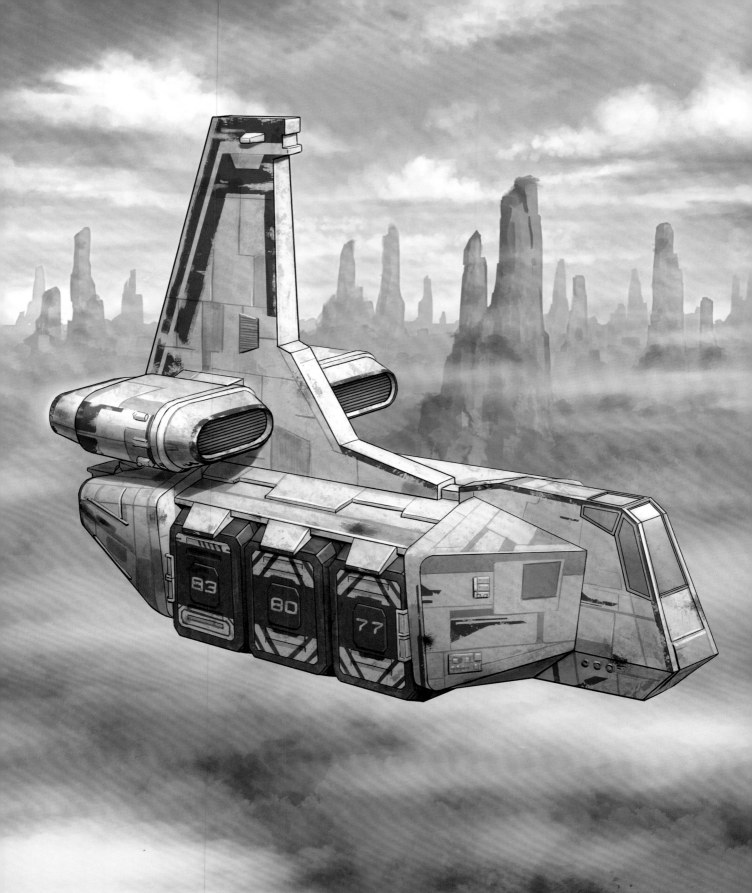

BLACK SPIRE CUISINE

Spaceports never really sleep, so I'm usually cookin' around the clock. But on the rare occasion that I do get to step outside the dockin' bay, I like to sample the local fare. No chef wants to eat their own food for every meal. And while I dare say I offer the closest thing Batuu has to fine dinin', seems the locals do a mighty fine job of keepin' each other fed without me.

RONTO ROASTERS

You wanna sink your teeth into the most delicious meat in the Outer Rim? Then head on over to the market and talk to Bakkar. This human is a fourth-generation butcher from Tatooine who uses the flames from a modified podracer engine to cook up giant hunks of ronto (a pack animal from his home planet) to perfection. Of course, most of the credit should probably go to his pitmaster, a former smelter droid named 8D-J8. He's been reprogrammed to constantly rotate the enormous ronto shanks under the engine's open fire to achieve a nice even cook. Bakkar and 8D-J8 roast up an assortment of other meats and local veggies, too, but the ronto wrap is their best seller for good reason. I've tried more than once to convince Bakkar to share his family's secret spice blend, but he always refuses. I respect that. But it ain't gonna stop me from tryin' to figure the recipe out for myself.

OGA'S CANTINA

Once your stomach is full of roasted ronto, you'll probably find yourself cravin' a tasty beverage to wash it down. You could always grab a Trandoshan ale from Bakkar or flag down an astromech droid pulling one of Jat Kaa's mobile coolers. But if you're lookin' for a libation with a bit more flair, there's only one place to go in Black Spire Outpost: Oga's Cantina. Oga's expert bartenders are eager to mix you up the strongest—and strangest—concoctions this side of Wild Space. This waterin' hole has naturally become the center of operations for the pirates and scoundrels who call Batuu home. And between you and me, there ain't no scoundrel bigger than the cantina's proprietor, Oga Garra herself. This Blutopian don't just run the cantina—she runs all of Black Spire. All business in the outpost, includin' mine, is her business, too. I usually try to keep my distance to avoid gettin' sucked into any unnecessary drama. But with potent drinks like the Carbon Freeze, the Fuzzy Tauntaun, and the Bloody Rancor on her menu, drama usually manages to find me on its own.

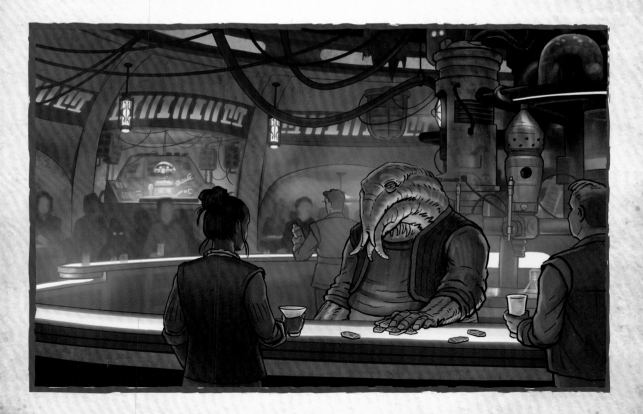

THE MILK STAND

That ronto-roastin' butcher Bakkar ain't the only transplant from Tatooine to bring his recipes to Black Spire. An Aqualish dairy farmer by the name of Bubo Wamba came to Batuu with nothin' but big dreams and a bigger pack of banthas. The large, furry, desert-dwellin' mammals produce a particularly sweet strain of blue milk unlike anythin' I've ever tasted. Bubo set up a market stall in Black Spire to sell this cool, refreshin' blue beverage and it was an instant hit with the locals. His stand also sells a rare green milk that comes from sea sows known as thala-sirens, found on a number of watery worlds. Both the blue and the green milk taste outstandin' on their own, but when they're used as the foundation for slightly more intoxicatin' beverages, they're truly outta this world.

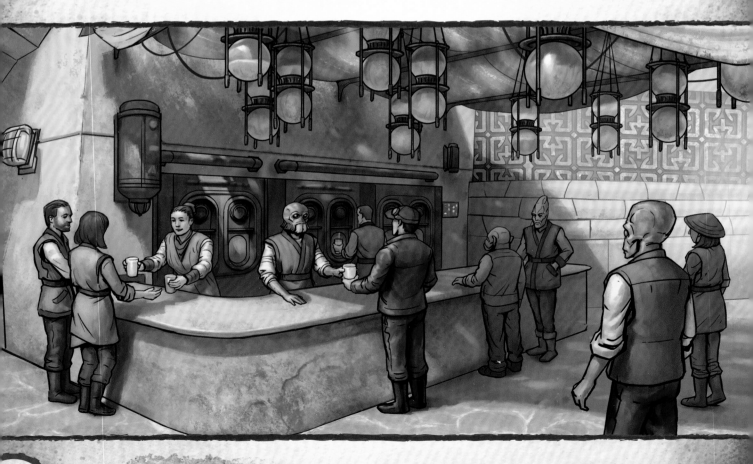

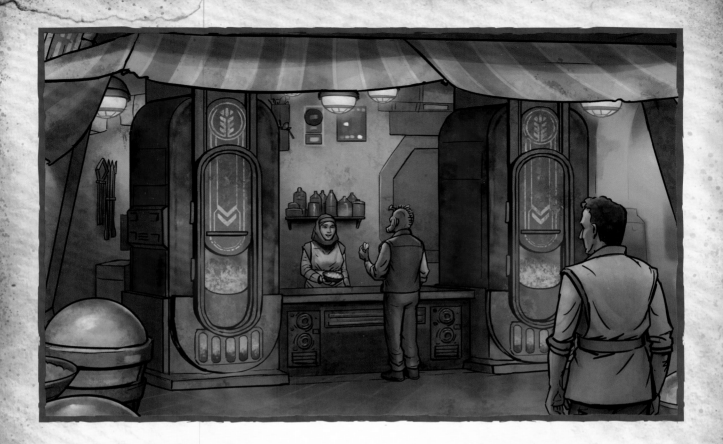

KAT SAKA'S KETTLE

Using heirloom seeds from her family's small farm on the outskirts of the
Black Spire Outpost, a human named Kat Saka creates one of the bustling
port's most unique and memorable snacks. Kat's kettle-popped grains are
combined with unusual flavors to create her signature Outpost Mix, available
in the market. It's somehow sweet and salty and spicy all at the same time.
Can't quite figure out how she does it, but whatever she's seasonin' it with, it
works. Kat also sells imported spices and local grains of the unpopped variety
straight from her family's farm, so I've become a regular customer of hers
whenever I'm in town. No matter how hard I try to resist, I always find myself
addin' a few bags of her delicious Outpost Mix to my order.

CONDIMENTS, SAUCES + GARNISHES

What, you thought we were gonna dive straight into the main courses? Ease off the thrusters a bit, kid. That's like tryin' to fly the Kessel Run before you even learn how to power up your ship. In my kitchen, before any chef jumps to culinary hyperspace, they gotta prove they can handle the basics. (Not that anythin' I put on a plate could be considered basic.)

You might feel like skippin' by this batch of recipes to get to the ones with a bit more meat to 'em, but you'll soon discover that these guys play key roles in some of the other, more complex dishes included in this book. They're the spices that accent the natural flavors, the dips and sauces that complement every bite, and the garnishes that elevate a dish from bland to breathtakin'.

Once you really figure out how to use these beauties, you'll start discoverin' excitin' new ways to incorporate 'em into your own creations. Hell, some might end up in every single dish you cook. (True story: I know a Wookiee who won't leave home without a shaker of my Nerfsteak Seasonin' [page 29] in his bandolier!)

NERFSTEAK SEASONING

PREP TIME: 5 MINUTES
YIELD: ½ CUP
DIFFICULTY: EASY

USED IN:
NERF KEBABS
(PAGE 105)

Time for a kitchen confession. I've become a bit of a spice addict over the years. Don't worry, though. I'm not talkin' the illegal stuff that the Pyke Syndicate mines on Kessel. Nah, I mean the *really* good stuff that you use to boost a meal's flavor. And lately the spice mix I've been cravin' most is one of my own creations. I call it Nerfsteak Seasonin' 'cause, well, it was originally designed to season nerfsteaks. But pretty soon I discovered that this seasoned salt goes well on just about anythin', from tip-yip to Fritzle Fries. If you're makin' your own, I recommend usin' a quality salt—like the kind you'd find on Crait—as the base. And if you're anythin' like me, you might wanna make a couple batches so you always have some ready to sprinkle whenever the mood strikes.

INGREDIENTS

1 TABLESPOON PAPRIKA
1 TABLESPOON SALT
1 TABLESPOON BROWN SUGAR
1 TABLESPOON GROUND CUMIN
1 TABLESPOON GRANULATED GARLIC
1 TEASPOON PEPPER
1 TEASPOON DRIED SAVORY, CRUSHED

1. In a small jar, combine all the ingredients and shake to combine.

2. Seal and store in an airtight container for up to two weeks.

SAKA SALT

Ain't many stalls in the Black Spire Outpost market more popular than Kat Saka's Kettle. Like I said before, Kat and her family have been growin' their heirloom grains on Batuu for generations, and now Kat is poppin' up those grains and tossin' 'em with all sorts of wild flavor combinations. Some are fruity, some are salty, some are spicy, and some—like her popular Outpost Mix—are all of the above. Kat has made it clear that she ain't got any intention of spillin' the secrets of her signature flavor combo, despite my best efforts to coax it outta her. But since I've become a frequent customer at her stall durin' my visits to Batuu, Kat was willin' to share one of her secondary seasonin' mixes. If somethin' this tasty is only her second-best seller, Kat's got some serious skill with the spice.

PREP TIME: 5 MINUTES
YIELD: ABOUT 3 TABLESPOONS
DIFFICULTY: EASY

USED IN:
KAT'S KETTLE
CORN (PAGE 43)

INGREDIENTS

2 TABLESPOONS RED SALT
2 TEASPOONS GARAM MASALA

1. Put all ingredients in a food processor and pulse until fully combined.

2. Store in an airtight container for up to two weeks.

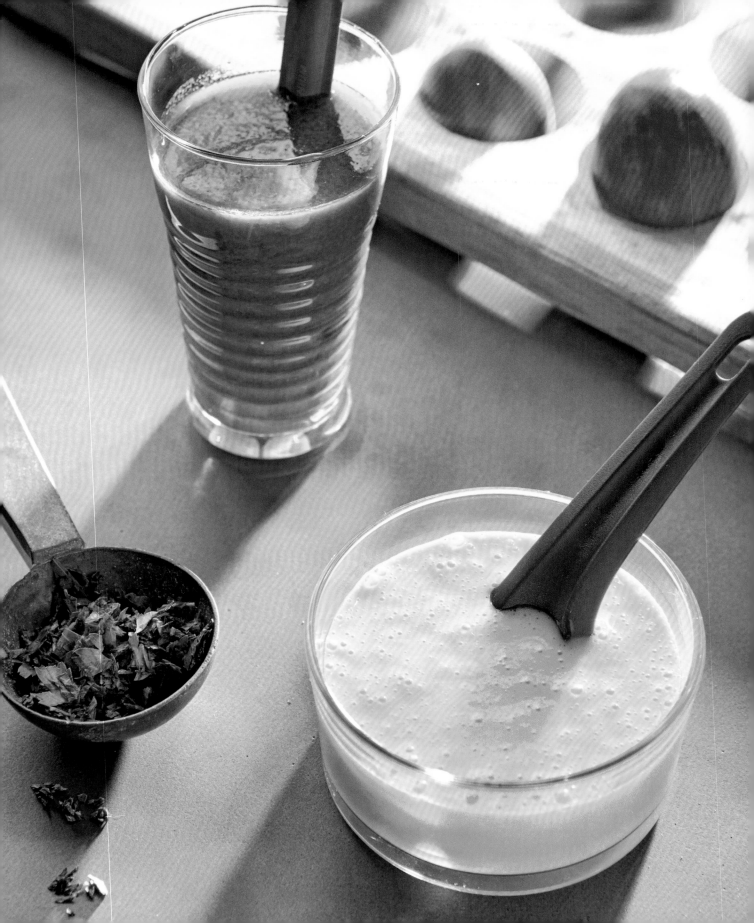

GURRECK GRAVY

Ewoks seem like the cuddliest creatures in the galaxy, but when they ain't singin' and dancin', they're usually showin' off their fierce huntin' skills. These furry forest dwellers are experts at craftin' weapons and traps to help 'em bring home some big game—and on Endor, there ain't much game bigger than the gurreck. When the Ewoks take down one of these fierce fanged predators, they celebrate by cookin' up a feast, which usually includes this rich, green gravy made with fresh Endorian herbs. Luckily, there ain't actually any gurreck in this savory sauce, so you don't gotta be a skilled hunter to whip it up. Use it to smother your fried tip-yip (page 97)—a juicy Endorian fowl—and I guarantee it'll have you shoutin' "yub nub!" (Whatever that means.)

PREP TIME: 5 MINUTES
YIELD: 1 BATCH
DIFFICULTY: EASY

USED IN:
FRIED ENDORIAN
TIP-YIP (PAGE 97)

INGREDIENTS

¼ CUP FRESH PARSLEY LEAVES
1 TABLESPOON FRESH GREEN HERBS, SUCH AS THYME, SAVORY, AND MARJORAM
PINCH OF SALT
2 TEASPOONS APPLE CIDER VINEGAR
½ CUP OLIVE OIL
¼ CUP CHICKEN STOCK

1. Combine all the ingredients except the chicken stock in a small bowl and puree with an immersion blender until smooth, with no large flakes of herbs remaining.

2. Mix in the chicken stock and continue to blend until very smooth.

3. Use straightaway, or store in the fridge for several days, letting the mixture come to room temperature and blending again before serving.

EMULSAUCE

Emulsauce is like the astromech of condiments. See, astromech droids were designed to repair starships, but they can also act as copilots, slicers, and even adorable travelin' companions. That kind of adaptability is pretty hard to find. Turns out, that same level of versatility can be found in this savory, smooth spread. You can use it as a dip, a dressin', or a simple sandwich toppin'. And if no one is lookin', you can even eat it by the spoonful. I may be a bit skittish about lettin' an actual astromech in my kitchen these days—thanks to an incident a ways back involvin' a couple of corrupt droids whose only appetite was for murder—but emulsauce will always be welcome.

PREP: 15 MINUTES
YIELD: ABOUT 1 CUP
DIFFICULTY: EASY

USED IN:
DEVILED PIKOBI EGGS
(PAGE 63)

INGREDIENTS

2 EGG YOLKS, AT ROOM TEMPERATURE
½ TEASPOON KOSHER SALT
2 TABLESPOONS VERY COLD WATER
1 TEASPOON RICE VINEGAR
1½ CUPS COLD OLIVE OIL
1 TO 2 TABLESPOONS WHITE MISO PASTE

1. Combine the egg yolks, salt, water, and vinegar in a small bowl or wide-mouthed jar and combine with an immersion blender.

2. While blending, slowly add the oil. Continue blending for a couple of minutes. The mixture should thicken and turn a pale color.

3. Blend in the miso, and adjust the quantity to taste.

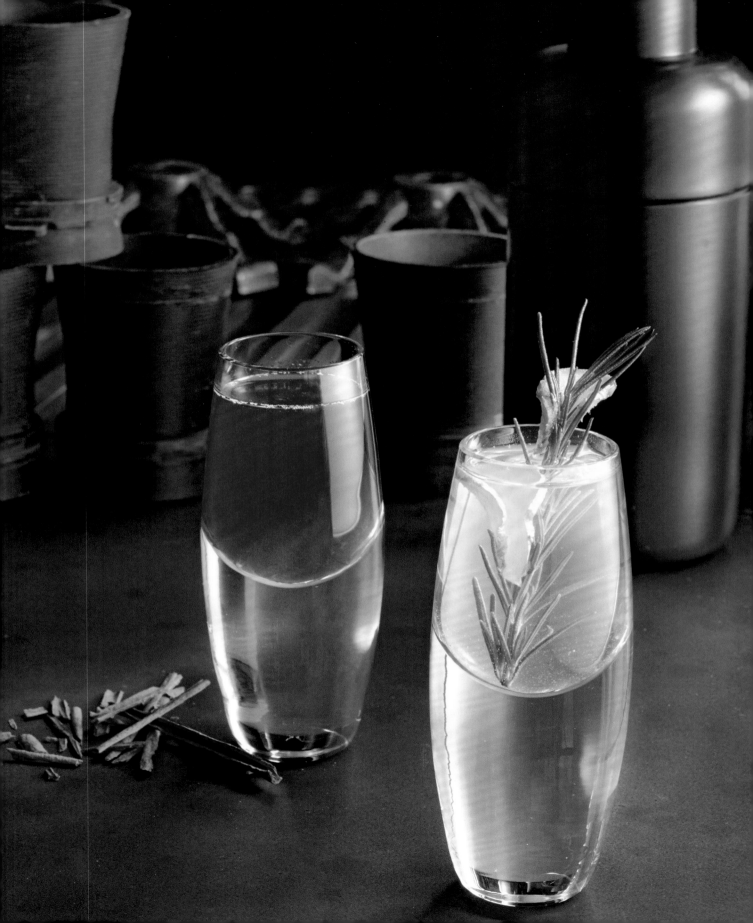

MOOGAN SPICE SYRUP

Used to be a time when the sweet and spicy libation known as Moogan Tea (page 143) was brewed fresh daily in every cantina on the Outer Rim. That all changed when the Commerce Guild took control of the planet Mooga and laid claim to its most renowned beverage. Determined to squeeze every possible credit outta their now-proprietary recipe, the guild set up its own manufacturin' plant—known as the Ardees Beverage Company—and started sendin' out cease and desist transmissions to any barkeep who dared brew a homemade version. Too bad for the guild, their secret recipe wasn't ever really a secret to begin with. I realize I might be riskin' some serious legal ramifications by passin' along my own personal blend for the syrup, but if the guild wants to get their hands on me, they're gonna have to go through a lot of happy customers first.

PREP TIME: 5 MINUTES
INFUSING TIME: 4 HOURS
YIELD: 1¼ CUPS
DIFFICULTY: EASY

INGREDIENTS

1 TEASPOON VANILLA EXTRACT
1 CINNAMON STICK, BROKEN INTO SMALL PIECES
½ CUP PACKED BROWN SUGAR
½ CUP GRANULATED SUGAR
1 CUP WATER

Combine all the ingredients in a small saucepan over medium heat. Cook until the sugar has dissolved, then let sit for at least 4 hours to let the flavors infuse. Strain into a clean bottle and refrigerate until ready to use. Keeps for 1 to 2 weeks.

USED IN:
MOOGAN TEA (PAGE 143)

DAGOBAH SLUG SYRUP

Sometimes the sweetest things come in the most repulsive packages. I'm livin' proof of that. Another critter that tends to get dismissed on account of its appearance is the Dagobah swamp slug. It's no surprise that a gargantuan mollusk with thousands of teeth ain't considered the most aesthetically pleasin' of species. But what these mucus-covered monsters lack in looks, they make up for in taste. The sticky secretions that swamp slugs leave in their wake are unusually saccharine, with hints of the fragrant swamp herbs that they have digested. Whenever I can get my mitts on a bottle of their gorgeous goop, I use it to mix into drinks or pour over desserts. And when there ain't any slugs around to help replenish my syrup supply, I know how to make a pretty sweet imitation usin' some everyday ingredients.

PREP TIME: 5 MINUTES
INFUSING TIME: 5 HOURS
YIELD: 1¼ CUPS
DIFFICULTY: EASY

INGREDIENTS

1 CUP SUGAR
1 CUP WATER
4 OUNCES FRESH GINGER, PEELED AND SLICED ¼ INCH THICK
ONE 3-INCH ROSEMARY SPRIG

In a small saucepan over medium heat, bring the sugar and water to a boil. Add the ginger and rosemary and return to a boil, stirring to dissolve the sugar. Remove from the heat and let rest to infuse for at least 5 hours, until very strong. Strain into a clean bottle and refrigerate until ready to use. Keeps for 1 to 2 weeks.

USED IN:
DAGOBAH SLUG SLINGER (PAGE 147)
PHOTON FIZZLE (PAGE 155)

CHADIAN DRESSING

When you're runnin' the kitchen in a castle full of smugglers and thieves, you learn to adapt to a lot of tastes quick. You wouldn't believe how many times I found myself starin' down the wrong end of a blaster just 'cause I added a bit too much dewback claw to a dish. Though the tastes and tempers of my patrons varied wildly, luckily they could all agree on one thing—my Chadian Dressin'. I first whipped up this zesty blue condiment for a Chadra-Fan outlaw desperate for a little taste of home, but when I tasted how much flavor was packed into this simple sauce, I started puttin' bottles of it on every table. Now the only time diners whip out their blasters is when a bottle of this stuff is empty!

INGREDIENTS

¼ CUP WHITE WINE VINEGAR

½ CUP LIGHT OLIVE OIL

2 TABLESPOONS WATER

1 CLOVE GARLIC, MINCED

PINCH EACH OF SALT AND PEPPER

½ TEASPOON DRIED MIXED HERBS, SUCH AS OREGANO AND MARJORAM

2 OUNCES BLUE CHEESE, CRUMBLED

A FEW DROPS BLUE FOOD COLORING

PREP TIME: 5 MINUTES
YIELD: ABOUT 1 CUP
DIFFICULTY: EASY

1. Combine the vinegar, olive oil, water, and garlic in a small bowl.

2. Blend with an immersion blender for about 1 minute, until emulsified.

3. Add the remaining ingredients, then blend again until smooth.

4. Cover and refrigerate until ready to use, up to 4 days.

USED IN:

XIZOR SALAD (PAGE 51)

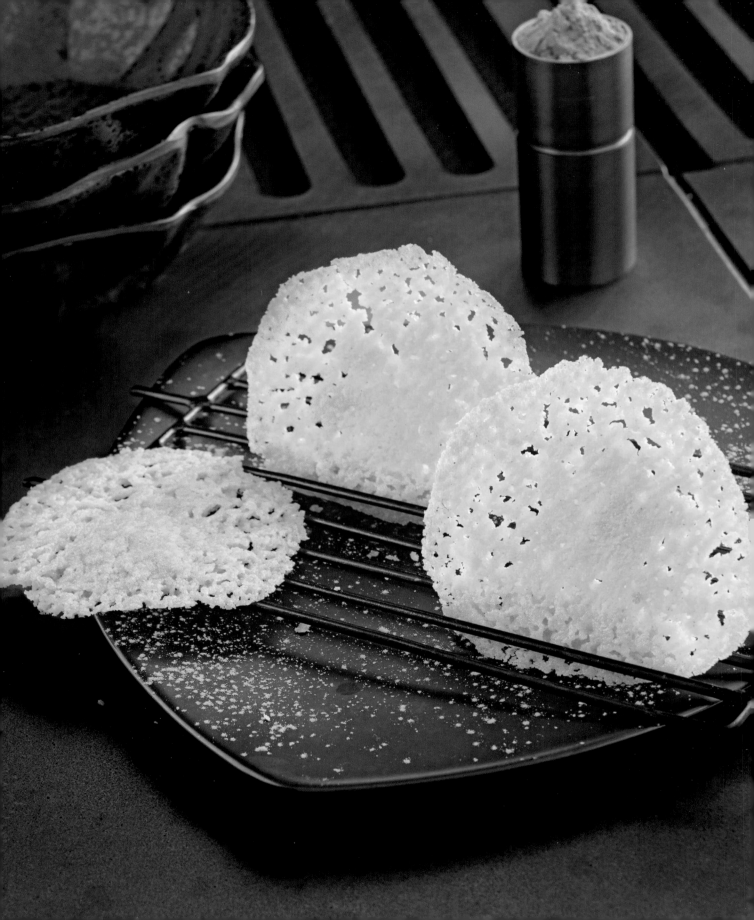

GOLDEN LICHEN TUILE

Sometimes I like to add a little extra crunch to a dish, and there ain't no better way to do that than with a tuile—a thin, crispy cookie that can be either sweet or savory. And in all my years cookin', I ain't made a better tuile than one flavored with gold dust. This rare golden lichen is only found on Batuu, so when I visit Black Spire, I make sure to fill my pantry with as much as I can find to keep my customers crunchin' on these delicate crisps wherever I go. (A bit of advice: Oga charges premium prices for the stuff, so you're better off scoutin' for some on your own.) Though I usually save tuiles to use as embellishments for my fancier dishes, I'll admit I occasionally eat a whole batch of the things in one sittin'.

INGREDIENTS

¼ CUP (½ STICK) BUTTER

¼ CUP SUGAR

1 TEASPOON GROUND TURMERIC

½ TEASPOON GROUND GINGER

3 TABLESPOONS ALL-PURPOSE FLOUR

PREP TIME: 5 MINUTES
COOKING TIME: 5 MINUTES
YIELD: 8 TO 10 LICHEN FLAKES
DIFFICULTY: MEDIUM

1. Preheat the oven to 375°F and line a large baking sheet with parchment paper or a silicone mat.

2. In a small saucepan over medium heat, melt together the butter and sugar.

3. Stir in the turmeric and ginger, then remove from the heat and stir in the flour.

4. Drop onto the prepared baking sheet by the teaspoon. There should be 8 to 10 total, with about 3 inches between them. Bake for about 5 minutes, until the edges are just starting to turn brown.

5. Remove from the oven and allow to cool until crisp. Tuiles are best used the same day, although they can be stored in an airtight container for up to 2 days.

USED IN:

NECTROSE FREEZE (PAGE 133)

CHRISTOPHSIAN SUGAR

If you've got a taste for somethin' sweet, then you're gonna want to mix up a shaker full of Christophsian sugar. Inspired by the crystalline forests on Christophsis, this caramelized-sugar mix is sure to warm you from head to tail with its subtle notes of spice and citrus. It's a multipurpose mix that can add just the right amount of sweetness to any treat. I can't resist sprinklin' it on top of freshly toasted mealbread, tossin' it with some freshly popped grains, or mixin' it into a nice hot cup of caf. This stuff is nearly as versatile as my Nerfsteak Seasonin' (page 29), and equally addictive.

COOKING TIME: 15 MINUTES
YIELD: 1 CUP
DIFFICULTY: MEDIUM

USED IN:
SWEET-SAND COOKIES (PAGE 125)
MOOGAN TEA (PAGE 143)

INGREDIENTS

1 CUP PLUS 1 TEASPOON SUGAR, DIVIDED
½ CUP WATER
½ TEASPOON ORANGE EXTRACT
½ TEASPOON VANILLA EXTRACT

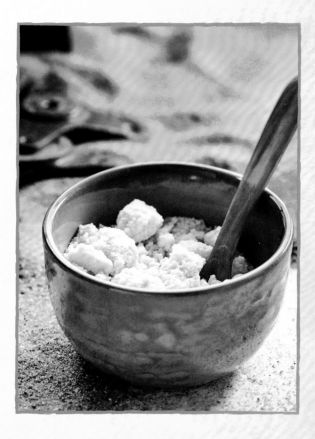

1. Combine 1 cup of the sugar, water, and orange extract in a small nonstick saucepan. Cook over medium heat without stirring for about 10 minutes, until the mixture develops a thick consistency and a golden amber color.

2. Add the vanilla extract and the remaining 1 teaspoon sugar, and stir vigorously, until the mixture turns pale and puffy and recrystalizes, about 5 to 10 minutes.

3. Stir a few more seconds to help dry it out, then remove from the heat.

4. While still warm, crumble or crush the sugar into fairly small pieces, and store in an airtight container.

NECTROSE CRYSTALS

Don't matter what planet you were born on, most species need water to survive. But on some worlds, findin' fresh water that tastes good enough to drink can be a real chore. That's where these beauties come in handy. Nectrose crystals might look like teensy gemstones, but they have a totally unexpected kind of value—pure flavor. These little guys quickly dissolve in a glass of water, infusin' it with an irresistibly fruity essence. I've seen 'em crushed up and used to line the rims of fancy cocktail glasses, and I've also heard stories of soldiers on the battlefront poppin' these rocks straight into their mouths for an extra boost of energy. Fair to say these sparklin' stones are precious no matter how they're used.

PREP TIME: 5 MINUTES
COOKING TIME: 15 MINUTES
YIELD: ABOUT 1½ CUPS
DIFFICULTY: MEDIUM

USED IN:
NECTROSE FREEZE (PAGE 133)
MIMBANESE MUDSLIDE (PAGE 131)

INGREDIENTS

1 CUP SUGAR
2 TABLESPOONS HONEY
2 TABLESPOONS WATER
½ TEASPOON ROCK SALT
1 TEASPOON BAKING SODA
1 TABLESPOON CITRIC ACID
RED, YELLOW, OR GREEN FLAVOR COMBO (SEE BELOW)

FLAVOR COMBOS:

Red: Food coloring, ½ teaspoon vanilla extract, dash of banana extract
Yellow: Food coloring, 1 teaspoon balsamic vinegar, dash of strawberry extract
Green: Food coloring, ½ teaspoon ground cardamom, dash orange extract

1. Line a rimmed baking sheet with parchment paper or a silicone mat.

2. In a medium saucepan over medium heat, melt together the sugar, honey, water, and salt. Cook without stirring until the mixture reaches 300°F on a candy thermometer, 5 to 10 minutes.

3. While the mixture is cooking, combine the baking soda and citric acid powder in a small bowl.

4. When the sugar solution is nearly up to temperature, stir in your desired flavor combo from the list below.

5. When the temperature hits 300°F, remove from the heat and quickly whisk in the combined baking soda and citric acid. This will cause the mixture to expand and bubble violently. Whisk just long enough for the powders to be incorporated, then immediately pour onto the prepared baking sheet.

6. Let cool completely for around an hour, at which point it will be brittle.

7. Break the crystals into smaller pieces. These can either be nibbled as is for a fizzy sensation on the tongue, or broken into smaller pieces in a food processor.

8. For a drink mixture, process into a fine dust; 1 tablespoon crystal dust per 8 ounces water should do the trick. You can use the dust on the rim of a cocktail glass.

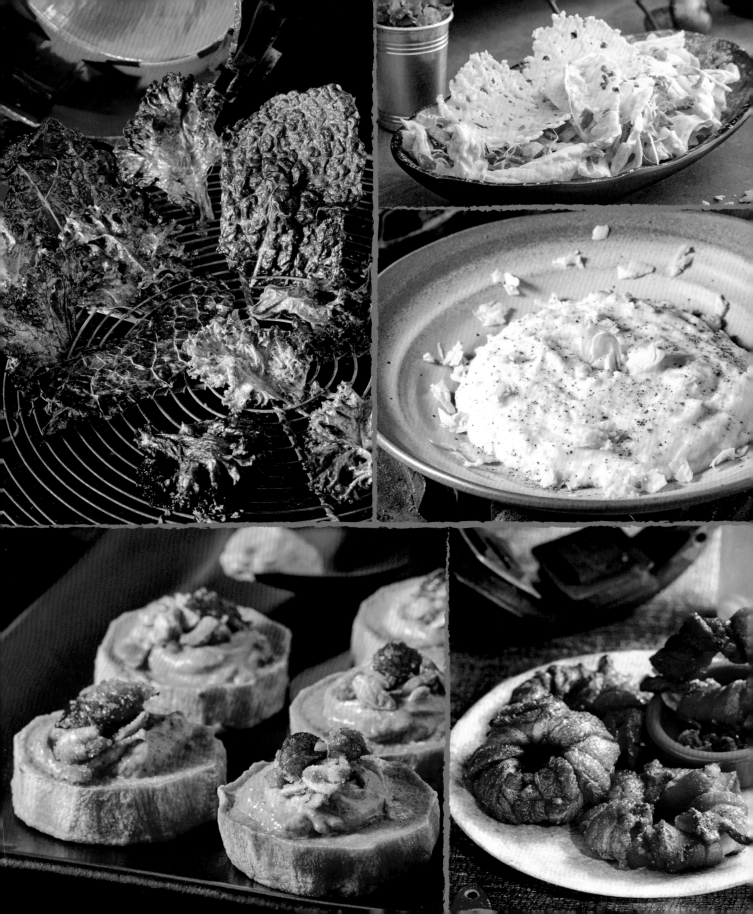

SIDES, STARTERS + SNACKS

You might have mastered sauces and garnishes, but you've still got a lot left to learn, my palate-pleasin' Padawan! Before you start braisin' a shaak roast (page 95) or stuffin' a puffer pig (page 107), you might wanna test your skills on some more manageable munchies. As Maz always said, size can be deceivin'. So even though they might be served on smaller plates, these scrumptious snacks have a galaxy of flavors packed into each itty-bitty bite.

Believe it or not, back on Takodana, these were some of my most frequently ordered dishes. And it wasn't just 'cause the castle's patrons were too cheap to splurge for a rack of smoked kaadu ribs. Truth is, folks with adventurous spirits tend to crave exotic flavors, so I carefully designed savory samplers like these to let 'em explore a wide variety of strange and excitin' new tastes without the risk of overfillin' their bellies or overspendin' their credits.

While most of the diminutive dishes detailed here were devised to stand on their own, some of 'em are just beggin' to be served alongside an entrée. It might seem overindulgent, but so far, no customer of mine has ever complained about havin' a heapin' pile of Fritzle Fries (page 57) with their Fried Endorian Tip-Yip (page 97).

At the end of the day, it really don't matter to me if you're havin' these bite-size beauties before your meal, with your meal, or in place of your meal. All I care about is that you're enjoyin' 'em.

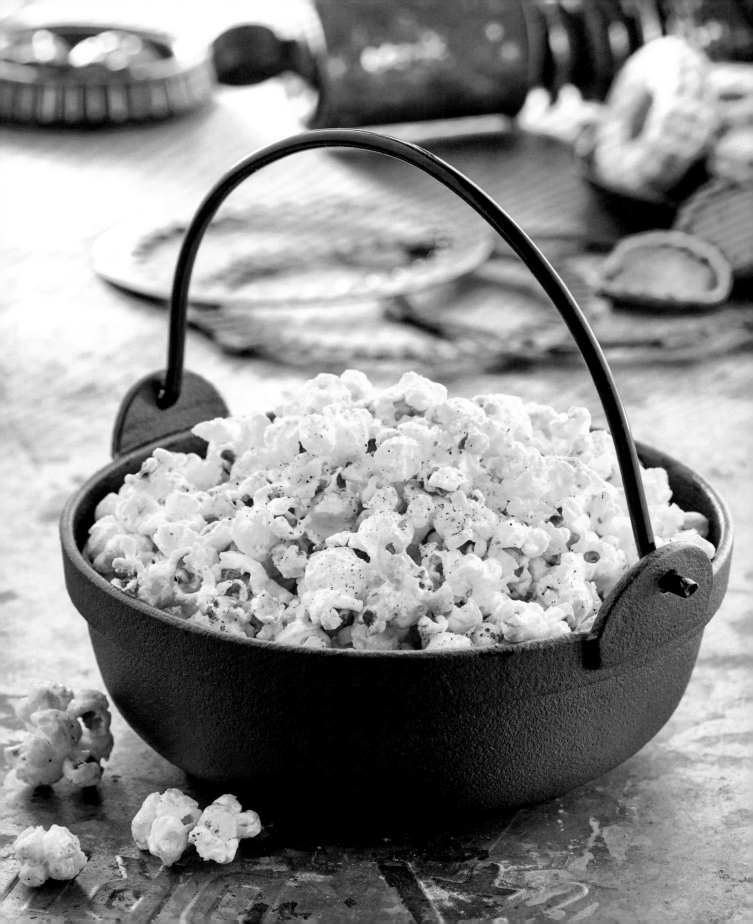

KAT'S KETTLE CORN

When I spend my credits at Kat Saka's Kettle on Batuu, the grains I buy are usually fully popped and perfectly seasoned. But sometimes I buy the Saka family's heirloom grains to use as ingredients in my own dishes. When placin' an order, I always make sure to add in a sack of unpopped corn kernels. That way, if I get a cravin' for Kat's signature snack when I'm docked at another outpost on the other side of the Rim, I can cook some up myself. Once the grains are popped up all nice and fluffy, you can toss 'em in just about anythin' you like—whether it's Saka Salt (page 29) or my own Nerfsteak Seasonin' (page 29). If you ain't got special seasonin' on hand, no worries. Quality grains like these are good enough to eat plain.

INGREDIENTS

¼ CUP VEGETABLE OIL

A FEW DROPS YELLOW FOOD COLORING

⅓ CUP SUGAR

½ CUP POPCORN KERNELS

1 TEASPOON SAKA SALT (PAGE 29)

PREP TIME: 5 MINUTES

COOKING TIME: 15 MINUTES

YIELD: SERVINGS VARY

DIFFICULTY: MEDIUM

1. Pour the oil and food coloring into a medium pot with a lid and place over medium-high heat. Add the sugar and popcorn kernels, pop the lid on, and give the pot a few shakes.

2. Leave the pot on the heat for several minutes, until the corn starts popping. At that point, shake the pot back and forth every so often until you can no longer see the bottom of the pot through the popped corn. Remove from the heat and continue to shake to cover the popcorn with the sweet coating.

3. Once the popping has mostly stopped, pour the popcorn into a large bowl. Sprinkle all over with the Saka Salt, tossing the popcorn occasionally to make sure it's all evenly coated. Best eaten the same day.

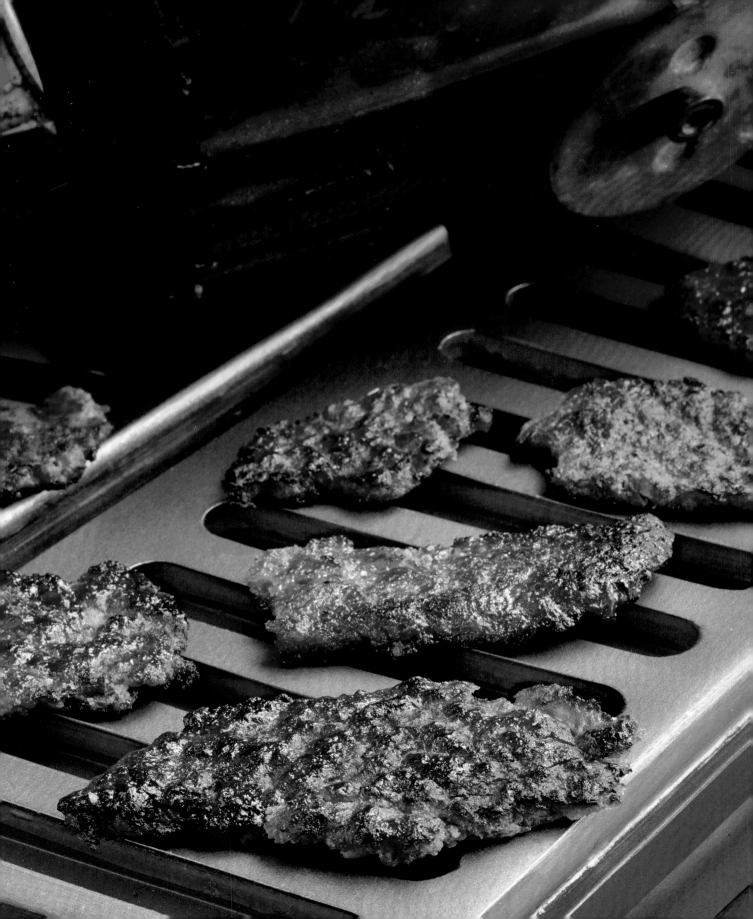

PITMASTER'S CHOICE

Bakkar the Butcher gets the credit for the delicious meats served at Ronto Roasters, but the real hero there is 8D-J8, aka the Pitmaster. This former smelter droid was designed to handle the heat, which is a good thing, because he never gets outta the blasted kitchen! When he's not turnin' those ronto shanks 'round the clock, 8D-J8 is busy addin' other meaty snacks to the menu, includin' a jerky made from the thin bands of meat hung around his roastin' pit. Whether it's nuna turkey or luggabeast, the Pitmaster's jerky is always sublime. Sadly, most of us ain't got a converted podracer engine on hand to cook up our own, but these meaty morsels should help keep you satisfied between trips to Black Spire.

INGREDIENTS

1 POUND GROUND PORK
1 TABLESPOON DARK SOY SAUCE
½ TEASPOON SESAME OIL
PINCH OF FIVE-SPICE POWDER
PINCH OF SALT
½ CUP SUGAR

PREP TIME: 5 MINUTES
CHILLING TIME:
8 HOURS, OR OVERNIGHT
COOKING TIME:
30 MINUTES
YIELD: ABOUT 1 POUND
DIFFICULTY: EASY

1. Combine all the ingredients in a large bowl, stirring with a spoon or mixing by hand until completely incorporated. Cover and refrigerate for 8 hours, or overnight.

2. Preheat the oven to 250°F and line a rimmed baking sheet with parchment paper or a silicone mat. Spread the pork out in a thin layer about ¼ inch thick.

3. Cook for about 15 minutes, then flip over and cook for another 15 minutes. Drain any excess fat from the pan.

4. Turn on the oven's broiler. Cut the jerky into rough squares and place these on a cooling rack set on the same baking sheet. Slide the pan under the broiler and cook for a few minutes on each side, until browned and crisping.

5. Store in an airtight container and refrigerate for up to a week.

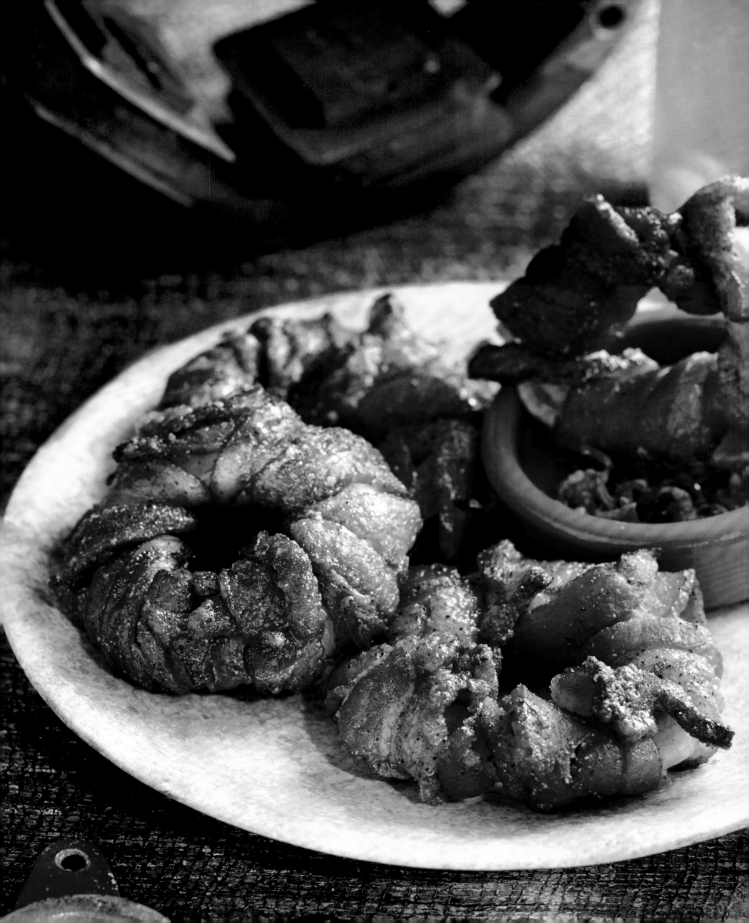

RINGS OF HUDALLA

The planet Hudalla is an enormous gas giant orbited by some of the largest rings in the galaxy. It's truly impressive to behold—but not nearly as impressive as the sumptuous snack that shares its name. Look, I'm well aware this ain't the first time someone's sliced up an onion, coated it with somethin' delicious, and served it next to a sandwich. But these baked beauties have got somethin' special that sets them apart from the traditional onion ring: They've traded breading for puffer pig bacon! That's right, each and every ring is wrapped in juicy strips of meat for a flavor that's bigger than any gas giant. Even better, the bacon is coated with a mixture of sugar and spice that caramelizes onto the surface of the rings as they cook. The real Hudalla might be a glorious sight, but believe me when I say that these rings are the true wonder.

INGREDIENTS

2 LARGE YELLOW ONIONS, PEELED
 AND CUT INTO ½-INCH-THICK DISCS
2 TABLESPOONS HOT SAUCE
1 CUP PACKED BROWN SUGAR
½ TEASPOON GARAM MASALA
1 POUND SLICED BACON

PREP TIME:
15 MINUTES
COOKING TIME:
30 MINUTES
YIELD:
SERVINGS VARY
DIFFICULTY: MEDIUM

1. Preheat the oven to 400°F. Line a baking sheet with aluminum foil to catch any drips and set a cooling rack on top.

2. Divide the sliced onions into sections of two same-size rings sandwiched together, which will give some stability as they bake. Choose the largest rings and work smaller from there. Lightly brush each pair of rings with hot sauce.

3. In a small bowl, combine the brown sugar and garam masala, then dip each slice of bacon in the sugar mix.

4. Wrap each onion in one or more slices of sugary bacon, making sure the bacon doesn't overlap and covers most of the onion. Place each wrapped ring on the cooling rack over the prepared baking sheet.

5. Bake for about 30 minutes, until the bacon is crisp but the rings hold their shape. If you'd like the bacon any crisper, slide the baking sheet under the broiler very briefly. Enjoy while still warm, but be careful—they will be hot from the oven.

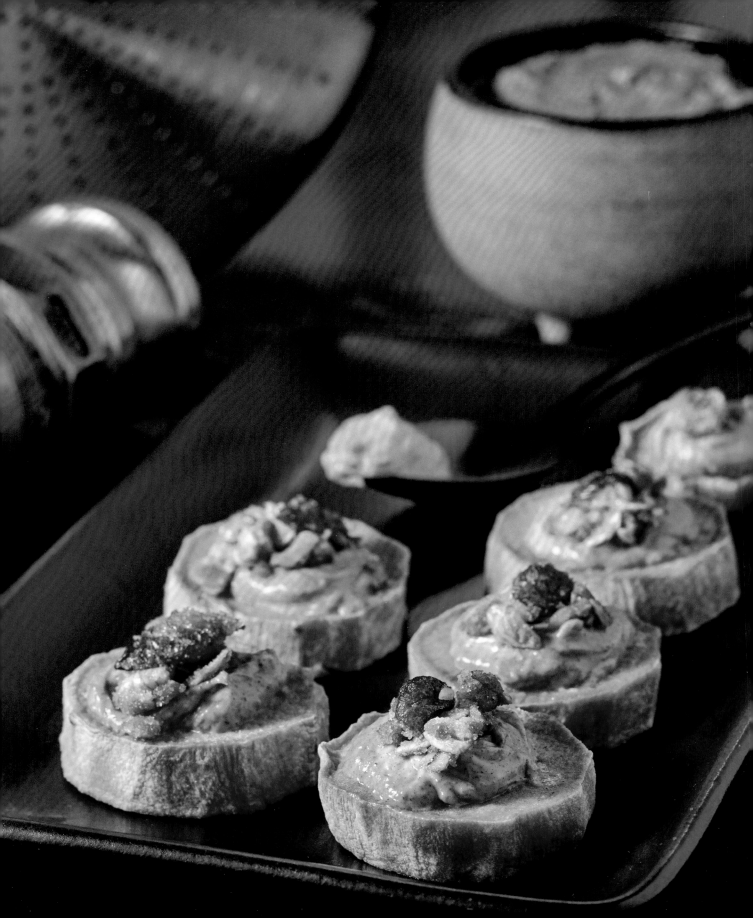

ROASTED KAJAKA ROOT

To some, a simple root like the kajaka might seem like nothin' more than another borin' side dish. Thankfully, all it takes is a pinch of imagination and a dash of skill to turn this tuber into somethin' far more interestin'. Kajaka outshines its blander root-veg cousins, possessin' a perfect harmony between sweet and savory, givin' it the potential to stand on its own as a snack or starter. Their surprisingly appealin' flavor made these starchy slices frequent favorites of the fabled Jedi Order way back before the fall of the Republic. You can deep-fry kajaka if you want, but unless you use a good troogan oil, you're just gonna drown out the root's natural flavors. I recommend roastin' your kajaka on skewers or toppin' them with some nice moof milk yogurt. It really brings out the subtle sweetness that makes this root so special.

INGREDIENTS

2 MEDIUM SWEET POTATOES, PEELED

1 TABLESPOON BUTTER, MELTED

½ CUP PLAIN YOGURT

¼ CUP PEANUT BUTTER OF YOUR PREFERRED STYLE

2 TABLESPOONS HONEY

2 TEASPOONS GROUND CINNAMON

ASSORTED TOPPINGS, LIKE NUTS, GRANOLA, DRIED FRUIT, CHOCOLATE CHIPS

PREP TIME: 5 MINUTES
COOKING TIME: 15 MINUTES
YIELD: 2 TO 4 SERVINGS
DIFFICULTY: EASY

1. Preheat the oven to 400°F and line a baking sheet with parchment paper.

2. Slice the sweet potatoes into ¼-inch-thick slices and arrange on the baking sheet.

3. Brush lightly with butter, then bake for 15 to 20 minutes, until fork-tender. Let cool for about 5 minutes.

4. While the sweet potatoes are baking, make the spread by combining the yogurt, peanut butter, honey, and cinnamon in a small bowl.

5. Spread evenly over the sweet potato slices, then sprinkle with your choice of topping to serve. Enjoy warm or cold.

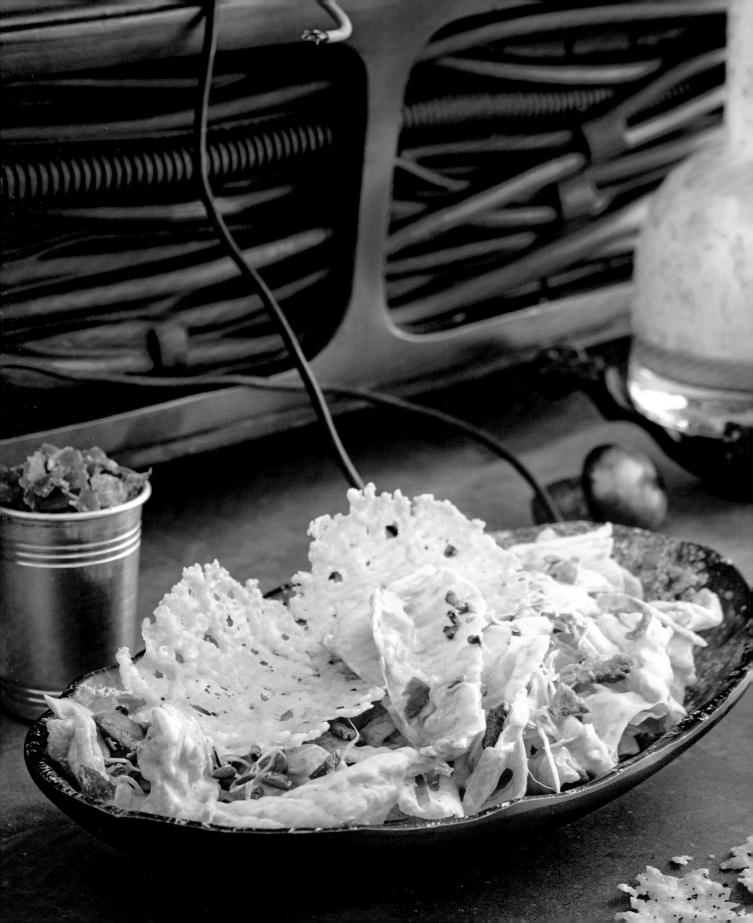

XIZOR SALAD

Most folks would probably agree that I don't look like the salad type. It ain't that I don't appreciate fresh veg, I just happen to know where it belongs—served alongside a giant hunk of roasted meat. But I've come to realize that my boundless appetite and my carnivorous inclinations ain't shared by everyone. For those who prefer their fare a bit lighter and healthier, this simple, refreshin' salad always does the trick. Rumor has it that it got its peculiar name from a Falleen prince-turned-crime-lord, but I'm pretty sure that's just a legend. What's indisputable, though, is that the crisp lettuce and sprouts in this mix taste divine when slathered in my Chadian Dressin' (page 35). And the fresh-baked cheese crisps are this salad's secret weapon, addin' an unexpected salty, tangy crunch. Of course, if you're like me, you can always add some crumbled bacon to keep your cravings at bay—at least until the main course.

INGREDIENTS

CHEESE CRISPS:
½ CUP GRATED PARMESAN CHEESE
¼ TEASPOON PEPPER

SALAD:
½ HEAD ICEBERG LETTUCE, TORN
 INTO SMALL PIECES
½ CUP PEA SPROUTS
¼ CUP BACON, COOKED AND
 CRUMBLED
CHADIAN DRESSING (PAGE 35)

PREP TIME: 10 MINUTES
COOKING TIME:
10 MINUTES
YIELD: 1 TO 2 SERVINGS
DIFFICULTY: MEDIUM

1. To make the cheese crisps: Preheat the oven to 400°F and line a baking sheet with parchment paper or a silicone mat.

2. Make little piles of cheese about 1 tablespoon each, then flatten them slightly, leaving a little room between them.

3. Sprinkle each with a little ground pepper, then bake for 5 to 10 minutes, until golden and crisp. Remove from the oven and let cool on the baking sheet.

4. To make the salad: While the crisps are cooking, toss the lettuce, sprouts, and crumbled bacon bits with the Chadian Dressing in a large bowl until evenly coated.

5. Transfer to serving bowls, then top with the cheese crisps. Enjoy straightaway.

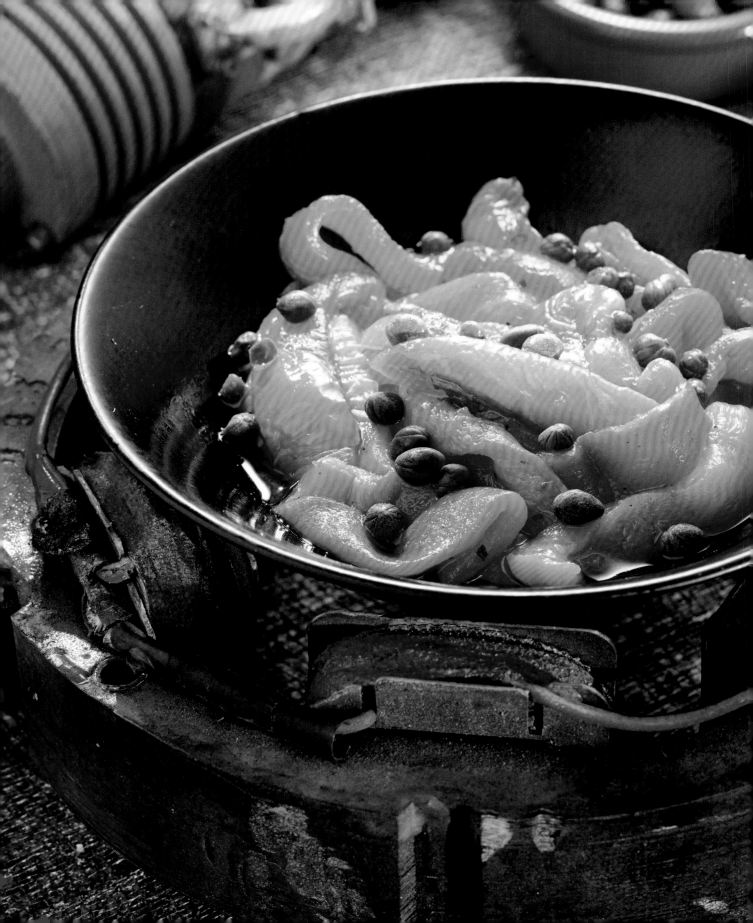

ROASTED CHANDO PEPPERS

When most folks think about peppers, they instantly assume they're gonna be spicy. But some peppers have a natural sweetness to 'em that opens up a whole new world of cookin' possibilities. One particularly sweet variety, known as the chando pepper, is native to Chandrila. Thanks to hyperspace tradin' routes, fresh chandos can now be found in market stalls across the Outer Rim. You can eat 'em raw, throw 'em on a grill to put a nice char on their skin, or add 'em to soups and stews. Back on Takodana, I even used to make a tangy jelly outta these zesty orange beauties. But a taste this bold don't need nothin' too fancy to help it shine through. So these days, I'm more likely to simply roast up my chandos and serve 'em alongside another dish in dire need of an extra boost in flavor.

INGREDIENTS

2 ORANGE BELL PEPPERS, HALVED, SEEDED, AND STEMMED

2 TABLESPOONS WHITE WINE VINEGAR

SPLASH OF LEMON JUICE

2 TABLESPOONS OLIVE OIL

1 TABLESPOON HONEY

½ TEASPOON DRIED SAGE

PINCH OF PEPPER

1 TABLESPOON CAPERS, RINSED

PREP TIME: 5 MINUTES
COOKING TIME: 45 MINUTES
YIELD: 4 SERVINGS
DIFFICULTY: EASY

1. Preheat the oven to 375°F. Place the peppers on a small baking sheet and roast for about 35 minutes, until the peppers are soft but not mushy, then peel the skins off. Cut into long thin slices.

2. In a medium sauté pan or skillet, combine the vinegar, lemon juice, olive oil, honey, sage, and pepper.

3. Add the sliced peppers and cook over medium-low heat for about 10 minutes, until the peppers are quite soft and fragrant.

4. Sprinkle in the capers and cook for about 1 minute more.

5. Transfer to a serving plate and enjoy warm.

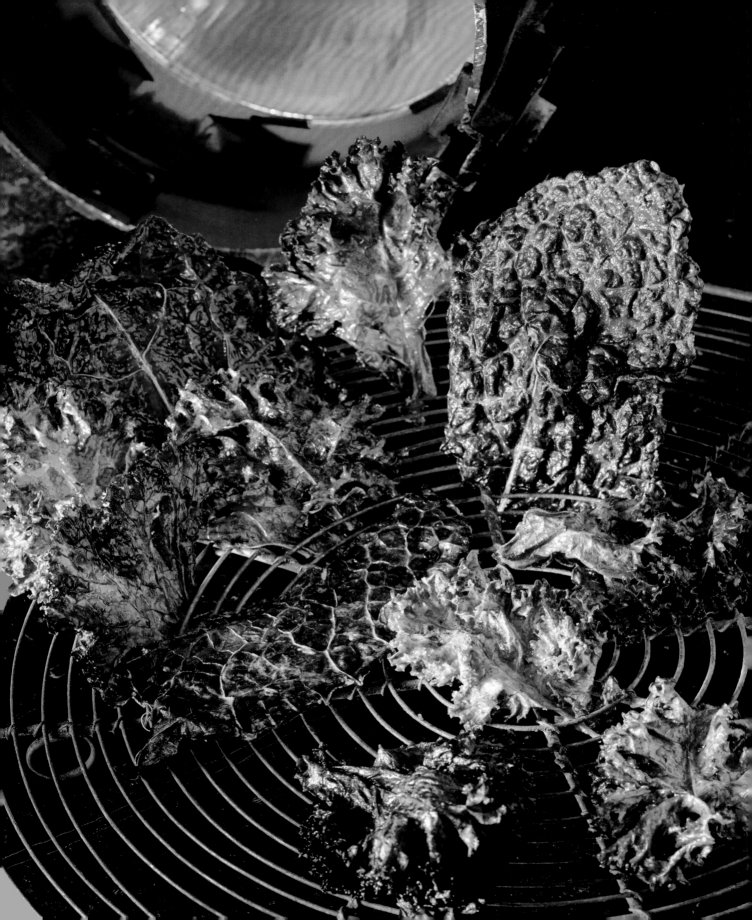

MOSS CHIPS

Want a simple snack that packs a lot of flavor without packin' on the kilos? Then you might wanna grab a healthy handful of moss chips. Moss wasn't really my thing until some folks campin' on Yavin 4 let me try these crispy little wafers they'd made. They're chock-full of green goodness that'll keep your digestive system from rebellin' after you've binged on some of the more decadent dishes detailed in these pages. Sure, they might not be flashy, but there's a reason that chips like these seem to be staples on virtually every planet I've visited: They're not just good—they're good for you. If you ain't got any edible moss growin' nearby, don't worry. In my travels, I've discovered endless variations, like this recipe from Dantooine that substitutes leafy greens with the same delectable results.

INGREDIENTS

3 OR 4 LARGE KALE LEAVES
1 TABLESPOON HONEY
2 TABLESPOONS OLIVE OIL
2 TEASPOONS WHITE MISO PASTE
½ TEASPOON GROUND GINGER
SPLASH OF BOILING WATER

PREP TIME: 5 MINUTES
COOKING TIME: 45 MINUTES
YIELD: SERVINGS VARY
DIFFICULTY: EASY

1. Preheat the oven to 200°F and line a baking sheet with parchment paper or a silicone mat.

2. Tear the kale into bite-size pieces, discarding any thick stems. Whisk together the honey, olive oil, miso paste, ginger, and boiling water in a medium mixing bowl, then toss the kale pieces in the mixture.

3. Place the kale on the baking sheet, gently shaking off any excess dressing so the leaves are not too wet. Bake for about 45 minutes, until crisp and dry.

4. Remove from the oven and allow to cool before enjoying. These are best enjoyed the same day.

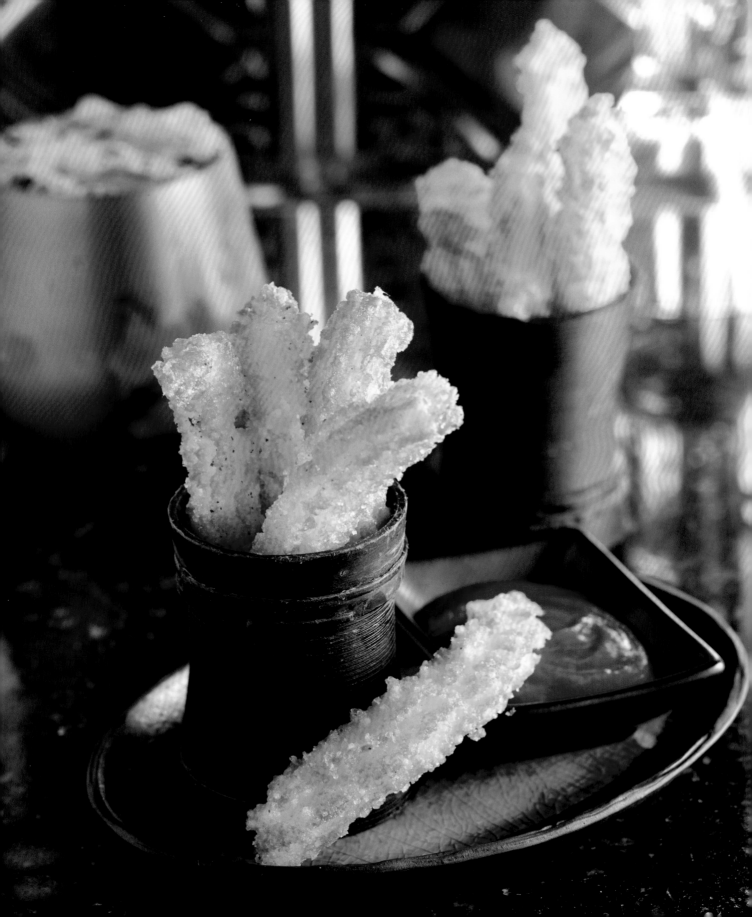

FRITZLE FRIES

Despite my best efforts to cook up a healthy meal, I've always had a weakness for a good plate of fried food. There's nothin' I crave more next to a sandwich than a pile of these crispy little fellas. My old friend Freerago used to run a satellite diner that orbited Hosnian Prime. To be honest, the frangella pie that the place served was only just passable, but somehow his kitchen droids managed to cook up the best plate of fritzle fries anywhere in the galaxy. Dip 'em in some Emulsauce (page 31), and you're in for a real treat! Based on the recent obliteration of the Hosnian system by the First Order, well, it's safe to assume poor ol' Free is permanently outta business. But food this good always finds a way to live on.

INGREDIENTS

¼ CUP SMALL TAPIOCA PEARLS
¼ CUP PLAIN YOGURT
¼ CUP WARM WATER
¼ CUP GRATED PARMESAN CHEESE
PINCH OF CAYENNE PEPPER
½ CUP RICE FLOUR
OIL FOR FRYING, SUCH AS CANOLA

PREP TIME: 15 MINUTES
SOAKING TIME: 15 MINUTES
COOKING TIME: 15 MINUTES
YIELD: SERVINGS VARY
DIFFICULTY: MEDIUM

1. In a medium mixing bowl, soak the tapioca in the yogurt and warm water for about 15 minutes.

2. Add the Parmesan cheese, cayenne, and rice flour, then stir together until just combined.

3. Transfer to a piping bag fitted with a large star tip or a regular round tip.

4. Fill a small saucepan with about 2 inches of oil and place over medium heat.

5. Once the oil is hot, squeeze small lengths of the batter into the oil. Fry until golden brown, flipping occasionally, about 15 minutes for the entire batch, then remove to a plate lined with paper towels to drain.

MON CALA SARDINE FRITTERS

A ways back, I won a high-stakes game of dejarik against a particularly annoyin' Clawdite. The prize he forfeited was one I honestly wasn't sure what to do with at first—a VIP ticket to the Moncaladrome to see some opera about the Faluvian cycle. As you might've guessed, I ain't exactly the high-society type, so just stayin' awake through the first act was a real chore. It all paid off durin' intermission, though, when I got my hands on one of the finest canapés to ever hit a tray. This salty fish cake sent my taste buds on a journey more epic than some five-hour song-and-dance routine ever could. And now that I can make 'em myself, I don't even have to put on a fancy suit.

INGREDIENTS

OIL FOR FRYING, SUCH AS CANOLA

TWO 5-OUNCE TINS SARDINES, DRAINED

1 EGG

6 PIECES SEAWEED SNACK, FLAKED SMALL

SQUEEZE OF FRESH LIME JUICE

1 TABLESPOON SESAME SEEDS

PINCH OF CAYENNE PEPPER

½ CUP PANKO BREADCRUMBS

SALT

PEPPER

PREP TIME: 5 MINUTES
COOKING TIME: 15 MINUTES
YIELD: ABOUT 20 FRITTERS
DIFFICULTY: EASY

1. Using two forks, mash the sardines to a paste in a medium bowl.

2. Add the egg, seaweed, lime juice, sesame seeds, and cayenne, and season with salt and pepper to taste.

3. Add the breadcrumbs until you have a mixture that is neither too wet nor too dry, but can be shaped easily by hand. Form into balls about 1 inch across.

4. Fill a small saucepan with about 1 inch of oil and place over medium heat.

5. Working in batches, add the fritters to the hot oil, making sure not to overcrowd them. Turn the fritters occasionally until they are a dark golden brown on all sides, about 5 minutes total.

6. Remove to a plate lined with paper towels and repeat until all the fritters are cooked.

DEVARONIAN SOUFFLÉ

Most cooks worry about their soufflé fallin', but the Devaronians added a whole new level of danger to this classic baked dish. Back in my early days at Maz's castle, I held a cookin' competition to fill a kitchen position left vacant followin' the untimely demise of my sous-chef Robbs Ely. One of the contestants, a Devaronian prep cook named Sama Macoy, whipped up this tangy soufflé, but it was that same whippin' that knocked her right outta the contest. See, if the batter for this delicate delight ain't stirred at just the right speed, the whole thing'll explode in your face! Let's just say ol' Sama went out with a bang. Hope you fare better.

INGREDIENTS

BUTTER FOR GREASING

3 TABLESPOONS SUGAR, PLUS MORE FOR DUSTING

4 LARGE EGGS, SEPARATED, AT ROOM TEMPERATURE

PINCH OF SALT

¼ CUP CREAM CHEESE, SOFTENED

4 OUNCES CRUMBLED GOAT CHEESE

JUICE AND ZEST OF 1 LEMON

½ TEASPOON PAPRIKA

PREP TIME: 15 MINUTES

COOKING TIME: 15 MINUTES

YIELD: 4 SERVINGS

DIFFICULTY: MEDIUM

1. Preheat the oven to 400°F. Lightly butter four 4-ounce ramekins, dust with a little sugar, and set aside.

2. In a medium bowl, beat together the egg whites and salt with a whisk or an electric mixer on high speed until they form soft peaks. While beating, gradually add the 3 tablespoons of sugar, continuing to beat until the mixture is glossy and forms stiff peaks. Set aside.

3. In a large bowl, beat together the egg yolks, cream cheese, goat cheese, lemon juice and zest, and paprika. Beat until thick and golden.

4. Add one-third of the whipped egg white mixture to the yolk bowl and gently incorporate. Then gently fold in the remaining egg white mix, scraping the bottom of the bowl but taking care not to overwork and deflate everything.

5. Divide the mixture evenly among the four prepared ramekins and set them on a baking sheet. Bake for about 15 minutes, until the soufflés are just a little wobbly still in the middle.

6. Remove from the oven and serve straightaway, being careful of the hot ramekins.

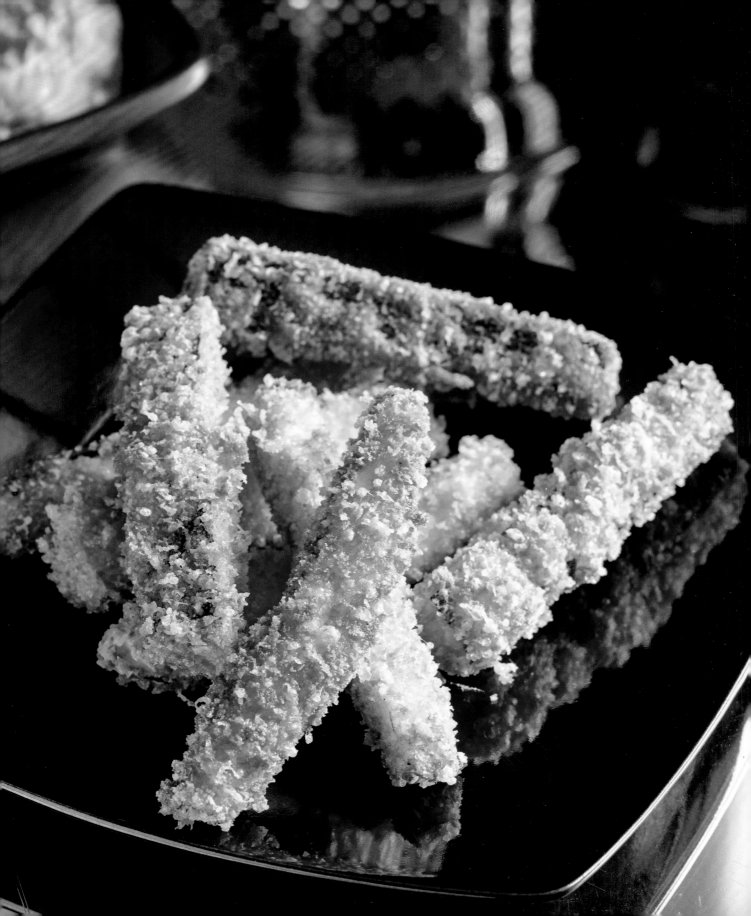

FRIED ZUCHII

Did your Devaronian Soufflé (page 59) unexpectedly detonate and you need a last-minute replacement that's equal parts delicious and easy to prepare? Sounds like fried zuchii might be the dish you're lookin' for. Back on Takodana, I always liked to have this sweet and juicy veg growin' in my garden. This particular recipe is about as straightforward as they come—some fresh zuchii, coated and flash-fried, then served with a tangy sauce for dippin'. That's it. But just 'cause this one is simple don't mean it ain't also scrumptious. With its perfectly crispy coatin', fried zuchii is an ideal way to start off any meal and impress your guests. It can make even a novice chef look like they studied under the great Jlibbous of Zenn-La.

INGREDIENTS

OIL FOR FRYING, SUCH AS CANOLA
¾ CUP PANKO BREADCRUMBS
1 CUP GRATED PARMESAN CHEESE
PINCH EACH OF SALT AND PEPPER
½ CUP ALL-PURPOSE FLOUR
1 EGG, BEATEN
1 TABLESPOON BUTTERMILK
2 MEDIUM ZUCCHINI, CUT INTO
 3-INCH STICKS

PREP TIME: 15 MINUTES
COOKING TIME:
15 MINUTES
YIELD: SERVINGS VARY
DIFFICULTY: MEDIUM

1. Fill a medium saucepan with about 2 inches of oil. Place over medium heat and warm to 350°F. Line a plate with paper towels.

2. Combine the breadcrumbs, Parmesan cheese, salt, and pepper in a small bowl. Put the flour in a second small bowl and the beaten egg and buttermilk in a third.

3. Working a few pieces at a time, dip the zucchini sticks first in flour, then egg, and finally in the breadcrumb mixture.

4. Lower the breaded sticks into the hot oil and fry for a couple of minutes, flipping occasionally, until dark brown on both sides.

5. Transfer the sticks to the prepared plate to drain.

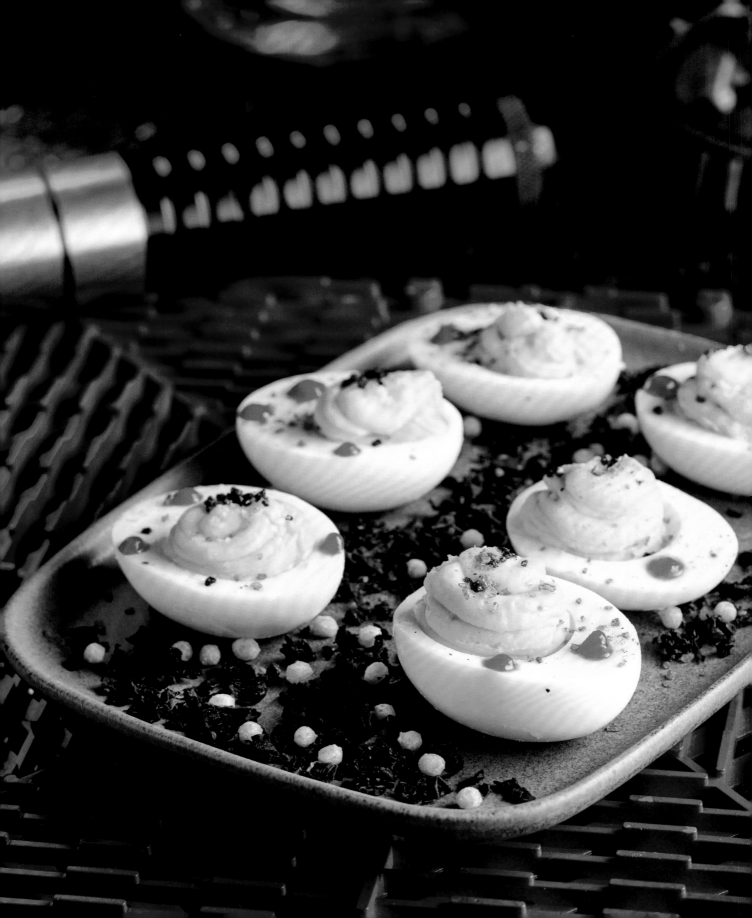

DEVILED PIKOBI EGGS

Pikobi are tiny lizard-like creatures that are a bit too gamy for my taste, but their eggs are unusually mouthwaterin'. Personally, I prefer mine lightly basted and seasoned, served alongside some freshly grilled dianoga back. Unfortunately, dianoga is a bit too tricky for the average home cook, what with all the blood parasites living in its fatty tissue. Luckily, pikobi eggs are plenty good on their own and can be served in a variety of ways, from scrambled to deviled. And if you ain't got pikobi on your world, don't worry. This recipe works pretty darn well with just about any other kind of egg, too!

INGREDIENTS

8 EGGS

⅓ CUP EMULSAUCE (PAGE 31) OR MAYONNAISE

1 TABLESPOON WHITE MISO PASTE

½ TEASPOON TOASTED SESAME OIL

1 TEASPOON SRIRACHA

BLACK SESAME SEEDS FOR GARNISHING

RED SALT FOR GARNISHING

PREP TIME: 10 MINUTES

COOKING TIME: 15 MINUTES

YIELD: 16 SERVINGS

DIFFICULTY: MEDIUM

1. Place the eggs in a medium saucepan and cover with water. Place over medium-high heat and bring to a boil, then remove from the heat and let sit for 10 minutes.

2. Run the eggs under cold water until they are cool enough to handle. Peel each egg, then slice in half lengthwise, separating the yolks into a small bowl and placing the whites on a serving plate.

3. Add the Emulsauce or mayonnaise, miso paste, and sesame oil to the bowl with the yolks, then mash with a fork until smooth. Place a dollop of this filling into the hollow of each egg white using a pair of spoons or a pastry bag.

4. Add a drop of sriracha to the top of each egg, then sprinkle with black sesame seeds and red salt.

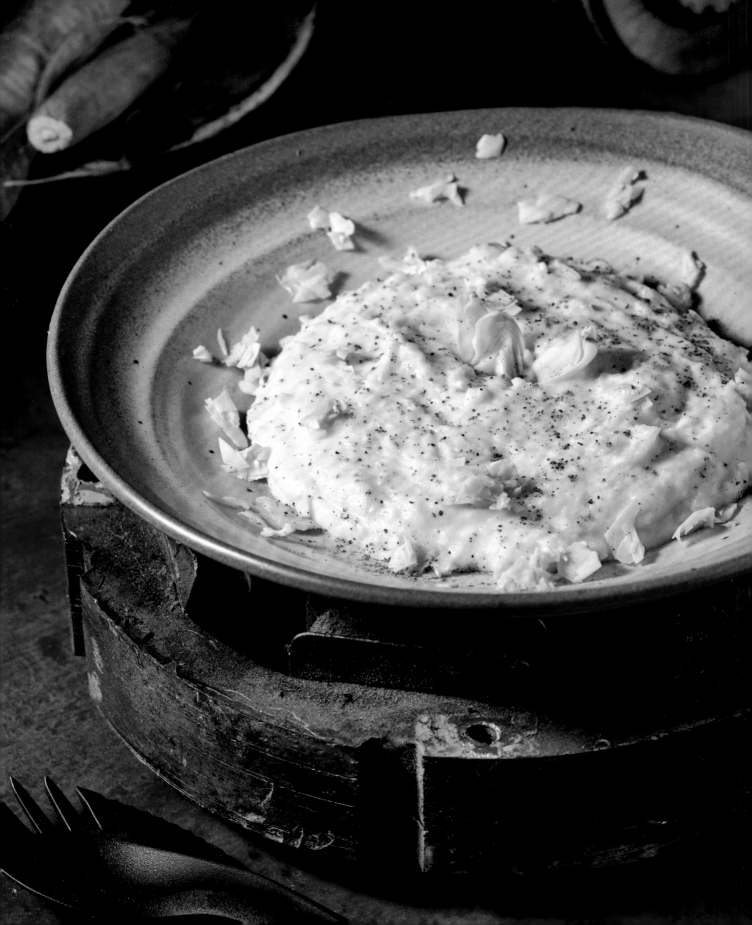

MASHED CHOKEROOT

Chokeroot may be an old family standard on a number of worlds, but until recently, it was somethin' I wouldn't even consider servin' in my kitchen. To be fair, chokeroot ain't terribly unpleasant. But it ain't terribly flavorful either, and I prefer not to waste my time on ingredients that are anythin' less than exceptional. So imagine my surprise when I discovered this creamy mashed chokeroot recipe on my last visit to Saleucami. Never would've guessed that mixin' in some falumpaset cheese and simple spices would bring out an inherent sweetness hidin' beneath the chokeroot's surface. Is this single stellar recipe enough to change my opinion about an ingredient I once despised? I dunno. Ask me after I scarf down another bowl or two . . .

INGREDIENTS

½ CUP MILK

½ CUP HEAVY CREAM

1 BAY LEAF

2 CLOVES GARLIC, MINCED

2 TABLESPOONS OLIVE OIL, PLUS
 MORE FOR DRIZZLING

1 POUND PARSNIPS, PEELED AND
 ROUGHLY CHOPPED

½ CUP GRATED PARMESAN CHEESE

PINCH OF GROUND NUTMEG

SALT

PEPPER

½ CUP CANNED ARTICHOKE
 HEARTS, DICED

PREP TIME: 5 MINUTES

COOKING TIME:
15 MINUTES

YIELD: 4 SERVINGS

DIFFICULTY: EASY

USED IN:

FRIED ENDORIAN
TIP-YIP (PAGE 97)

1. Combine the milk and cream in a medium saucepan along with the bay leaf, garlic, and olive oil. Bring to a simmer over medium heat, then add the parsnips.

2. Cover and let simmer for about 15 minutes, until the parsnips are very tender.

3. Remove from the heat, remove the bay leaf, and puree with an immersion blender until smooth, adding extra milk or cream if needed.

4. Add the Parmesan cheese and nutmeg, and season with salt and pepper to taste.

5. Stir in the artichoke hearts, and enjoy!

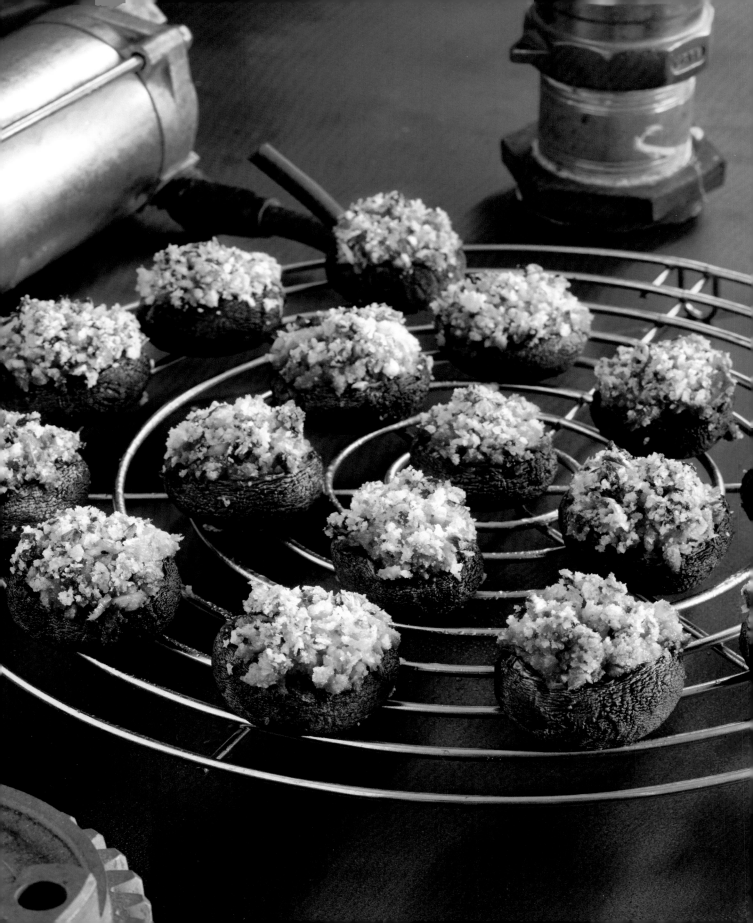

CONSTABLE'S CAPS

These stuffed fungi got their quirky name because they bear a strikin' resemblance to the iconic helmets worn by the Kyuzo lawmen who patrol Jakku's Niima Outpost. But since mushrooms big enough to stuff are rare on a world as dry and barren as Jakku, you'd be better off settin' your course for the fungal forests of Skako Minor if you're lookin' to forage for some truly titanic toadstools. Once you've acquired the agarics, the fun part is stuffin' 'em. I've used diced meat, mixed veg, and even imitation killcrab as fillin' before, but this here recipe is one of my favorite variations, hands down. Taste this spectacular can't possibly be legal!

INGREDIENTS

1 POUND BUTTON MUSHROOMS

3 TABLESPOONS BUTTER

1 CLOVE GARLIC, MINCED

½ CUP PANKO BREADCRUMBS

¼ CUP GRATED PARMESAN CHEESE

2 GREEN ONIONS, BOTH WHITE AND GREEN PARTS, FINELY CHOPPED

1 TABLESPOON FINELY CHOPPED PARSLEY

½ TEASPOON GARAM MASALA

SALT

PEPPER

PREP TIME: 10 MINUTES

COOKING TIME: 15 MINUTES

YIELD: SERVINGS VARY

DIFFICULTY: MEDIUM

1. Preheat the oven to 350°F and line a baking sheet with parchment paper or a silicone mat.

2. Clean and stem the mushrooms and dice the stems small. Arrange the mushroom caps on the baking sheet, leaving a little room between each.

3. Melt the butter in a medium sauté pan or skillet over medium heat. Add the garlic and cook for 2 to 3 minutes, until soft and fragrant. Add the diced mushroom stems and cook for about 5 minutes, until they have released their juices.

4. Stir in the breadcrumbs, Parmesan cheese, onions, parsley, garam masala, and salt and pepper to taste, and cook 1 minute more, until the cheese is softened and everything is incorporated. Remove from the heat.

5. Using a small spoon, press the filling into the hollows of the mushroom caps. Continue adding filling, mounding it up on top of each cap. Bake for about 15 minutes, until the mushrooms are soft. Serve hot.

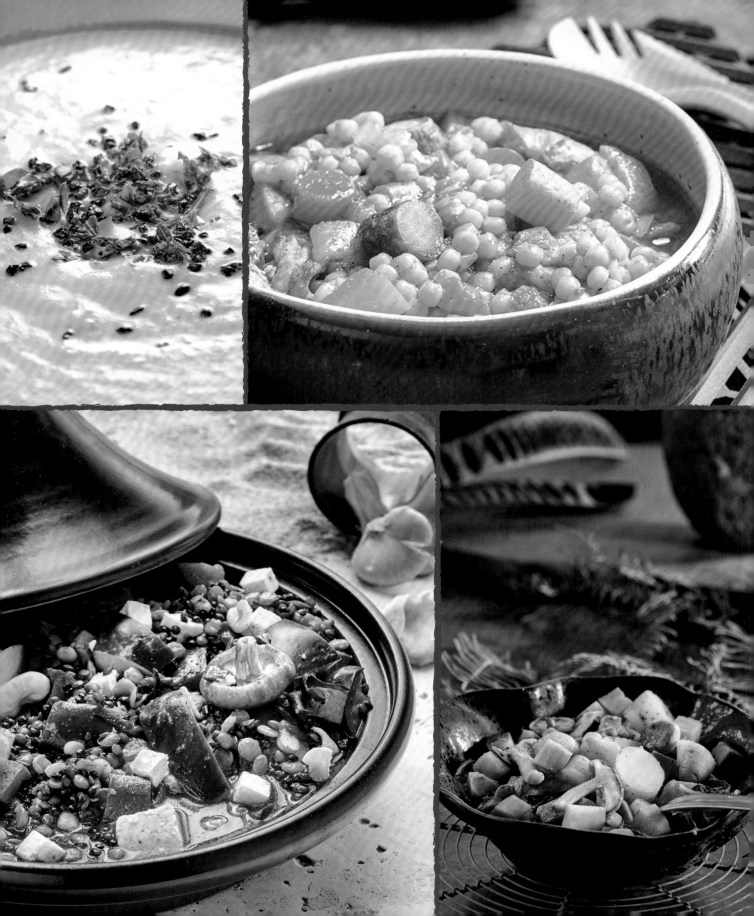

SOUPS
+ STEWS

I've visited a lot of worlds in my travels, and I ain't found one sentient species yet that didn't have some sort of soup or stew as a part of their diet. Might be 'cause they're some of the galaxy's easiest dishes to cook. All you need is a pot, some water, and somethin' to flavor it with. Don't take a degree from the Orto Culinary Academy to pull that off.

Of course, just 'cause soup is simple to make don't mean it's always good to eat. I've had a few that legitimately made me wonder if the chef had served me a spoonful of swamp scum on accident. Still, when you come across a soup or stew that really works, it's somethin' you're not likely to forget. A well-crafted bowl can send my mind reelin' back to my childhood on Artiod Minor. There's no denyin' it—good soup feels like home.

One more great thing about soups and stews is that a single batch can go a long way, feedin' your entire clan and still leavin' plenty of leftovers for meals to come. Everyone's got different tastes, sure, but I've gathered a small selection of brothy bowls that manages to please the crowds no matter where I go. I just hope I brought enough pots . . .

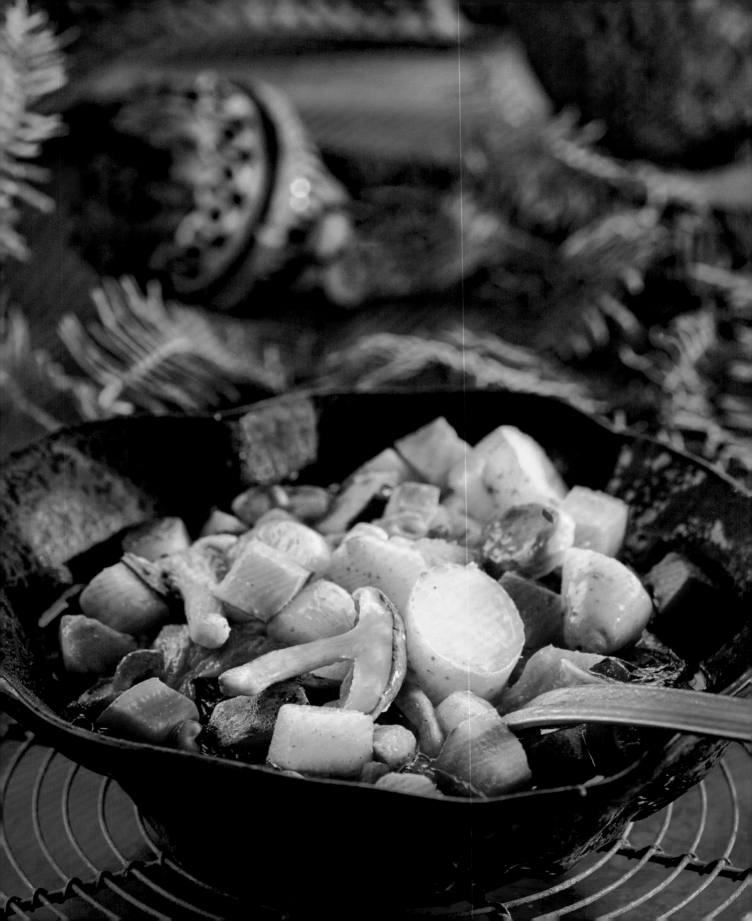

ROOTLEAF STEW

A swamp world like Dagobah ain't exactly where you expect to find a galaxy-class meal, but you'd be surprised how pleasant a steamin' pot of weeds and fungus can be if you take the time to prepare it right. Over the years, I've perfected my own variation on the classic rootleaf stew that I always keep simmerin' in one of the kettles on my stove. The dish hails from a world that smells like an Imperial trash compactor, so I understand why it's considered an acquired taste. But mine ain't quite as pungent as other variations. It's bubblin' with just the right amount of potent flavor and tons of vital nutrients. I promise you'd be missin' out if you didn't at least give it a try.

INGREDIENTS

2 TABLESPOONS OLIVE OIL

8 OUNCES MIXED MUSHROOMS, SLICED

2 CLOVES GARLIC, FINELY MINCED

1 TABLESPOON FRESHLY GRATED GINGER ROOT

½ TEASPOON GROUND CUMIN

½ TEASPOON GROUND TURMERIC

½ TEASPOON GROUND CINNAMON

2 CUPS VEGETABLE BROTH

2 CUPS CHOPPED ROOT VEGETABLES, SUCH AS POTATO, CARROT, AND PARSNIP

SEVERAL HANDFULS COLLARD GREENS, TORN INTO SMALL PIECES

PREP TIME: 5 MINUTES

COOKING TIME: 20 MINUTES

YIELD: 4 SERVINGS

DIFFICULTY: EASY

1. Heat 1 tablespoon of the oil in a large saucepan over medium heat and cook the mushrooms for several minutes, stirring occasionally, until they have released their juices. Remove the mushrooms to a bowl and set aside.

2. Add the remaining 1 tablespoon oil, followed by the garlic, ginger, cumin, turmeric, and cinnamon, stirring for about 30 seconds until fragrant.

3. Pour in the vegetable broth, followed by the root vegetables. Add water to just cover the vegetables, and simmer until they are soft, 10 to 15 minutes, depending on their size.

4. Add the mushrooms back in, followed by the collard greens. Cook for another 1 to 2 minutes, then ladle into serving bowls.

TOPATO SOUP

Remember when I said that good soup feels like home? Well, in the case of this classic topato soup I mean it literally. Yeah, I might have learned the ins and outs of craftin' a fine meal from old holovids, but that don't mean I never tasted good food before that. My mother was no Gormaanda, but she knew her way around a kitchen well enough. And whenever she started some of this aromatic broth simmerin' on the stove, you could guarantee that the entire family would be back in time for dinner. It was one of the first dishes she taught me how to make once she realized where my passion for food was takin' me. Hey, we all gotta start somewhere, right?

INGREDIENTS

1 TABLESPOON OLIVE OIL

2 TO 3 CLOVES GARLIC, MINCED

½ MEDIUM YELLOW ONION, DICED

¾ CUP GREEN SALSA

1 CUP CHICKEN BROTH

1 MEDIUM POTATO, PEELED AND DICED

1 CUP BABY SPINACH LEAVES

½ CUP HEAVY CREAM, OR MORE TO TASTE

SALT

PEPPER

PREP TIME: 5 MINUTES

COOKING TIME: 15 MINUTES

YIELD: 4 SERVINGS

DIFFICULTY: EASY

1. Heat the oil in a medium saucepan over medium heat. Add the garlic and onion and cook for a few minutes, stirring occasionally, until fragrant and soft.

2. Add the salsa, chicken broth, and potato, then cook for about 15 minutes more, until the potato is fork-tender.

3. Stir in the spinach for about 30 seconds, then puree everything with an immersion blender.

4. Add the cream, then season with salt and pepper to taste, adding more cream if it is too spicy.

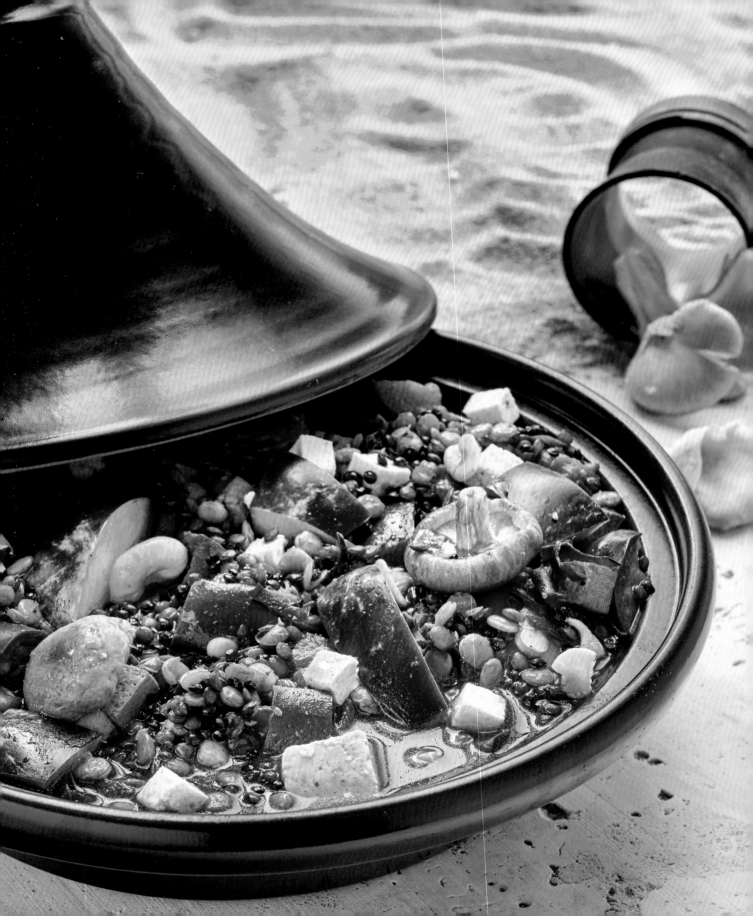

TATOOINE TERRINE

Cookin' in low-moisture environments ain't easy. After all, to make a soup, you gotta have liquid. On most worlds, that ain't much of a problem, but on desert planets like Tatooine, every single drop of water counts. A quality vaporator can usually collect enough moisture out of the arid air, but it'll take a day's harvest to fill a decent pot. Fortunately, this tasty terrine maximizes the moisture in the dish by drawin' extra juices from a special breed of mushrooms that grows right in the vaporator's excess condensation. The result is a hearty dish that ain't quite a soup, but it'll still be sure to get your juices flowin' again, even after a day of toilin' under the planet's twin suns.

INGREDIENTS

1 TABLESPOON OLIVE OIL

1 MEDIUM YELLOW ONION, DICED

1 CLOVE GARLIC

½ CUP CUBED FIRM TOFU

1 TABLESPOON RED CURRY PASTE

2 TEASPOONS GARAM MASALA

2 TEASPOONS GROUND CORIANDER

1 LARGE EGGPLANT, CUT INTO
 1-INCH CUBES

6 CUPS CHICKEN BROTH

¼ CUP MOLASSES

½ OUNCE DRIED MUSHROOMS
 OF YOUR CHOICE

¼ CUP BLACK LENTILS

SALT

PEPPER

PREP TIME: 5 MINUTES
COOKING TIME:
35 MINUTES
YIELD: 4 SERVINGS
DIFFICULTY: EASY

1. In a large saucepan, heat the olive oil over medium heat. Add the onion and garlic, and cook, stirring occasionally, for about 5 minutes, until soft and fragrant.

2. Add the tofu and cook until brown all over, about 5 minutes.

3. Stir in the curry paste, garam masala, and coriander, then add the remaining ingredients, seasoning with salt and pepper to taste.

4. Cook for about 25 more minutes, until the eggplant is very soft and the lentils are cooked through.

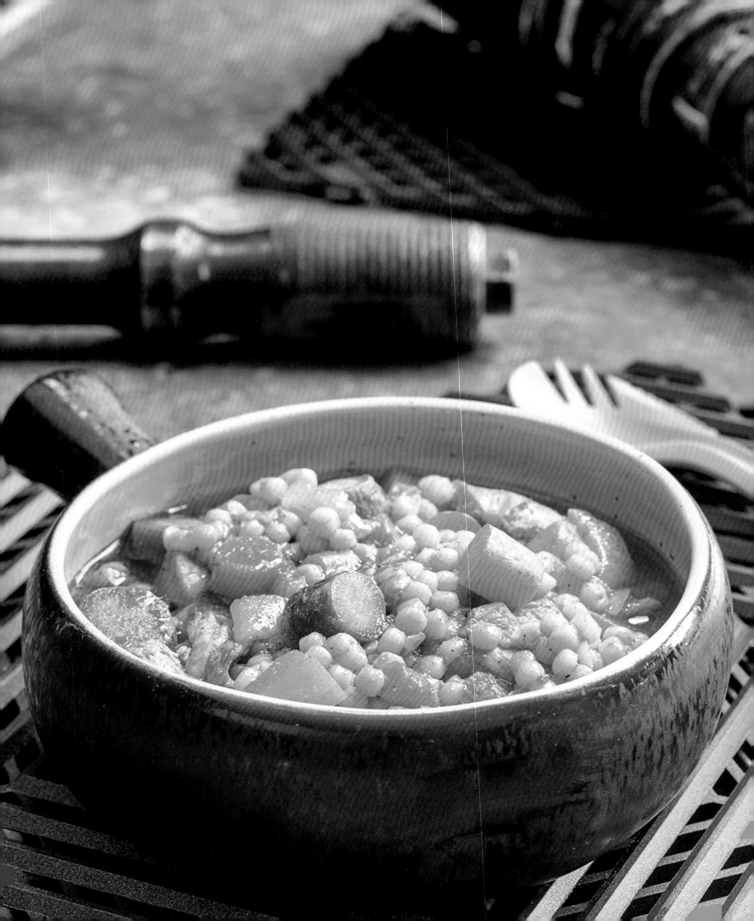

SPICY MANDALORIAN STEW

Mandalorians were proud warriors with a real reputation for toughness. If somethin' didn't pose a challenge, it wasn't worth their time. Apparently, that point of view carried over into suppertime as well, as evidenced by this traditional stew that's so blazin' hot it'll burn the hair right outta your nostrils. This old Mandalorian gem is known in their native tongue as *tiingilar*—I ain't fluent in Mando'a, but I assume it roughly translates to "eat at your own risk." Combinin' a hearty blend of meat and veg with a scorchin' seasonin' mix, this concoction would make even the hardiest Mandalorian sweat themselves right outta that crazy armor of theirs.

INGREDIENTS

2 TABLESPOON OLIVE OIL

1 MEDIUM YELLOW ONION, DICED

2 CLOVES GARLIC, MINCED

1 TABLESPOON GRATED FRESH GINGER

1 POUND BONELESS, SKINLESS CHICKEN THIGHS, ROUGHLY CHOPPED

1 MEDIUM RED APPLE, CORED AND DICED

3 TABLESPOONS ALL-PURPOSE FLOUR

2 CARROTS, ROUGHLY CHOPPED

1 PURPLE POTATO, ROUGHLY CHOPPED

2 TEASPOONS GARAM MASALA

2 TABLESPOONS CURRY POWDER

2 TABLESPOONS TOMATO PASTE

1½ TABLESPOONS SUGAR

2 TABLESPOONS SOY SAUCE

4 CUPS CHICKEN BROTH

½ CUP PEARL COUSCOUS

PREP TIME: 5 MINUTES

COOKING TIME: 40 MINUTES

YIELD: 4 SERVINGS

DIFFICULTY: EASY

1. Heat the olive oil in a large saucepan over medium heat, then add the onion, garlic, and ginger.

2. Cook for a couple of minutes, stirring occasionally, until soft and fragrant, then add the chicken. Stir occasionally until the meat is browned on all sides.

3. Add the remaining ingredients and cook, covered, for about 30 minutes, until the vegetables are soft. Serve hot.

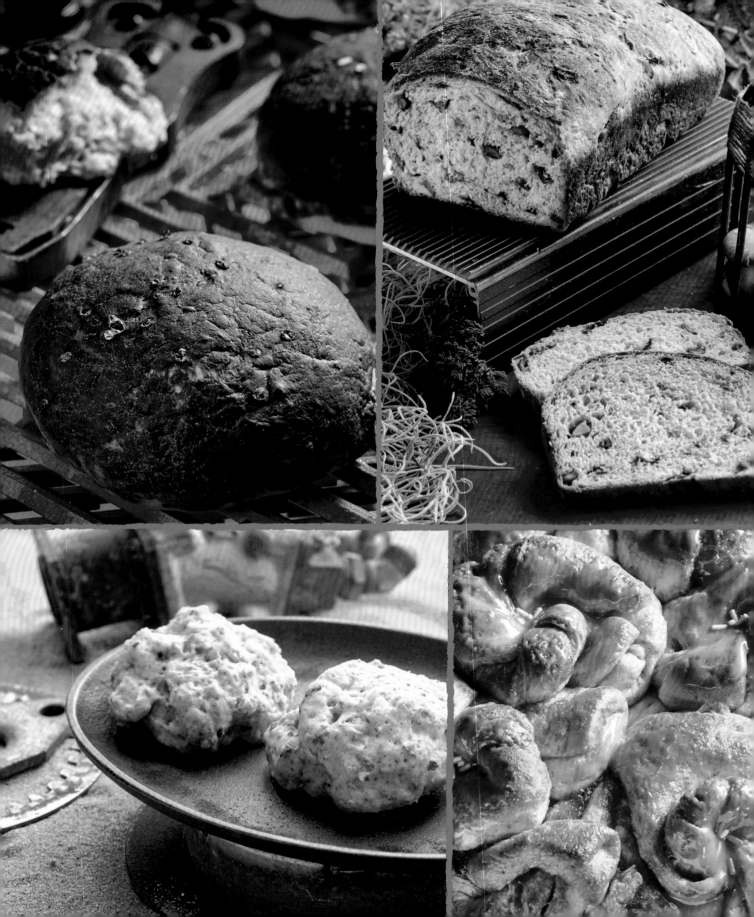

BREADS

As I've said, cookin' is an art. But when it comes to bakin', there's a whole lot more science involved. There's a precision involved in bakin' that can be a bit intimidatin'. I prefer to be a bit more free-flowin' with my recipes in the kitchen, addin' a dash of this and a pinch of that as I go to even out the flavors. Bread don't share that same philosophy. After all, a quarter teaspoon of extra worm yeast can be the difference between absolute perfection and disaster.

When you look under the crust, most loaves of bread are made up of the same basic components. Flour, water, yeast, and so on. They just happen to be combined in different ways to make each of 'em unique. So in a way, bakin' is kinda like bein' a mechanic, seein' that you gotta develop a solid understandin' of how all those pieces work together before you can even think of startin' to make fancy upgrades. I mean, no one would expect you to be able to install a hyperdrive the first time you picked up a wrench. And the same goes for bakin' bread. Even the most skilled chefs have burned a few loaves in their day. But we ain't about to let a few ugly crashes keep us from buildin' just the right vessel for our flavors. 'Cause we know when we finally put together that perfect loaf, it's gonna take our meal to all-new heights.

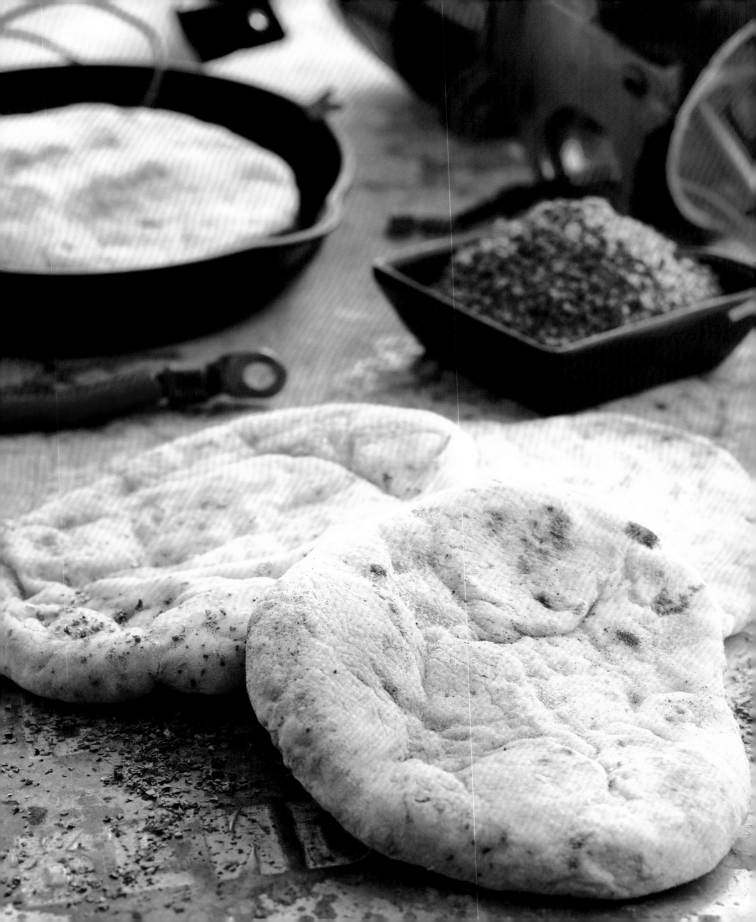

RONTO WRAPPERS

Some breads are so hearty they take the place of a meal, others so fancy they can serve as the centerpiece to the finest feast. But some bring out the best in a meal without stealin' the spotlight for themselves. This flatbread, for instance, is baked up by the fine folks at Ronto Roasters with one sole purpose—to get those savory piles of meat safely into your mouth hole. It's thin and flexible enough to wrap around just about any fillin' but also durable enough that it ain't gonna turn into a soggy mess the second it gets stuffed. If a sandwich ain't on your menu, use some for scoopin' up hummus or soppin' up gravy. This bread might be simple, but it has so many uses that it's hard to wrap my head around 'em all.

INGREDIENTS

¾ CUP WARM WATER

1 TABLESPOON OLIVE OIL

1 TEASPOON BROWN SUGAR

½ TEASPOON SALT

1 TEASPOON INSTANT DRY YEAST

2 CLOVES GARLIC, MINCED

1 TABLESPOON MIXED DRIED HERBS, SUCH AS SAVORY OR MARJORAM

2 CUPS ALL-PURPOSE FLOUR, PLUS MORE FOR DUSTING

PREP TIME: 10 MINUTES
RISING TIME: 1 HOUR
COOKING TIME: 20 TO 30 MINUTES
YIELD: 6 FLATBREADS
DIFFICULTY: MEDIUM

1. In a medium bowl, combine the water, olive oil, brown sugar, salt, and yeast.

2. Add the garlic and herbs, then gradually mix in the flour until you have a dough that isn't too sticky.

3. Turn out onto a lightly floured surface, then knead for a minute or two, until the dough is soft and bounces back when poked.

4. Place the dough in a clean bowl, cover lightly with plastic wrap or a damp kitchen towel, and set in a warm place to rise for about 1 hour, or until doubled in size.

5. Once the dough has risen, heat a dry medium sauté pan or skillet over medium heat.

6. Divide the dough into six equal balls, and roll each one out to about ¼ inch thick.

7. One at a time, lay a piece of dough in the pan. Let cook on each side for 3 to 5 minutes, until golden brown. Remove to a plate to finish cooling.

USED IN:

RONTO WRAP (PAGE 99)
FELUCIAN GARDEN SPREAD (PAGE 101)

POLYSTARCH PORTION BREAD

Jakku is a remote world with little to offer but heat and sand. Food is scarce, and water even more so. That makes cookin' anythin' worthwhile there a bit of a chore. However, I did manage to discover a minor culinary miracle on one of my recent visits: instant bread. Known to the locals as "portion bread," it's really just a simple mix of polystarch flour and water. The chemical reaction from the combination of the two creates a self-risin' miniature loaf that would satisfy even the pickiest scavenger. Maybe the intense heat of the Jakku desert aids in the reaction somehow, 'cause I ain't quite been able to replicate the process in my own kitchen. But with my oven at the right frequency, I've managed to come pretty close.

INGREDIENTS

½ TEASPOON VEGETABLE OIL
4 TABLESPOONS WHEAT FLOUR
1 TABLESPOON INSTANT OATS
1 TEASPOON SUGAR
¼ TEASPOON BAKING POWDER
½ TEASPOON THIN FLAKES DRY SEAWEED
PINCH EACH OF SALT AND PEPPER
PINCH OF GROUND CINNAMON
ABOUT 2 TABLESPOONS WATER

PREP TIME:
1 MINUTE

COOKING TIME:
1 MINUTE

YIELD: 1 SERVING

DIFFICULTY: EASY

1. Lightly grease a 6-inch microwave-safe ramekin or small bowl with the oil.

2. In a medium bowl, combine the flour, oats, sugar, baking powder, seaweed, salt, pepper, and cinnamon, followed by just enough water to hold it all together, about 2 tablespoons.

3. Quickly form into a rough ball, and place in the center of the prepared ramekin.

4. Place the ramekin in the microwave, and cook on high for 45 seconds, during which time the bread should puff up somewhat. Allow to cool slightly before eating.

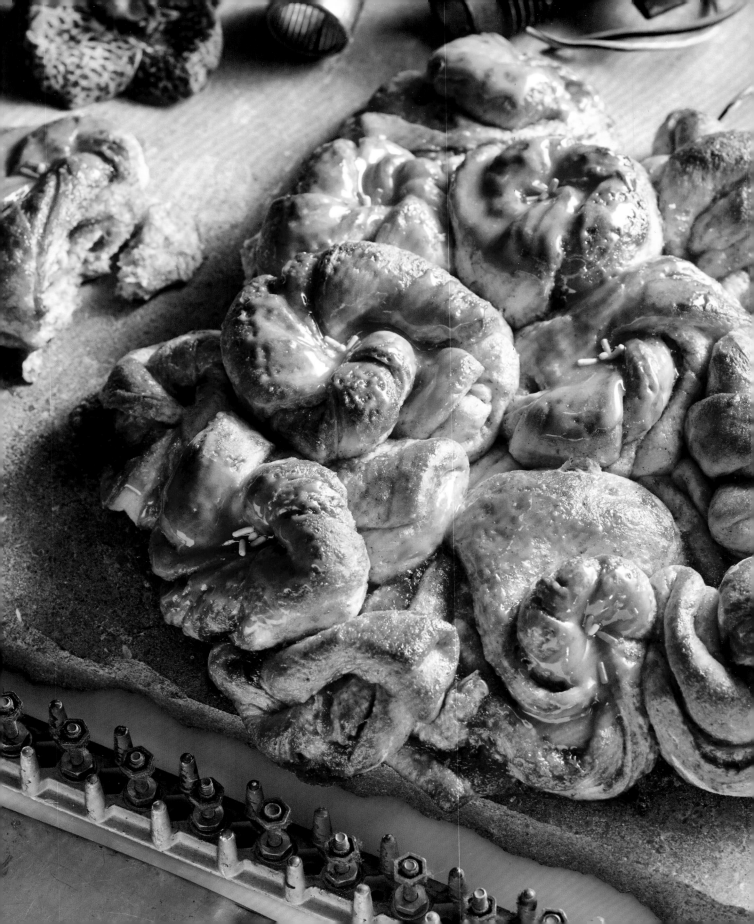

FIVE-BLOSSOM BREAD

I've made my fair share of baked goods over the centuries, but I ain't sure I've ever seen anythin' prettier come outta an oven than a traditional Naboo five-blossom loaf. Each roll in this bready bundle is carefully placed so that they all rise together to form a single loaf that resembles a bouquet of bloomin' flowers. The five blossom is meant for folks to tear and share—though some of my patrons have been known to tear into each other to get their grubby hands on the last piece. Rumor has it the five-blossom bread was beloved by the royal court on Naboo, with the legendary Queen Amidala herself bein' particularly skilled at bakin' it. Thankfully for us, a crown ain't required to experience this loaf's majesty.

INGREDIENTS

BREAD:

½ CUP WARM MILK

¼ CUP (½ STICK) BUTTER, MELTED

¼ CUP GRANULATED SUGAR

2 TEASPOONS INSTANT DRY YEAST

1 TO 2 TEASPOONS GROUND CARDAMOM

1 EGG

½ TEASPOON SALT

3 CUPS ALL-PURPOSE FLOUR, PLUS MORE FOR DUSTING

FILLING:

¾ CUP PLUM OR SEEDLESS BERRY JAM

2 TABLESPOONS ALL-PURPOSE FLOUR

3 TABLESPOONS BROWN SUGAR

2 TEASPOONS GROUND CINNAMON

ICING:

1 CUP POWDERED SUGAR

1 TABLESPOON DESERT PEAR SYRUP

2-3 TABLESPOONS HEAVY CREAM

2 TABLESPOONS CHOCOLATE-COVERED SUNFLOWER SEEDS OR SPRINKLES FOR GARNISHING

PREP TIME:
15 MINUTES

RISING TIME:
1½ HOURS

BAKING TIME:
20 MINUTES

YIELD:
1 SHAREABLE LOAF

DIFFICULTY:
HARD

1. To make the bread: In a large bowl, combine the milk, butter, sugar, yeast, cardamom, and egg. Add the salt, then gradually add the flour until you have a dough that isn't too sticky. Turn the dough out onto a lightly floured work surface and knead for a couple of minutes, until it bounces back when poked. Cover with plastic and set in a warm place to rise for about 1 hour, until doubled in size.

2. To make the filling: In a small bowl, combine all the ingredients and set aside.

3. Assemble the bread: Line a baking sheet with parchment paper or a silicone mat. Once the dough has risen, divide it in half. Roll one half into a round disc about 12 inches across. Gently lay this disc on the prepared baking sheet, then spread the filling over it. Roll out the other half of the dough, then lay it on top of the first piece. Place a small glass or ramekin in the very center of the dough as a visual aid, then take a sharp knife and cut four slits radiating out from the center. Cut each section in half and then divide all the slices in half one more time for a total of 24 strips. Remove the glass from the center of the dough. Working one strip at a time, gently pull the dough to elongate it slightly, then twist the strand lengthwise as much as you can. Coil each twisted strand into a knot shape around the center of the loaf. When you are done, you should have a loaf that looks a bit like a bouquet of flowers. Press a fingertip into the center of each knot to make an indent for the icing. Let the loaf rise uncovered for another 30 to 40 minutes, until puffy and soft.

4. Preheat the oven to 375°F. Bake for about 20 minutes, until golden brown. Let cool completely before adding the icing.

5. To make the icing: Combine the powdered sugar, desert pear syrup, and just enough heavy cream to give it a thick consistency. Add a dollop of icing to the center of each indent, then set three chocolate-covered sunflower seeds or sprinkles in the middle of each. To serve, tear off a "flower" and enjoy.

MUSTAFARIAN LAVA BUNS

There's a lot of superstition around the planet Mustafar. Some say that the magma-covered world is a nexus for the dark side of the Force. Others claim that Darth Vader himself had a secret castle there. I don't know if any of that is true. What I do know is that the temperatures on Mustafar are as hot as an oven, makin' it the perfect destination to do some quality bakin'. On one visit, I came across some Southern Mustafarians heatin' up these sweet balls of dough directly on the planet's scorchin' volcanic crust. The result was this sweet red bread with a cracked, blackened exterior. Looked nearly as impressive as it tasted. If you ain't got an open lava fissure handy, I'm sure a traditional oven will work just fine. Either way, this is one bun too hot to pass up.

INGREDIENTS

BUNS:

1½ CUPS WARM MILK

1 TABLESPOON BUTTER, MELTED

1 TABLESPOON SUGAR

1 TEASPOON SALT

2 TEASPOONS INSTANT DRY YEAST

RED GEL FOOD COLORING, AS NEEDED

3 CUPS ALL-PURPOSE FLOUR, PLUS MORE FOR DUSTING

TOPPING:

1 CUP RICE FLOUR

1 TEASPOON INSTANT DRY YEAST

1 TABLESPOON SUGAR

1 TABLESPOON VEGETABLE OIL

¾ CUP WARM WATER

BLACK GEL FOOD COLORING, AS NEEDED

½ TEASPOON COARSE SALT

PREP TIME:
15 MINUTES

RISING TIME:
1¾ HOURS

BAKING TIME:
20 MINUTES

YIELD: 12 ROLLS

DIFFICULTY:
HARD

1. To make the buns: In a medium bowl, combine the milk, butter, sugar, salt, yeast, and enough food coloring to give you a nice robust red color. Gradually add the flour until you have a nice soft dough that isn't too sticky. Turn out onto a lightly floured surface and knead for a couple of minutes, until it bounces back when poked. Place in a clean bowl and cover with plastic. Set in a warm place to rise for about 1 hour, or until doubled in size.

2. Line a baking sheet with parchment paper or a silicone mat. Turn the dough out of the bowl and divide into 12 equal portions. Loosely roll each of these into a smooth ball and set on the prepared baking sheet. Cover and let the dough begin to rise again while you make the topping.

3. To make the topping: Whisk together all the ingredients in a small bowl until smooth. Set aside and let rise, along with the rolls, for about 20 minutes. Then, using a pastry brush, brush a thick layer of the topping onto each roll, covering as much as possible. Preheat the oven to 400°F and let the rolls rise another 20 minutes.

4. When ready, bake the rolls for 15 to 20 minutes, until puffed and firm to the touch. Let cool for about 10 minutes before serving.

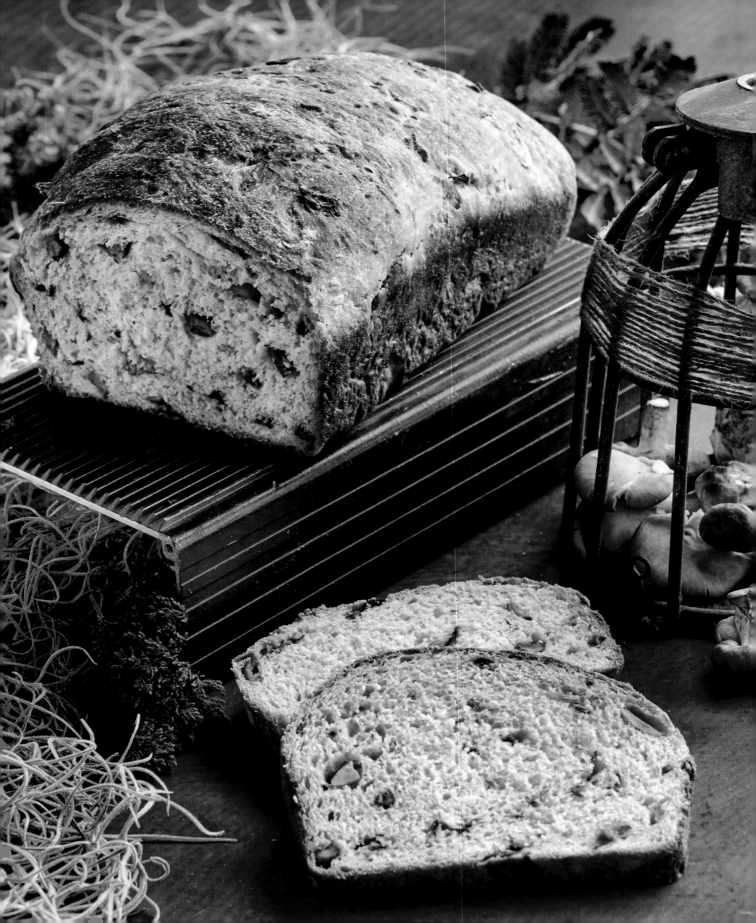

MUNCH-FUNGUS LOAF

When I'm searchin' the galaxy for new ingredients, I prefer to stock my pantry with ones that are as versatile as possible. I ain't got space on my freighter to bring along somethin' I can use in only one dish. That's why I love munch-fungus, a toadstool-like growth that I first happened across on a visit to the Twi'lek homeworld of Ryloth. This multipurpose mushroom is commonly eaten raw by the locals, but it can also be added to soups and stews to create a rich and hearty broth. One of the most interestin' uses of munch-fungus I've witnessed, though, is when it's baked into a traditional Twi'lek bread, like this lovely little loaf here. Full of warm, pungent flavors and a hint of spice, it's a unique accompaniment to any meal that you simply won't be able to resist munchin' on.

INGREDIENTS

- 2 TO 3 TABLESPOONS OLIVE OIL, PLUS MORE FOR THE TOP
- ½ POUND FRESH MUSHROOMS, DICED
- 2 CLOVES GARLIC, MINCED
- 3 TABLESPOONS SOY SAUCE
- 1 TABLESPOON RED CURRY PASTE
- 1 CUP WARM WATER
- 1 TABLESPOON HONEY

- 2 TEASPOONS INSTANT DRY YEAST
- 1 TABLESPOON SUGAR
- 3 TABLESPOONS PLAIN YOGURT
- ½ TEASPOON PEPPER
- 1 TEASPOON SALT
- 3¼ CUPS ALL-PURPOSE FLOUR, PLUS MORE FOR DUSTING
- COOKING SPRAY, FOR GREASING

PREP TIME: 15 MINUTES
RISING TIME: 2 HOURS
BAKING TIME: 40 MINUTES
YIELD: 1 LOAF
DIFFICULTY: MEDIUM

1. Heat the olive oil in a large sauté pan or skillet over medium heat. Add the mushrooms and garlic, then cook, stirring occasionally, for about 5 minutes, until tender. Stir in the soy sauce and cook another minute or so, until any excess liquid has cooked off or been absorbed. Remove from the heat and stir in the curry paste. Set aside and let cool completely.

2. In a large bowl, combine the warm water, honey, yeast, sugar, and yogurt. Add the mushroom mixture, then gradually mix in just enough flour (about 3¼ cups) to bring the mixture together into a workable dough. Turn out onto a lightly floured surface and knead for several minutes, until the dough bounces back when poked. Place in a clean, lightly greased bowl, cover with plastic or a damp towel, and let rise for about 1 hour, or until doubled in size.

3. When the dough is ready, lightly grease a 9-by-5-inch loaf pan. Punch down the dough and roll out to a rectangle shape, roughly the length of the loaf pan, and twice as wide. Roll into a tube shape, then lift and set into the loaf pan, seam-side down. Cover and let rise again for another 45 minutes or so, until puffy and soft.

4. Preheat the oven to 400°F. Bake the loaf for around 40 minutes, or until the top is golden brown and firm to the touch. Let cool slightly before turning out onto a cooling rack, and let cool completely before slicing.

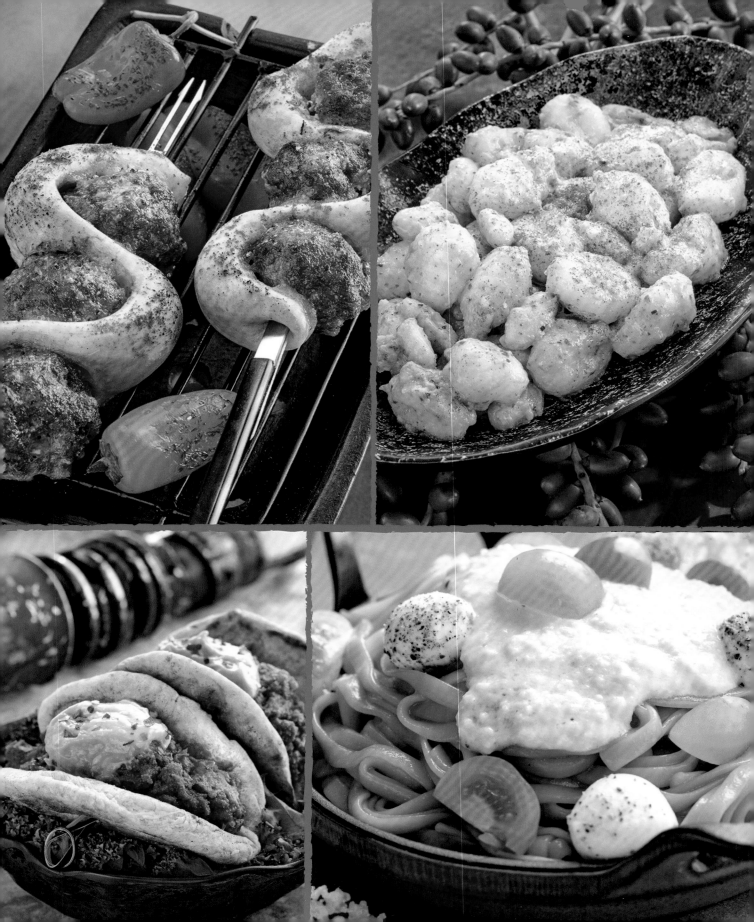

MAIN COURSES

When I first started cookin' for diners at Maz's castle, I was determined that every meal on my menu show off my full range of skills. Back then, until a dish was absolutely perfect, it didn't leave my kitchen. Unfortunately, as a direct result, a lot of potential customers ended up leavin' our tables instead.

Maz set me straight pretty quick. She convinced me that her average customer wasn't lookin' for me to wow 'em with flashy techniques and exotic ingredients. Truth told, most folks don't give a womp rat's rear end how thin you can slice a shuura. All they're lookin' for is somethin' that'll fill 'em up fast. And if it tastes good, too? Well, then you've got yourself a customer for life.

I took Maz's words to heart and focused on streamlinin' my main courses for faster service without sacrificin' quality. It wasn't easy, but with a bit of experimentation, I concocted a batch of recipes that were big on flavor but didn't require endless hours of slavin' over a hot stove.

"Fast and flavorful" might not sound like a terribly impressive culinary point of view, but trust me, it gets the job done better than you'd expect. These recipes have proved popular at every outpost I've visited in my travels across the Outer Rim. Give 'em a try at home and I think you'll see why.

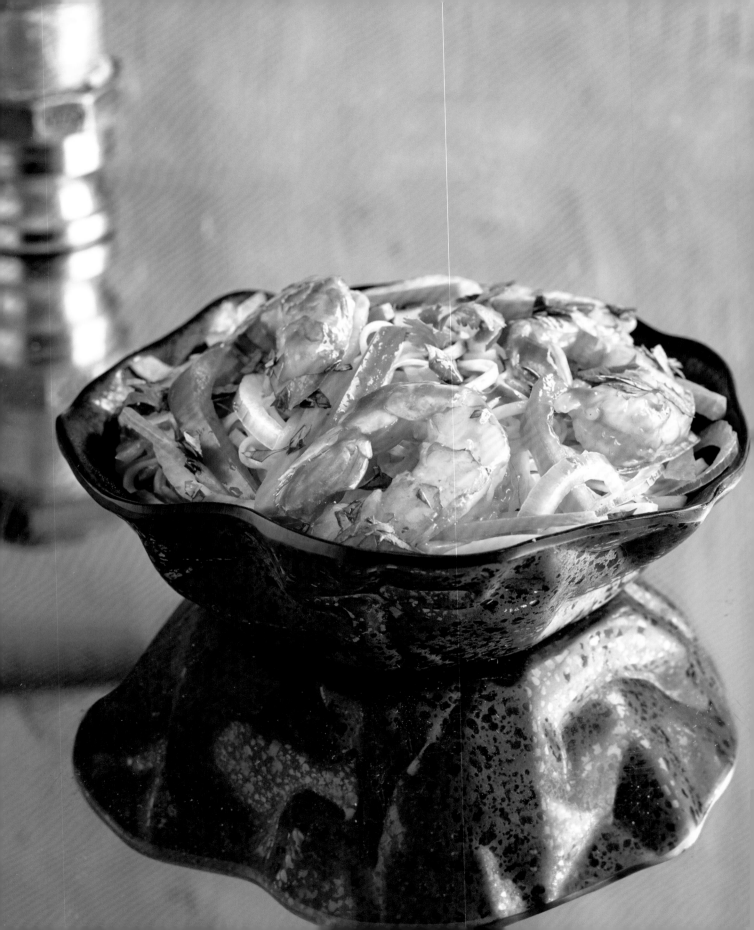

YOBSHRIMP NOODLE SALAD

Yobshrimp are small sea creatures native to the waters of Naboo. Nearly every species on that planet, from humans to Gungans, enjoys dinin' on these delectable decapods. While yobshrimp are plenty abundant, there's still a certain amount of danger to fishin' for fresh ones in the Abyss. If you ain't careful, the enormous opee and colo claw fish lurkin' in those depths will put *you* on the menu instead. Lucky for me, I found a Gungan willin' to hook me up with a healthy supply of 'em for a reasonable price. Though yobshrimp can be prepared in countless ways, I like to highlight their freshness by marinatin' the slippery little fellas and tossin' 'em into a cold noodle salad.

INGREDIENTS

VINAIGRETTE:

- ½ CUP LOW-SODIUM SOY SAUCE
- 2 TABLESPOONS LIME JUICE
- 1 TEASPOON SUGAR
- 1 CLOVE GARLIC, MINCED
- 1 TEASPOON HOT SAUCE
- ½ TEASPOON XANTHAN GUM

NOODLE SALAD:

- 4 OUNCES VERMICELLI RICE NOODLES
- 12 COOKED MEDIUM SHRIMP
- ¼ RED BELL PEPPER, SLICED THIN
- 2 OUNCES CARROTS, PEELED AND SLICED THIN (¼ CUP)
- 1½ OUNCES DRIED WOOD EAR MUSHROOMS, SOAKED IN WATER FOR 1 HOUR, DRAINED AND SLICED
- ½ RED ONION, SLICED THIN
- ½ TEASPOON MINCED CILANTRO
- PINCH OF SALT

PREP TIME: 15 MINUTES PLUS OVERNIGHT

COOKING TIME: 15 MINUTES

YIELD: 2 SERVINGS

DIFFICULTY: MEDIUM

1. To make the vinaigrette: Combine all the ingredients in a food processor and puree until smooth. Transfer to a small bowl, cover, and let sit overnight in the fridge.

2. To make the noodle salad: Fill a medium pot with water and bring to a boil. Add the noodles and cook for about 15 minutes, until the noodles are cooked through. Rinse the noodles in cold water, then drain. Toss with the shrimp, bell pepper, carrots, mushrooms, onion, and the vinaigrette, and sprinkle a little cilantro and salt on top before serving.

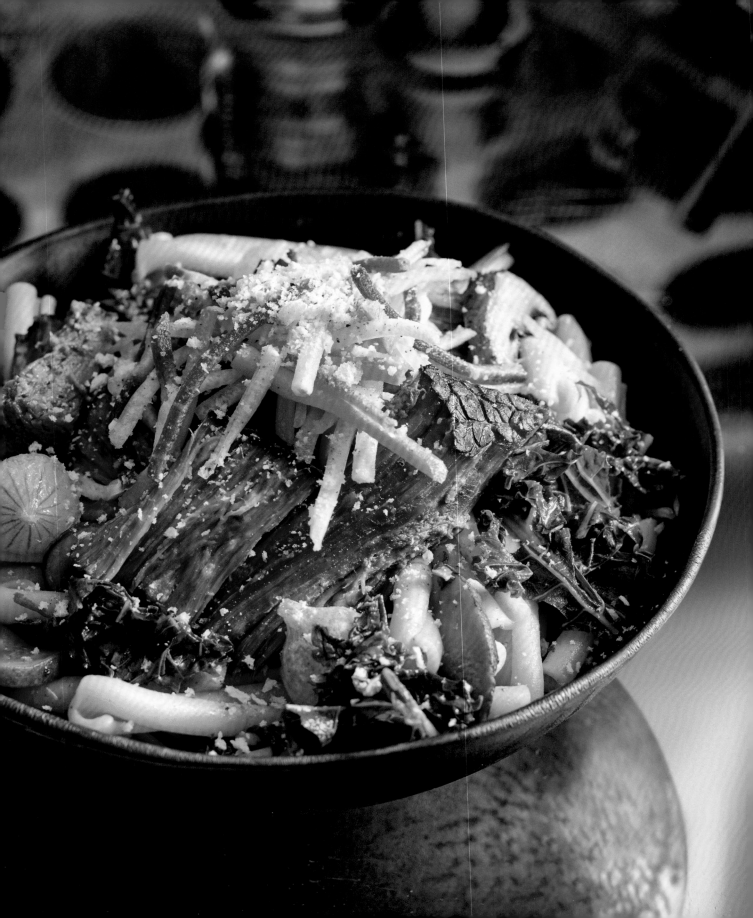

BRAISED SHAAK ROAST

If you've ever been to Naboo, you've probably seen herds of shaak grazin' in the grasslands. These rotund beasts are basically big balls of lard with legs, but if you're a skilled butcher who can manage to navigate past all that fat, there's actually some pretty mouthwaterin' meat under there. When it comes to shaak, the roast is the only way to go. It's an ample cut packed with flavor, particularly when braised with some local greens and fungi. Braisin' is a long slow process, sure, but the end result is so tender that it practically falls apart the second your fork touches it. I usually add some noodles to the mix as well, just to fill out the dish and soak up all the delicious juices. My braised shaak roast is rustic, it's hearty, and it's usually sold out as soon as I open the pot.

INGREDIENTS

- 2 OR 3 POUNDS POT ROAST BEEF ROUND
- ¼ CUP SOY SAUCE, OR MORE TO TASTE
- 3 CLOVES GARLIC
- WATER, AS NEEDED
- 8 OUNCES CAVATELLI OR ORECCHIETTE PASTA
- 6 TABLESPOONS OLIVE OIL
- 1½ CUPS WHOLE PEARL ONIONS, PEELED
- 2 CUPS SLICED MUSHROOMS
- 1 HEAPING CUP KALE, TORN INTO SMALL PIECES
- ½ CUP PEELED AND SHREDDED RAINBOW CARROTS
- 1 TO 2 TABLESPOONS SEASONED PANKO BREADCRUMBS
- SALT
- PEPPER

COOKING TIME:
3 HOURS FOR BEEF,
15 MINUTES FOR ASSEMBLY

YIELD: 4 SERVINGS

DIFFICULTY: MEDIUM

1. Place the beef in a medium saucepan along with the soy sauce and garlic. Fill with just enough water to cover the beef, then set over medium heat, cover and cook for about 2 hours, until the meat has started to soften and is cooked through.

2. Using a pair of forks, divide the beef into smaller pieces, and allow to cook about 1 hour more, until the beef is very tender. Remove to a separate plate and keep warm.

3. Once the beef is cooked, bring a large pot of salted water to boil for the pasta. Add the pasta and cook according to package instructions, until soft, but still a little al dente. Drain the pasta and keep warm.

4. In a medium sauté pan or skillet, heat the olive oil over medium heat. Cook the pearl onions and mushrooms for about 5 minutes, until soft, then add about ½ cup or so of the beef liquid, stirring until it has been absorbed.

5. Remove from the heat and stir in the kale until is wilted. Add about ½ cup of the beef liquid to each serving bowl, then divide the pasta between them. Stir the mushroom, onion, and kale mix in with the cooked pasta and keep warm.

6. Place the cooked beef on top of the pasta, then follow with the carrots and a pinch of the seasoned breadcrumbs. Season to taste with salt and pepper.

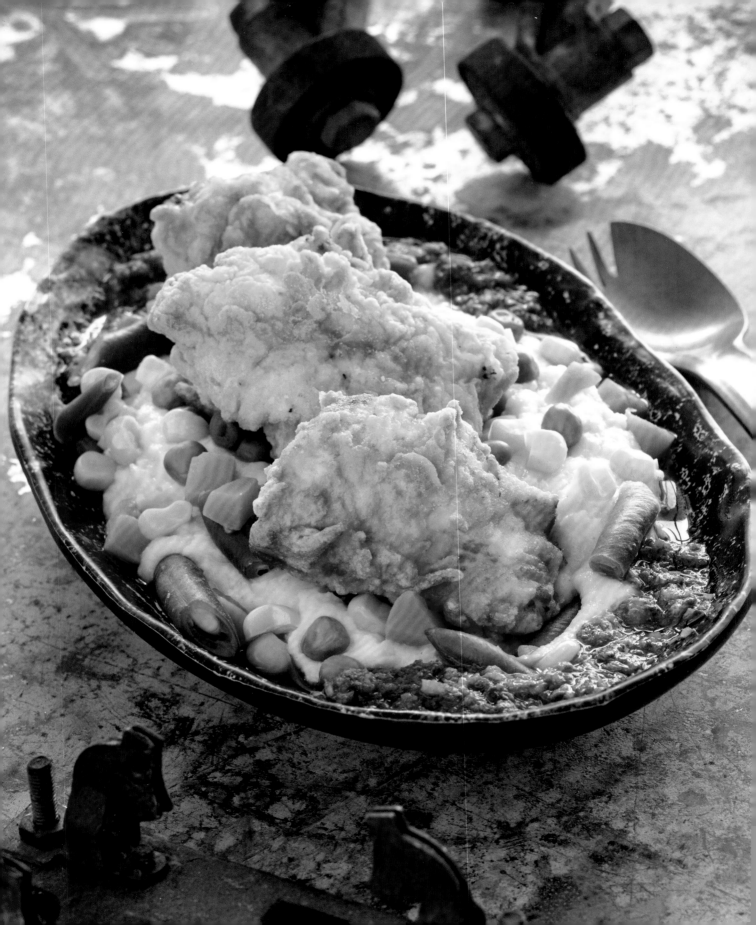

FRIED ENDORIAN TIP-YIP

Tip-yip is a type of hen that is commonly raised by the Ewoks on the forest moon of Endor as a source of eggs and meat. Though it ain't all that different from the domestic fowl found on countless other worlds, I find tip-yip to be particularly juicy and flavorful. Plus, when it's oven roasted and served over a bed of fresh vegetables and local grains, that little bird is about as healthy a meal as you can get. But if you don't mind your tip-yip flyin' a slightly less wholesome path, you can always bread it, fry it up, and cover it in warm herb gravy. My variation is drippin' with natural flavor, makin' it one of my biggest sellers at nearly every spaceport I visit. Maybe it ain't the traditional way that Ewoks cook up their feathered friend, but if you ask me, there's plenty of room on Endor for more than one type of tip-yip.

INGREDIENTS

2 LARGE BONELESS, SKINLESS CHICKEN BREASTS

OIL FOR FRYING, SUCH AS VEGETABLE OIL

1½ CUPS ALL-PURPOSE FLOUR

1 TEASPOON SALT

½ TEASPOON BLACK PEPPER

PINCH OF CAYENNE PEPPER

1 EGG

2 TABLESPOONS BUTTERMILK

1 BATCH MASHED CHOKEROOT (PAGE 65) OR MASHED POTATOES

1 CUP COOKED MIXED VEGETABLES, SUCH AS PEAS, CARROTS, AND CORN

1 BATCH GURRECK GRAVY (PAGE 31)

PREP TIME: 15 MINUTES
COOKING TIME: 30 MINUTES
YIELD: 2 SERVINGS
DIFFICULTY: HARD

1. Cut the chicken into small pieces and set aside. Fill a small saucepan with 2 inches of oil. Place over medium heat and begin to heat it up to around 350°F while you prepare the chicken.

2. In a small bowl, whisk together the flour, salt, black pepper, and cayenne pepper to mix evenly. In another small bowl, beat together the egg and the buttermilk.

3. Working with one piece at a time, dip the chicken into the egg mixture, then the flour mixture, making sure it's well coated. Repeat that sequence, then set the chicken aside.

4. Once all the meat is coated, begin frying by lowering it into the hot oil a few pieces at a time. Flipping occasionally, cook for about 5 to 10 minutes, until a nice dark golden brown color. Remove to a plate lined with paper towel to drain.

5. To assemble the dish, stir together the Mashed Chokeroot (or mashed potatoes) and the mixed vegetables. Add a generous dollop of this to each serving dish, then pour the Gurreck Gravy around the edge. Tumble several of the nuggets on top and enjoy straightaway.

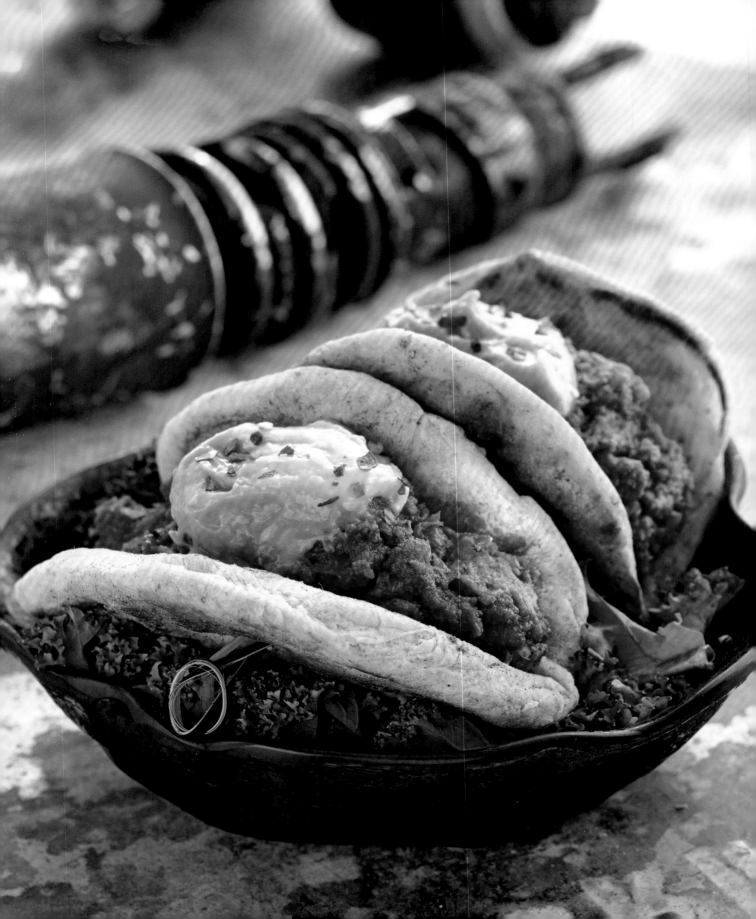

RONTO WRAP

While you're most likely to encounter a real-live ronto lumberin' through the deserts of Tatooine, there's only one planet to go to if you want to taste the best ronto that's ever been cooked—Batuu. At his stand in the Black Spire Market, Bakkar the Butcher works his magic roastin' huge ronto shanks under an open flame. The result is a flatbread full of tender, juicy carvings that melt in your mouth. Bakkar ain't too eager to share his family's secret spice blend, but I think I've managed to come pretty darn close after countless attempts to re-create it. I'm willin' to admit that my version ain't quite as sublime as Bakkar's, but smother it in enough Emulsauce and you'll barely notice the difference.

INGREDIENTS

2 TABLESPOONS VEGETABLE OIL
½ MEDIUM YELLOW ONION, DICED
½ POUND GROUND PORK
6 OUNCES CHORIZO SAUSAGE, CASINGS REMOVED
2 TABLESPOONS BROWN SUGAR
14 OUNCES TOMATO PUREE
SALT
PEPPER
RONTO WRAPPERS (PAGE 81) FOR SERVING
1 CUP GUACAMOLE FOR SERVING

PREP TIME: 5 MINUTES
COOKING TIME: 25 MINUTES
YIELD: 6 SERVINGS
DIFFICULTY: MEDIUM

1. Heat the oil in a large sauté pan or skillet over medium heat. Add the onion and cook until soft, for several minutes.

2. Add the pork and chorizo and cook for about 5 minutes, until all the meat is browned.

3. Add the brown sugar and tomato puree, and cook for about 15 minutes more, until the sauce is thick.

4. Season to taste, then spoon onto the Ronto Wrappers. Top each with a few dollops of guacamole and enjoy straightaway.

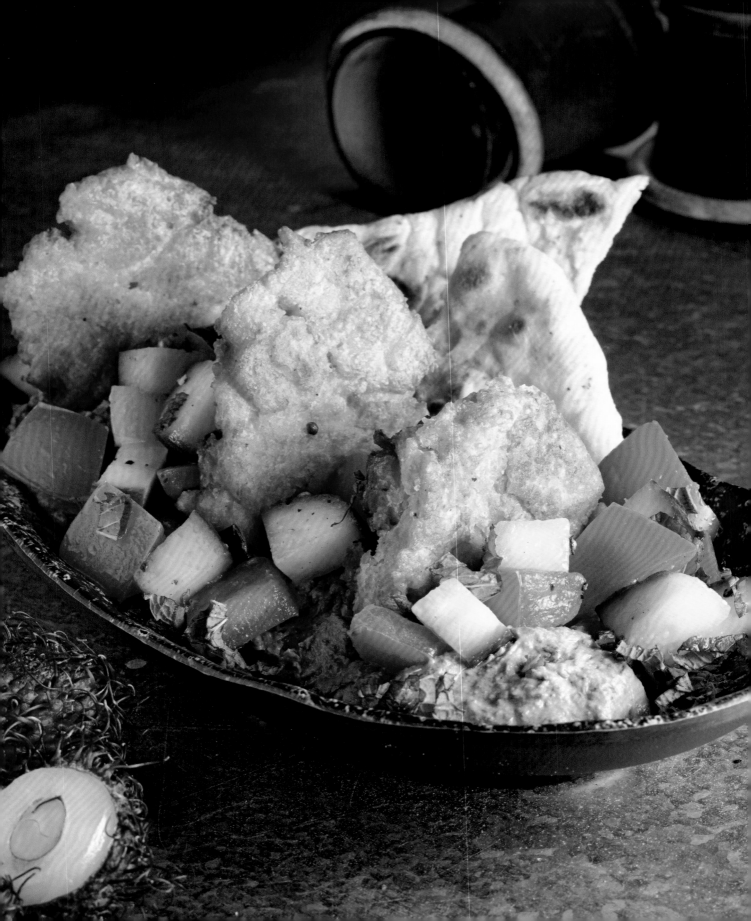

FELUCIAN GARDEN SPREAD

Despite a period when its jungles were devastated by the Clone Wars, Felucia has always been a peaceful planet where farmers lived in harmony with the land around 'em. Way before I started cookin' for Maz, I spent time on one of those Felucian farms and learned the importance of usin' fresh and local ingredients in all my dishes. It's a philosophy I still live by to this day. The Felucians were masters at turnin' their harvest into plentiful and well-balanced meals, a skill I tried to reflect in this tasty vegetarian spread that I named in their honor. It's got some Parwan Nutricakes (page 109) accompanied by a herby hummus spread and a cool, refreshin' relish. You could scoop it all up with a piece of flatbread, but no one's gonna blame you if you just lick it right off the plate.

INGREDIENTS

TOMATO-CUCUMBER SALAD:

1 LARGE TOMATO, DICED

1 LARGE CUCUMBER, DICED

2 TEASPOONS CHOPPED FRESH MINT

¼ CUP OLIVE OIL

SALT

PEPPER

RONTO WRAPPERS (PAGE 81) OR PITA BREAD

PARWAN NUTRICAKES (PAGE 109) OR FALAFEL

BLACK BEAN HUMMUS:

ONE 16-OUNCE CAN BLACK BEANS, DRAINED AND RINSED

½ CUP TAHINI

2 OR 3 CLOVES GARLIC, MINCED

2 TABLESPOONS OLIVE OIL

3 TABLESPOONS PARSLEY, ROUGHLY CHOPPED, PLUS MORE FOR GARNISHING

2 TABLESPOONS LEMON JUICE

1 TEASPOON DRIED OREGANO

½ TEASPOON GROUND CUMIN

SALT AND PEPPER

2 TABLESPOONS MINCED CILANTRO

PREP TIME: 20 MINUTES

YIELD: SERVINGS VARY

DIFFICULTY: HARD

1. To make the tomato-cucumber salad: Toss the tomato, cucumber, mint, and olive oil together, and season with salt and pepper to taste. Set aside.

2. To make the hummus: Combine all the ingredients except the cilantro in the bowl of a food processor and puree until smooth. Transfer to a serving bowl and fold in the fresh herbs.

3. Top with the tomato-cucumber salad and add Ronto Wrappers and Parwan Nutricakes on the side. Enjoy straightaway.

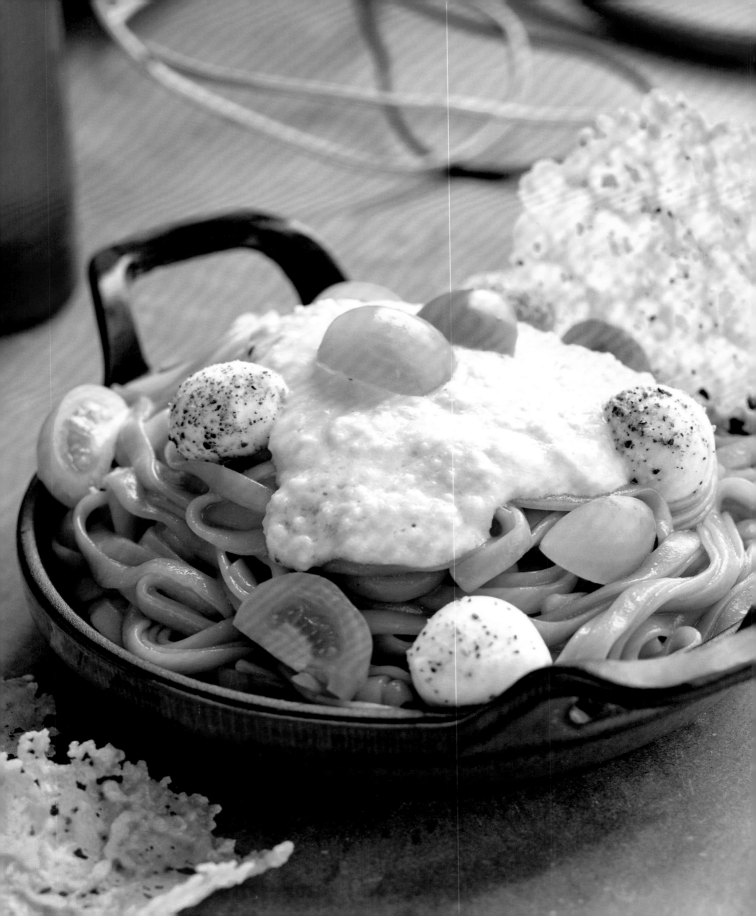

GORMAANDA'S GLOWBLUE NOODLES

I've made it pretty clear that it was the great Chef Gormaanda who inspired me to pick up my first cleaver. That ol' gal could cook just about any dish and make it look fun and easy. Just a bit of stirrin', whippin', beatin', and tastin', and you had yourself a masterpiece. Who needed a degree from the Orto when I had her holovids? Since then, I've put lots of effort into curatin' a menu that stays true to my culinary point of view and experience, but I still occasionally like to whip up one of Gormaanda's old recipes to remember where it all began. Her glowblue noodles are my go-to. They're easy to modify for any type of diet, and, most important, they always taste as great as they look. Have a plate and maybe Gormaanda will inspire you too!

INGREDIENTS

4 CUPS WATER

2 BLUE BUTTERFLY PEA TEA BAGS

SALT

8 OUNCES RICE NOODLES

½ CUP (1 STICK) UNSALTED BUTTER

1 CLOVE GARLIC, MINCED

PEPPER

½ CUP HEAVY CREAM

1½ CUPS GRATED PARMESAN CHEESE

½ CUP MOZZARELLA PEARLS

½ CUP CHERRY TOMATOES, QUARTERED

GOLDEN LICHEN TUILE (PAGE 37) FOR GARNISHING

PREP TIME: 5 MINUTES
COOKING TIME: 15 MINUTES
YIELD: 2 TO 4 SERVINGS
DIFFICULTY: MEDIUM

1. In a medium saucepan, bring the water to a boil along with the tea bags and a generous pinch of salt. Cook the noodles according to the package instructions until just al dente, then drain.

2. While the noodles are cooking, warm the cream, butter, and garlic in a second medium saucepan over medium heat, until steaming.

3. Whisk in salt and pepper to taste. When the cream begins to steam, sprinkle in the Parmesan cheese. Whisk until all the cheese has melted, then remove from the heat.

4. Divide the noodles among serving bowls, then pour the cheese sauce over top. Dot with the mozzarella pearls and tomatoes. A Golden Lichen Tuile can be added for garnish. Enjoy straightaway.

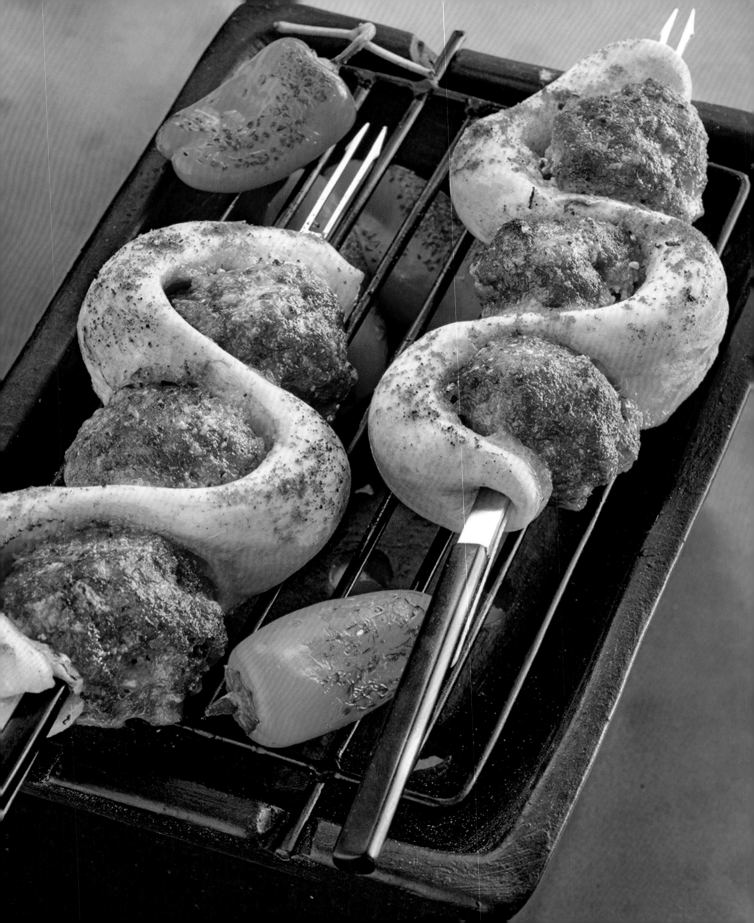

NERF KEBABS

I never really understood why "nerf herder" was an insult. I mean, sure, nerfs are scruffy, they smell terrible, and they attract bloodflies, but the same can be said of about half my patrons back at Maz's. When you look past their reputation, nerfs have a lot to offer sentient species, includin' fresh milk, leathery hides, and a coat of shaggy fur that would make a Wookiee jealous. But as you can imagine, it's nerf meat that I'm most interested in. Since nerfs are common on a number of worlds, from Lothal to Ibaar, most folks don't consider 'em a gourmet menu option. But with a bit of culinary flair—and a dash of my special Nerfsteak Seasonin' (page 29)—I'm aimin' to take this familiar meat into unfamiliar territory. One try and you'll wanna start herdin' nerfs yourself so you can eat these kebabs every day.

INGREDIENTS

½ CUP WARM WATER
1 TEASPOON INSTANT DRY YEAST
PINCH OF SALT
1 TABLESPOON SUGAR
1 TABLESPOON OLIVE OIL
1 CUP ALL-PURPOSE FLOUR, PLUS MORE FOR DUSTING
1 POUND GROUND BISON OR BEEF
½ CUP ITALIAN BREADCRUMBS
1 EGG
½ CUP GRATED PARMESAN CHEESE
3 TABLESPOONS NERFSTEAK SEASONING (PAGE 29)
½ CUP SHREDDED CHEDDAR CHEESE

PREP TIME: 10 MINUTES
RISING TIME: 1¼ HOUR
COOKING TIME: 20 TO 25 MINUTES
YIELD: 5 SKEWERS
DIFFICULTY: MEDIUM

1. Combine the water, yeast, salt, sugar, and olive oil in a small bowl. Add about 1 cup flour, or just enough to make a dough that pulls together. Knead for a minute or two on a lightly floured surface, then place in a clean bowl, cover with plastic wrap or a damp towel, and let rise for about 1 hour, until roughly doubled in size.

2. In a medium bowl, mix together the bison or beef, breadcrumbs, egg, Parmesan cheese, and Nerf-steak Seasoning. Form into 15 equal meatballs, roughly 1 inch across. Set aside while the dough finishes rising.

3. Once the dough has risen, preheat the oven to 375°F and line a baking sheet with parchment paper or a silicone mat. Divide the dough into 5 equal pieces and roll each of these into a rope about 10 inches long.

4. Starting with one end of the dough rope, thread it onto a 10- to 12-inch wooden skewer, follow it with a meatball, then wrap the dough up around and skewer again. Repeat with another 2 meatballs, alternating with the dough. Set on the prepared baking sheet and repeat with the remaining meatballs and dough.

5. When all the skewers have been assembled, let the dough rise another 15 minutes, then bake for 20 minutes, until the dough is a light golden brown and the meatballs are cooked through.

6. When the kebabs are cooked, remove the tray from the oven and sprinkle them with the shredded cheddar cheese. Return to the oven for 1 to 2 minutes more, until the cheese is melted. Best enjoyed fresh from the oven.

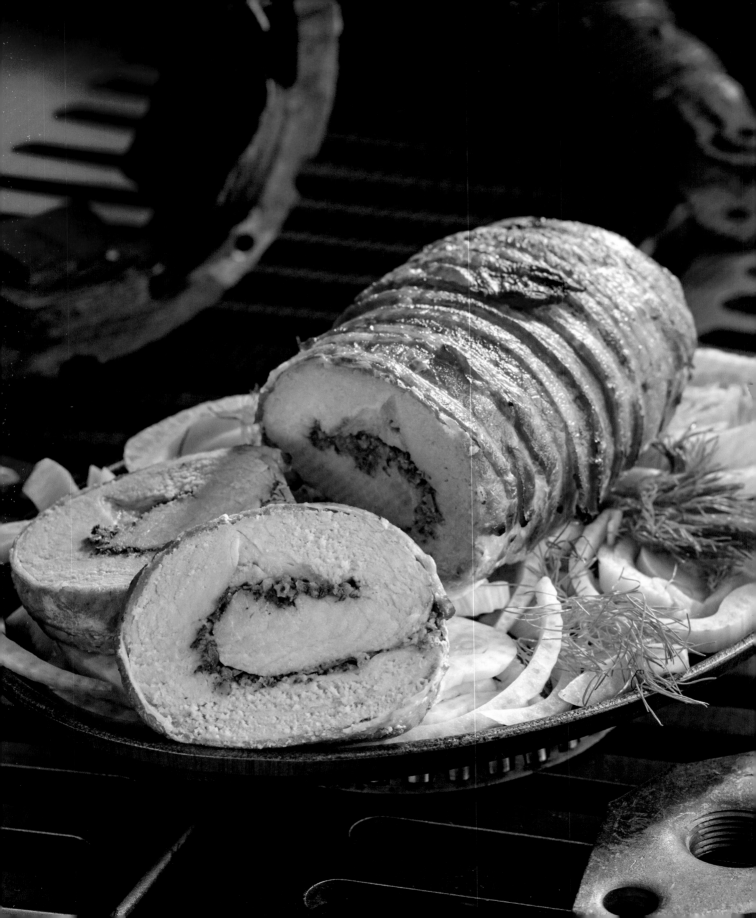

STUFFED PUFFER PIG

Storage is limited in my food freighter, so when I travel from planet to planet, I try to bring along only the essential ingredients. That means some beasts, like puffer pigs, rarely make the menu. It's got nothin' to do with their taste. In fact, puffer pigs are pretty spectacular when you stuff 'em with some fresh herbs and roast 'em in their own juices. It's merely a matter of economy. See, when a puffer pig gets skittish—which is far too often—its body swells up to an enormous size, makin' it hard to fit 'em into a cargo pod. I'm better off usin' that same amount of space to transport a hundred tip-yips instead. While I might not have the room to bring these swollen swine along with me, sometimes I can get a good deal on one from a local smuggler at the outpost where I'm docked, so I always keep this perfect recipe ready to go.

INGREDIENTS

2 PORK TENDERLOINS, ABOUT 1½ POUNDS EACH

3 CUPS BABY SPINACH, LOOSELY PACKED

1 TART APPLE, CORED AND DICED

1 FENNEL BULB, ROUGHLY CHOPPED

½ TEASPOON DRIED SAGE

½ TEASPOON PEPPER

SALT

1 POUND BACON

PREP TIME: 15 MINUTES
COOKING TIME: 25 MINUTES
YIELD: 4 SERVINGS
DIFFICULTY: MEDIUM

1. Preheat the oven to 375°F.

2. Slice the tenderloins lengthwise almost all the way through, leaving a hinge, then pound flat to about ¼ inch to ½ inch thick.

3. Combine the spinach, apple, fennel, sage, pepper, and salt to taste in a food processor and puree until well combined.

4. Spread the filling over the pork. Roll each tenderloin up and place on a baking sheet lined with parchment paper, seam-side down.

5. Working with one strip at a time, carefully wrap both tenderloins in bacon.

6. Roast for around 25 minutes. If you'd like the bacon layer a little crisper, slide the roast under the broiler for 1 to 2 minutes.

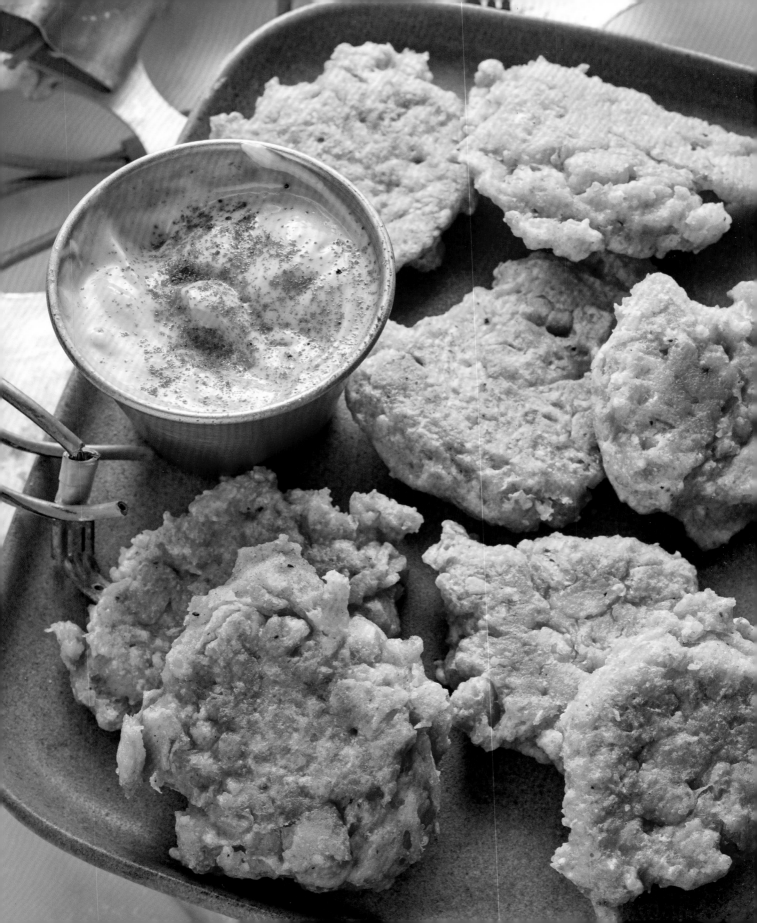

PARWAN NUTRICAKES

Despite their unsavory line of work, bounty hunters tend to be true professionals. They know how to meet their end of a deal and are a lot more likely to pay their tab than the usual scum and villainy. So, when bounty hunters showed up at Maz's castle with special requests for the kitchen, I tended to go outta my way to please 'em. One time, a Parwan bounty hunter named Derrown asked me to whip him up a month's supply of his favorite nutricakes to take with him on his next mission. I was glad to oblige and even kept a stash for myself. These delectable discs are meat free but packed with enough protein to keep your hunt goin' strong until you've claimed every last bounty.

INGREDIENTS

ONE 15.5-OUNCE CAN CHICKPEAS,
 DRAINED AND RINSED

1 GARLIC CLOVE, MINCED

1 TEASPOON GROUND CUMIN

½ TEASPOON SALT

½ TEASPOON BLACK PEPPER

PINCH OF CAYENNE PEPPER

1 EGG

¼ CUP ALL-PURPOSE FLOUR

2 TABLESPOONS OLIVE OIL

PREP TIME: 5 MINUTES
**COOKING TIME:
15 MINUTES**
YIELD: ABOUT 12
DIFFICULTY: MEDIUM

USED IN:

FELUCIAN GAREDN
SPREAD (PAGE 101)

1. Combine the chickpeas, garlic, cumin, salt, black pepper, and cayenne pepper in the bowl of a food processor.

2. Pulse several times, then add the egg and puree until smooth.

3. Gradually add in the flour until you have a thick paste.

4. Heat a little of the olive oil in a medium sauté pan or skillet over medium heat. Drop the batter onto the hot skillet by large tablespoonsful, a few at a time, and flatten with an oiled spatula.

5. Let the cakes cook for a few minutes on each side, until golden brown and firm.

6. Remove to a plate lined with paper towels and repeat with the remaining batter.

7. Serve with your favorite dipping sauce. Sriracha mayonnaise sprinkled with cayenne is a great option.

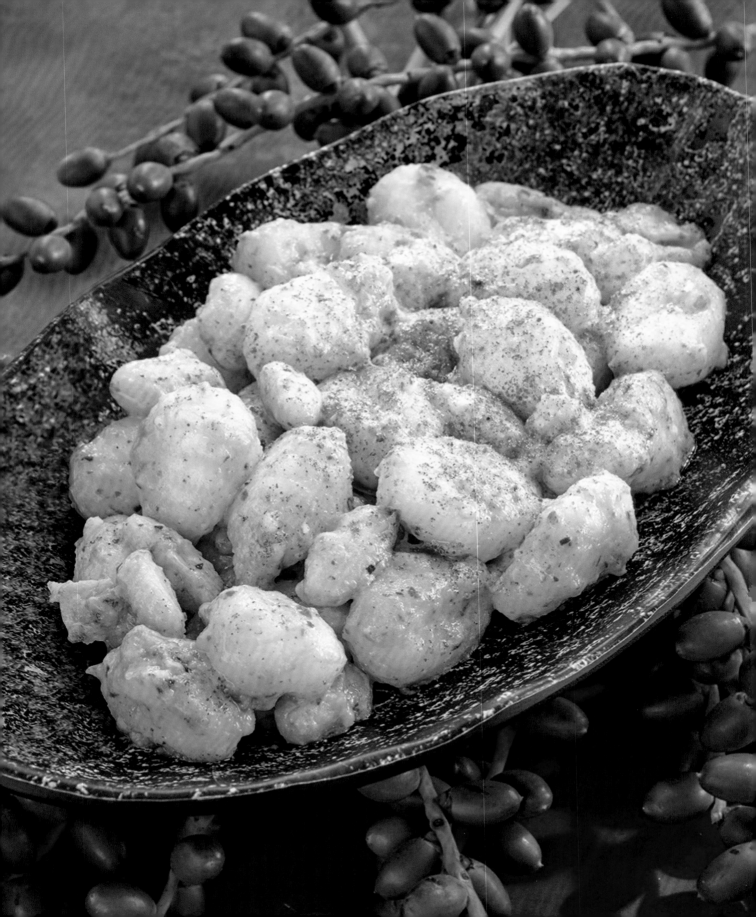

HUTTESE SLIME PODS

Thought I might find some exotic spices on Nal Hutta a while back. Instead, I found nothin' but trouble in the form of the Hutts, the planet's giant sluglike galactic gangsters. Got caught in their clutches for a short time, but managed to trade my culinary expertise for my eventual freedom. Luckily, Hutts will eat just about anythin', from raw gorgs to paddy frogs, so pleasin' 'em wasn't terribly hard. But I did discover one surprisingly scrumptious snack I'd never tasted before—bloated little creatures known as "slime pods" that are found floatin' in the swamps of Nal Hutta. I got off the Hutts' planet as soon as I had the chance, so I wasn't able to collect any of these disgustin'-yet-delightful delicacies for my pantry. Fortunately, though, the worst experiences often inspire the best dishes, and I was able to come up with somethin' equally delicious that's only half as grotesque.

INGREDIENTS

1 POUND UNCOOKED GNOCCHI

1 CUP FRESH SPINACH

½ CUP SHELLED PISTACHIOS

4 CLOVES GARLIC, MINCED

½ CUP OLIVE OIL

1 TABLESPOON LIME JUICE

1 AVOCADO, PEELED AND PITTED

¼ CUP GRATED PARMESAN CHEESE

¼ CUP HEAVY CREAM

SALT

ONE 15-OUNCE CAN CANNELLINI BEANS, DRAINED AND RINSED

SRIRACHA FOR GARNISHING

PREP TIME: 5 MINUTES

COOKING TIME: 5 MINUTES

YIELD: 2 HUMAN SERVINGS, OR ONE HUTT APPETIZER

DIFFICULTY: EASY

1. Bring a medium pot of salted water to a boil over medium-high heat. Add the gnocchi and let cook until they float. Scoop out the cooked gnocchi and keep warm.

2. While the water is heating, combine the spinach, pistachios, garlic, olive oil, lime juice, and avocado in the bowl of a food processor. Pulse until smooth, then gradually add the Parmesan cheese, cream, and salt to taste, pulsing again until incorporated.

3. Add this mixture to the cooked gnocchi along with the beans, and stir to combine and heat through.

4. Transfer to serving bowls, add a few dashes of sriracha, and enjoy. These are best enjoyed the same day, served hot.

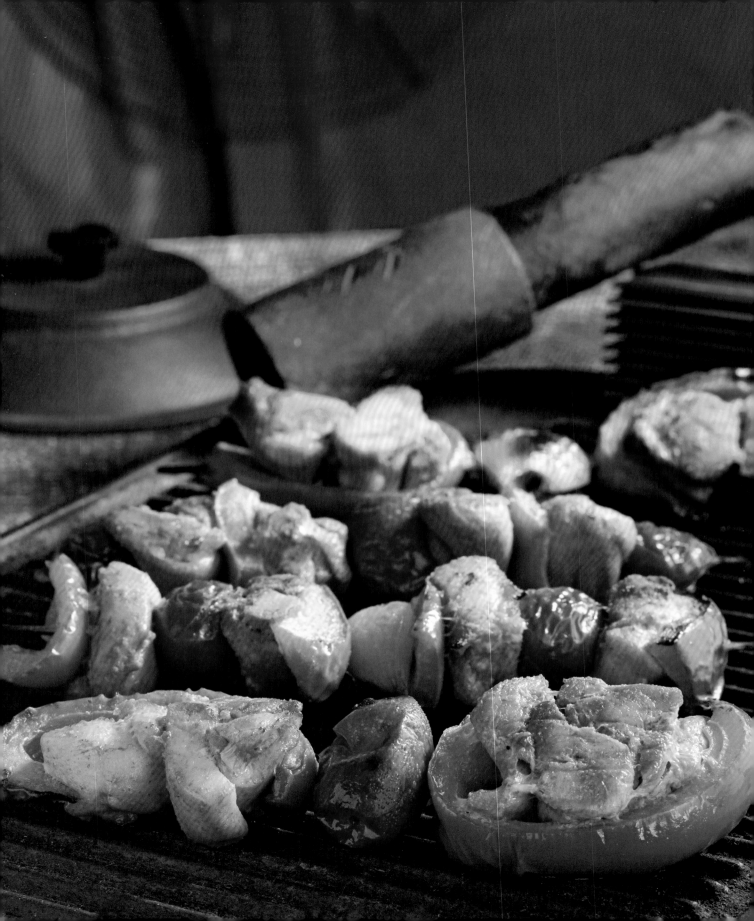

GRUUVAN SHAAL KEBAB

There was a time when these classic Twi'lek kebabs were banned from my menu on Takodana. It had nothin' to do with the recipe itself, but rather how it was served. See, there was a short period when Maz wouldn't let me serve food that required any sort of utensil to eat. There'd been a sudden rise in violent standoffs between patrons, and checkin' their blasters at the door wasn't provin' to be enough of a deterrent. After a Klatooinian attacked a Nikto with a spoon for cheatin' at Sabacc, Maz banned anythin' that could potentially be used as a weapon. Sadly, though, it was fans of fine dinin' who ended up gettin' hurt most in the process. Once Maz lifted her prohibition on pointy things, I brought my skewers outta retirement and started grillin' up these savory sticks of meat and veg again.

INGREDIENTS

1 TABLESPOON RED CURRY PASTE
1 TABLESPOON SOY SAUCE
1 TEASPOON GARAM MASALA
3 CLOVES GARLIC, MINCED
JUICE OF 1 LIME
½ CUP OLIVE OIL
SALT
PEPPER
1 POUND BONELESS ALLIGATOR OR
 CHICKEN THIGH MEAT, CUT INTO
 BITE-SIZE PIECES
1 MEDIUM GREEN BELL PEPPER, SEEDED
 AND CUT INTO 1-INCH PIECES
1 MEDIUM RED ONION, CUT INTO 1-INCH
 PIECES

PREP TIME: 10 MINUTES
MARINATING TIME: 3 HOURS
COOKING TIME: 15 MINUTES
YIELD: 6 SKEWERS
DIFFICULTY: MEDIUM

1. Combine the red curry paste, soy sauce, garam masala, garlic, lime juice, olive oil, and a generous pinch each of salt and pepper in a small bowl, then toss the meat with it.

2. Refrigerate for at least 3 hours to let the flavors develop. Soak 6 bamboo skewers in water.

3. When you are ready to cook, preheat the oven's broiler, setting it to high.

4. Skewer the meat, bell pepper, and onion alternately, then place on a baking sheet.

5. Cook under the broiler for about 15 minutes, flipping halfway through, until the meat is cooked through. Serve hot.

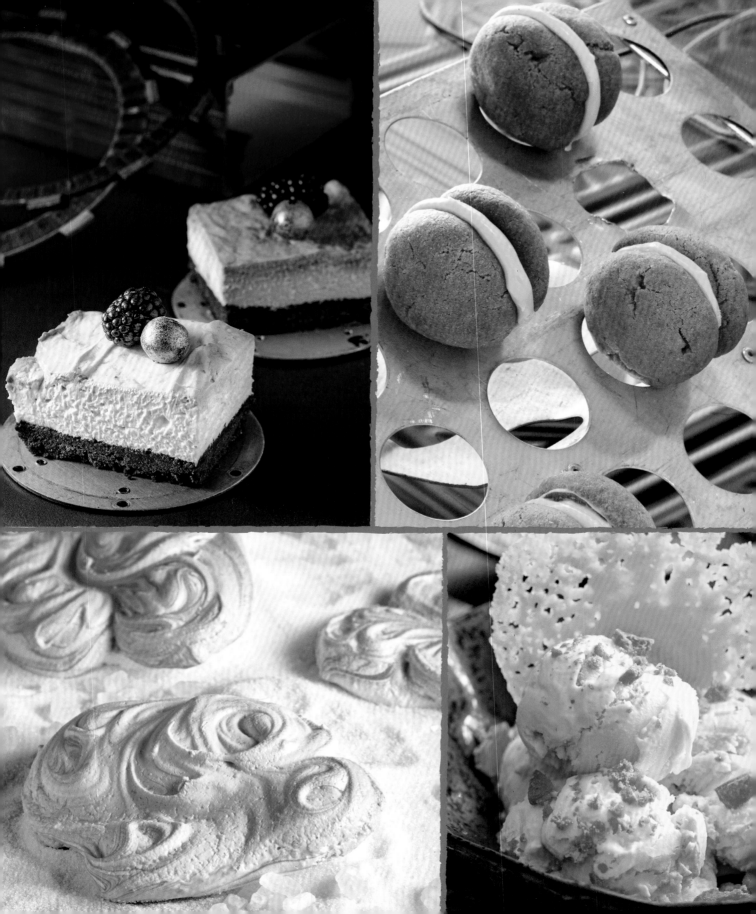

DESSERTS

If you're anythin' like me, you skipped the main course and went straight for dessert. We Artiodacs ain't exactly known for our sweet dispositions, but when it comes to a sweet tooth, well, that's a different story altogether.

Might shock ya, but some people don't see dessert as a necessity. Folks scrapin' to survive are usually too busy findin' a basic meal to worry about what comes after it. But those are the folks who could probably use a little after-dinner treat the most. And I aim to bring it to 'em.

From small, rich bites of pure bliss to decadent displays of confectionery creativity, the possibilities are limited only by your imagination—and maybe your pantry. But I find the best desserts are the ones that don't just tantalize the taste buds—they speak to the heart.

Here, you'll find a collection of some of the most interestin' sweets and treats I've encountered in my travels. Most of 'em were dreamed up to satisfy a specific species, but it's about time they were enjoyed by the rest of the galaxy. So what are you waitin' for? It's time for dessert!

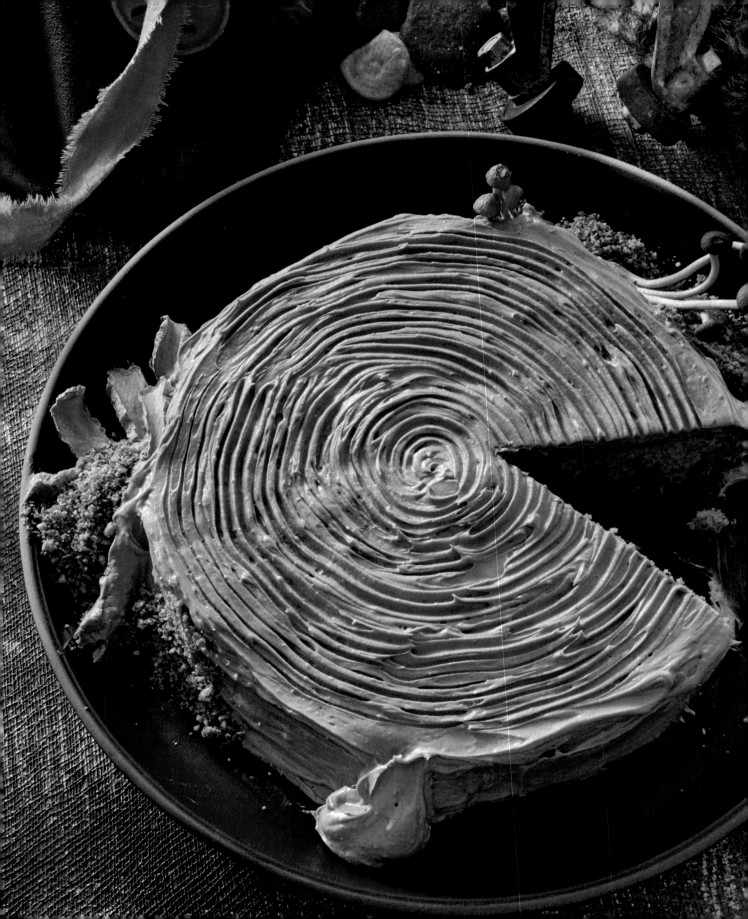

WROSHYR TREE CAKE

I don't know much about Life Day other than it's some sort of sacred holiday that Wookiee families celebrate around a giant tree on Kashyyyk. (Or somethin' like that. My Shyriiwook is a little rusty.) What I do know for sure is nothin' is more depressin' than a sad Wookiee. Back when I was working at Maz's castle, I remember one poor furry fella had to spend his Life Day stranded on Takodana, so I did my best to spread some cheer by bakin' up this beauty. I shaped it like one of the enormous trees that cover his home planet's surface to help him feel more at home. Didn't get my arms ripped off, so I'm assumin' he liked it. Got a feelin' you will too.

PREP TIME: 20 MINUTES
BAKING TIME: 50 MINUTES
COOLING TIME: 1 HOUR
YIELD: 1 CAKE, AT LEAST 8 SERVINGS
DIFFICULTY: HARD

INGREDIENTS

CAKE:

½ CUP (1 STICK) UNSALTED BUTTER, SOFTENED, PLUS MORE FOR GREASING
½ CUP GRANULATED SUGAR
3 EGGS
½ CUP BUTTERMILK
1 TEASPOON VANILLA EXTRACT
1 CUP CASHEW OR ALMOND FLOUR
1 TEASPOON GROUND CINNAMON
1 TEASPOON GROUND GINGER
½ TEASPOON BAKING POWDER
1 TEASPOON BAKING SODA
1 CUP ALL-PURPOSE FLOUR, PLUS MORE FOR DUSTING

FROSTING:

6 OUNCES CREAM CHEESE, SOFTENED
¼ CUP (½ STICK) BUTTER
4 CUPS POWDERED SUGAR, DIVIDED
1 TEASPOON VANILLA EXTRACT
¼ CUP MAPLE SYRUP, PLUS MORE FOR SERVING
2 TABLESPOONS COCOA POWDER

EDIBLE MOSS:

1 CUP GRAHAM CRACKER CRUMBS
¼ CUP GRANULATED SUGAR
¼ CUP SHELLED PISTACHIOS
3 TABLESPOONS MELTED BUTTER
GREEN GEL FOOD COLORING

1. To make the cake: Preheat the oven to 350°F, then lightly butter and flour an 8-inch round cake pan. In a large bowl, cream together the butter and sugar until pale golden. Add the eggs one at a time, beating until thick. Add the buttermilk, vanilla, cashew or almond flour, cinnamon, and ginger. Finally, stir in the baking powder, baking soda, and flour, scraping the sides of the bowl to ensure everything is evenly mixed. Transfer the batter to the prepared pan.

2. Bake for about 35 minutes, until a toothpick inserted into the middle of the cake comes out clean. When the cake is done, turn it out onto a cooling rack and let cool completely before frosting.

3. To make the frosting: While the cake is baking and cooling, cream together the cream cheese and butter until smooth. Add half the powdered sugar along with the vanilla, maple syrup, and cocoa powder. Add the remaining powdered sugar slowly, until you have a consistency that is spreadable.

4. To make the edible moss: Preheat the oven to 250°F. Add the graham crackers to the bowl of a food processor along with the sugar and pistachios. Pulse several times until it is a reasonably fine consistency. Continue to pulse while adding the butter, then follow with the food coloring, stopping when you reach a color you like. Spread this mixture out evenly on a rimmed baking sheet, then bake for about 10 minutes. Give it a stir, then return to the oven for about 5 minutes more, until it feels dry. This can be made several days in advance and stored in an airtight container.

5. Spread the frosting over the top and sides of the cooled cake, and use a fork to swirl it around the top of the cake to imitate the look of the rings of a tree. Press the edible moss into the sides of the cake.

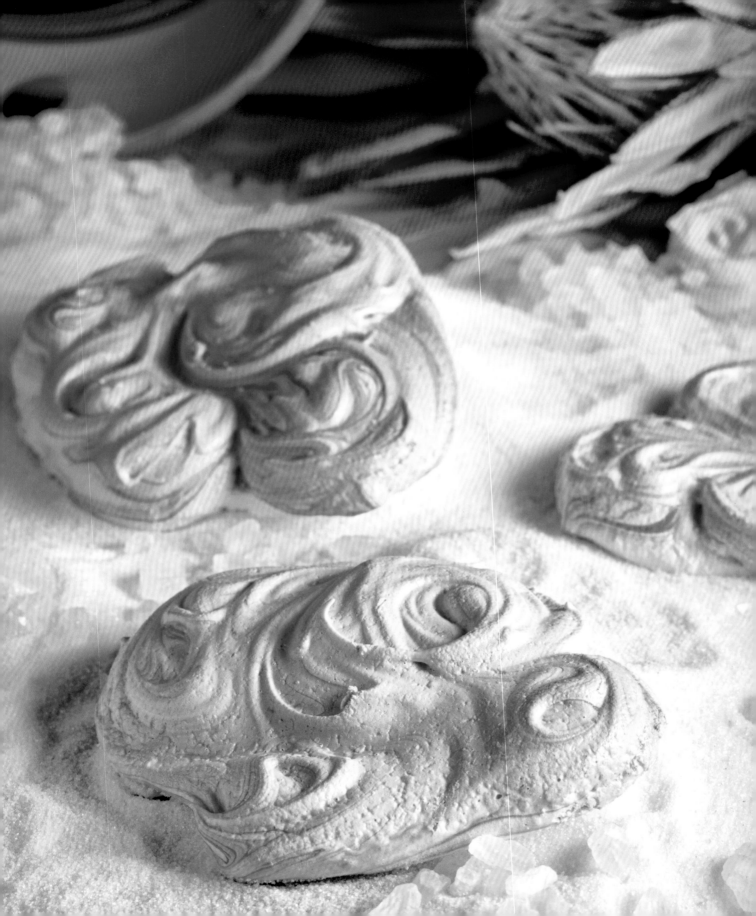

BESPIN CLOUD DROPS

When you live in a fancy floatin' city, it's fair to assume that everythin' is gonna be a touch opulent. This delicate dessert is certainly no exception. These fancy meringue drops were designed to resemble the clouds of Tibanna gas that drift gently through the planet Bespin's atmosphere, and you ain't gonna believe the storm front of flavor in each whimsical wisp. Cloud drops practically melt away in your mouth. I could eat these angelic little treats by the handful (and given the size of my hands, that says a lot). As beautiful as Bespin is on a clear day, I guarantee these dainty delights will have you beggin' for clouds.

INGREDIENTS

3 EGG WHITES
½ TEASPOON CREAM OF TARTAR
¾ CUP SUGAR
1 TABLESPOON DESERT PEAR SYRUP
 OR GRENADINE
LIGHT BLUE FOOD COLORING

PREP TIME: 15 MINUTES
COOKING TIME:
1½ HOURS
COOLING TIME:
1 TO 2 HOURS
YIELD: SERVINGS VARY
DIFFICULTY: MEDIUM

1. Combine the egg whites and cream of tartar in a medium bowl and beat on medium speed using electric mixer until soft peaks form.

2. Turn the speed up to high and begin adding the sugar in a slow stream.

3. Beat until the sugar is completely dissolved, then quickly beat in the desert pear syrup or grenadine.

4. Preheat the oven to 200°F and line a baking sheet with parchment paper.

5. Drop dollops of the meringue onto the baking sheet using a spoon, then form into rough cloud shapes.

6. Dip a toothpick into the blue food coloring and swirl it through each cloud to add a little more color.

7. Bake for 1½ hours, then turn off the heat and prop the oven door open just a little. Let the meringues cool for another hour or so.

CAVAELLIN SPICE CREAMS

Used to be a time when I had a fair number of droids workin' in my kitchen. That was back before a couple of 'em went corrupt and tried to kill me and a bunch of my staff. Nowadays I like my chefs the same way I like my ingredients—organic. Still, there are days I miss havin' access to one of those droids' databases, 'cause they were burstin' with enough recipes to fill a thousand of these books. This one old 434 unit had the most spectacular recipe for Cavaellin creams—snappy little cookies from the Cavaell system filled with exotic fruit. Their spicy zing made you wonder if you were bitin' them or they were bitin' you. It's truly a recipe to die for . . . but don't tell a droid that. They might take you literally.

INGREDIENTS

COOKIES:

¾ CUP (1½ STICKS) BUTTER
½ CUP GRANULATED SUGAR
½ CUP PACKED BROWN SUGAR
1 EGG
½ CUP MOLASSES
1 TEASPOON BAKING SODA
1 TEASPOON GROUND CINNAMON
1 TEASPOON GROUND GINGER
½ TEASPOON FIVE-SPICE POWDER
2½ CUPS ALL-PURPOSE FLOUR

FILLING:

4 OUNCES CREAM CHEESE
DASH OF DESERT PEAR SYRUP OR ORANGE EXTRACT
¾ CUP POWDERED SUGAR
1 TABLESPOON HEAVY CREAM, OR AS NEEDED

PREP TIME: 5 MINUTES
CHILLING TIME: 1 HOUR
BAKING TIME: 10 MINUTES
YIELD: ABOUT 12
DIFFICULTY: MEDIUM

1. To make the cookies: In a medium bowl, cream together the butter and sugars. Incorporate the egg and molasses, followed by the baking soda, cinnamon, ginger, and five-spice powder. Finally, mix in the flour until you have a somewhat stiff dough. Cover and refrigerate for about an hour.

2. When you are ready to bake, preheat the oven to 375°F and line a baking sheet with parchment paper. Roll the dough into balls about 1 inch across and place on the baking sheet, spacing about 3 inches apart (they'll spread). Bake for 10 to 12 minutes, until they're just turning brown on the edges. Let cool on the baking sheet for about a minute, then transfer to a cooling rack to cool completely.

3. To make the filling: While the cookies are baking and cooling, mix together the cream cheese, pear syrup or orange extract, and powdered sugar. Add just enough heavy cream to give the filling a stiff but spreadable texture.

4. Pair the cookies up roughly by size. Add about 1 tablespoon of filling to the bottom of a cookie, then sandwich another on top, pressing gently but not so hard that the filling comes out. Set aside and repeat with the remaining cookies and filling.

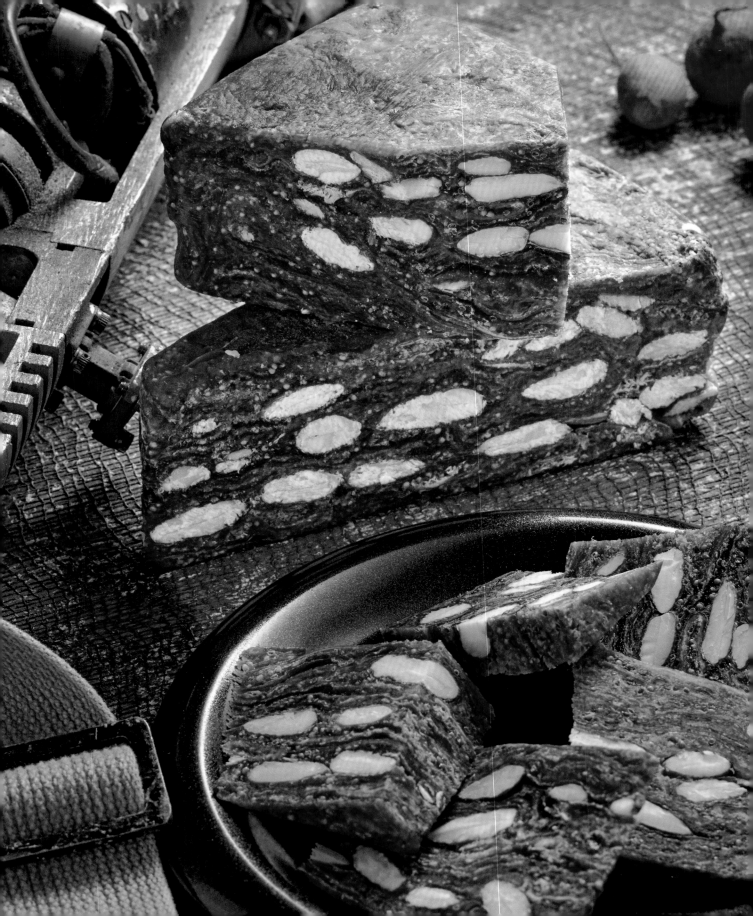

MANDALORIAN UJ CAKE

The sweet, sticky cake known as *uj'alayi* is a traditional Mandalorian dessert, the secret recipe for which was handed down through the generations. (How it found its way into my kitchen I ain't at liberty to discuss.) It's filled with dried fruit and nuts, creatin' a cake with a particularly dense texture. Thankfully, the spiced syrup that infuses the whole thing keeps it nice and moist. Back in their heyday, Mandalorians served uj cakes on nearly every occasion, from clan gatherings to victory feasts. Soldiers were even known to carry pieces of uj cake with 'em into battle in that fancy armor of theirs. Maybe that's why they said Mandalorians always stuck to their guns!

INGREDIENTS

BUTTER, FOR GREASING

2 CUPS WALNUTS, ROUGHLY CHOPPED

¼ CUP WHOLE HAZELNUTS

¼ CUP SLIVERED ALMONDS

½ CUP MIXED CANDIED PEEL

1 CUP GOLDEN RAISINS

½ CUP DICED DRIED FIGS

¼ CUP DRIED CURRANTS

¼ CUP DRIED CHERRIES

2 HEAPING TABLESPOONS DICED CANDIED GINGER

½ TEASPOON GROUND CINNAMON

¼ TEASPOON GROUND MACE

PINCH OF PEPPER

PINCH OF CURRY POWDER

PINCH OF SALT

¾ CUP ALL-PURPOSE FLOUR

⅔ CUP HONEY

⅔ CUP POMEGRANATE OR DATE MOLASSES

2 TABLESPOONS BUTTER

POWDERED SUGAR FOR TOPPING

PREP TIME:
20 MINUTES

BAKING TIME:
40 MINUTES

COOLING TIME:
45 MINUTES

YIELD:
SERVINGS VARY

DIFFICULTY:
MEDIUM

1. Preheat the oven to 300°F and line an 8-inch round springform cake pan with parchment paper, then butter both the parchment and the sides of the pan.

2. Combine the walnuts, hazelnuts, slivered almonds, candied peel, raisins, dried figs, dried currants, dried cherries, candied ginger, cinnamon, mace, pepper, curry powder, pinch of salt, and flour in a large bowl. Stir to combine, making sure to break up any clumps of stuck-together fruit or overly large nut pieces. Set aside.

3. Combine the honey, molasses, and butter in a saucepan over medium heat. Bring it to a boil, and then keep cooking down until it reaches soft-ball stage, about 245°F as measured on a candy thermometer. Remove from the heat and immediately pour into the bowl of nuts and fruits. Stir thoroughly and quickly to make sure the flour is all absorbed and the mixture is evenly covered, then scrape it all into the prepared pan. Press it down firmly with moistened fingers. Bake for about 40 minutes, until mostly set.

4. It won't seem firm enough when it comes out of the oven, but let it sit for another 45 minutes, then run a knife around the edge to loosen it. Flip out onto a cutting surface lined with more parchment paper. Wrapped tightly, uj cake can be and kept for several months at room temperature. Slice into thin wedges to serve.

Note: This is a common assortment of ingredients, but feel free to adapt according to what is available to you, keeping to the rough ratio of 2½ cups of nuts and 2½ to 3 cups of dried fruit.

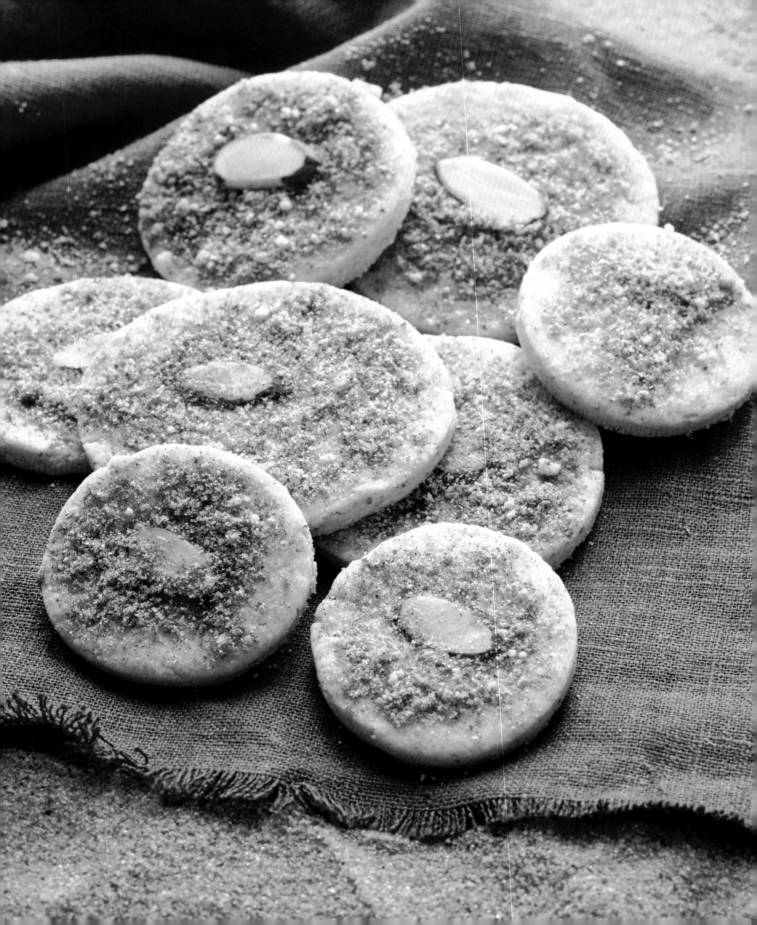

SWEET-SAND COOKIES

Don't matter which planet you hail from or where your journey took ya, there's one thing that undeniably binds each and every one of us together—the love of a fresh-baked cookie. There's just somethin' special about the smell of a pipin'-hot batch of sweet-sand cookies, straight outta the oven and waitin' to be devoured. Every species has its own spin on this classic. Believe it or not, I got my current recipe from a reprogrammed battle droid by the name of Roger who paid a visit to Maz's castle with his human family. (It's a long story.) But no matter the recipe, the result is the same: When I put out a tray of 'em, even the most hardened criminals can't help but smile.

INGREDIENTS

COOKIES:

- ½ CUP (1 STICK) BUTTER
- ½ CUP GRANULATED SUGAR
- ½ CUP ALMOND MEAL
- 1 EGG
- PINCH OF GROUND VANILLA
- 1½ CUPS FLOUR, PLUS MORE FOR DUSTING
- SLICED ALMONDS FOR GARNISHING

TOPPING:

- ¼ CUP CHRISTOPHSIAN SUGAR (PAGE 38)
- 1 TABLESPOON BROWN SUGAR
- 1 TABLESPOON ALMOND MEAL
- ½ TEASPOON GROUND CINNAMON
- 2 TABLESPOONS HEAVY CREAM

PREP TIME: 10 MINUTES

CHILLING TIME: 30 MINUTES

BAKING TIME: 10 MINUTES

YIELD: ABOUT 2 DOZEN

DIFFICULTY: MEDIUM

1. Line two baking sheets with parchment paper and set aside.

2. Cream together the butter and sugar, followed by the almond meal, egg, and vanilla. Gradually add the flour until the dough is no longer sticky, and pulls together.

3. Roll out on a lightly floured surface to about ⅛-inch-to-¼-inch thickness, then cut into discs. If you like, press almond slices into the top of some. Transfer the cookies onto the prepared baking sheets, and place in the fridge to chill for at least 30 minutes.

4. Just before you are ready to bake, preheat the oven to 350°F. Bake for around 10 minutes, until the bottoms and sides of the cookies are just starting to brown.

5. While the cookies bake, prepare your sweet-sand mixture by combining the sugar, brown sugar, almond meal, and cinnamon.

6. When the cookies are done, allow to cool for around a minute, then brush the cream onto the hot cookies. Immediately dip each brushed cookie into the sweet-sand mix, tap off any excess, and set aside.

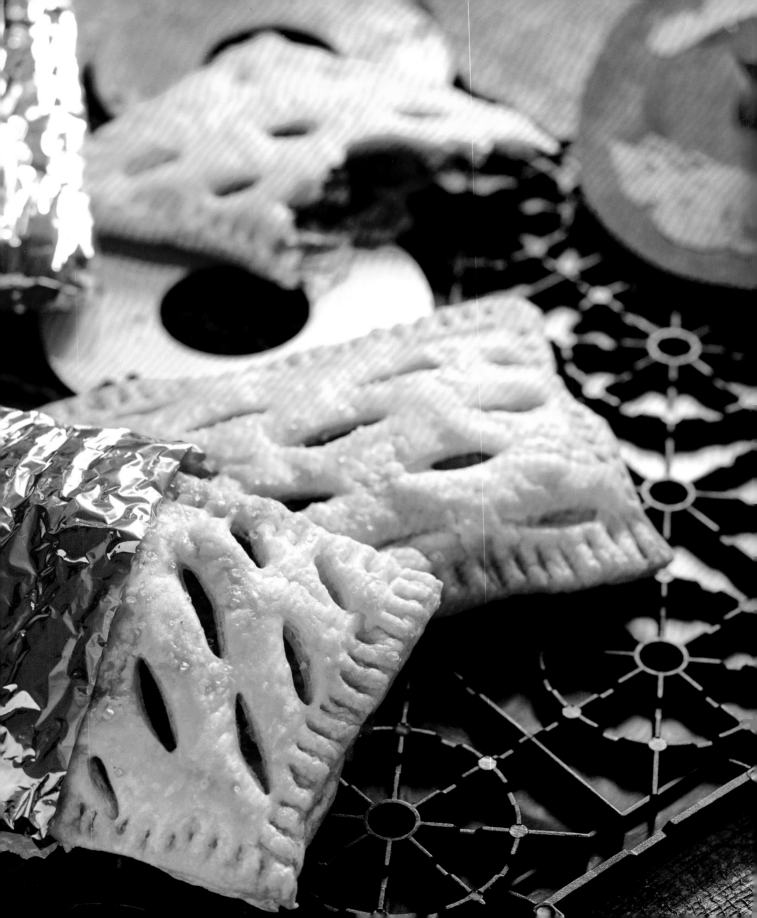

CORELLIAN RYSHCATE

Hate to say it, but there ain't much to celebrate on Corellia. I'm sure it was a lovely planet once, but whatever charm it had was buried a long time ago beneath a thick layer of pollution generated by its bustlin' shipyards. Today's Corellians are renowned as skilled builders, but some of the older generation were also talented bakers. One of their most esteemed creations was the ryshcate, a flaky pastry layered with nuts and soaked with Corellian whiskey. While ryshcate was traditionally served at celebrations, it was also commonly eaten by Corellians who had managed to escape to clearer skies, yet were still hungry for a little piece of home. You don't really need a special occasion to enjoy this dessert, but if you're like me, you're probably celebratin' the fact that you don't gotta go to Corellia to get it.

INGREDIENTS

1 POUND FROZEN PUFF PASTRY, THAWED

½ CUP WALNUTS

½ CUP GOLDEN RAISINS

¼ CUP SHELLED PISTACHIOS

½ CUP PACKED BROWN SUGAR

2 TABLESPOONS BUTTER, SOFTENED

1 TABLESPOON HONEY

1 TEASPOON GROUND CINNAMON

½ TEASPOON GROUND CARDAMOM

2 TABLESPOONS FLOUR, PLUS MORE FOR DUSTING

PINCH OF SALT

1 TEASPOON WHISKEY OR BRANDY

HEAVY CREAM FOR GLAZING

PREP TIME: 20 MINUTES

BAKING TIME: 25 MINUTES

YIELD: 6 PASTRIES

DIFFICULTY: MEDIUM

1. Preheat the oven to 400°F and line a baking sheet with parchment paper.

2. On a lightly floured surface, unfold the puff pastry and roll it out slightly. Cut into 12 equal pieces. Set six pieces on the baking sheet, then use a sharp knife to score small decorative cuts in the remaining six pieces, leaving the edges intact.

3. In the bowl of a food processor, combine the walnuts, raisins, pistachios, brown sugar, butter, honey, cinnamon, cardamom, flour, and salt. Pulse until the mixture is very fine, then transfer to a small bowl and stir in the whiskey.

4. To assemble, spread the filling over the uncut pieces of pastry on the baking sheet, leaving about ¼ inch empty dough around the edge of each piece. Place the scored pieces of pastry on top, then crimp the edges shut with the tines of a fork.

5. Brush with a little heavy cream, and bake for about 25 minutes, until the pastry is puffed and golden brown.

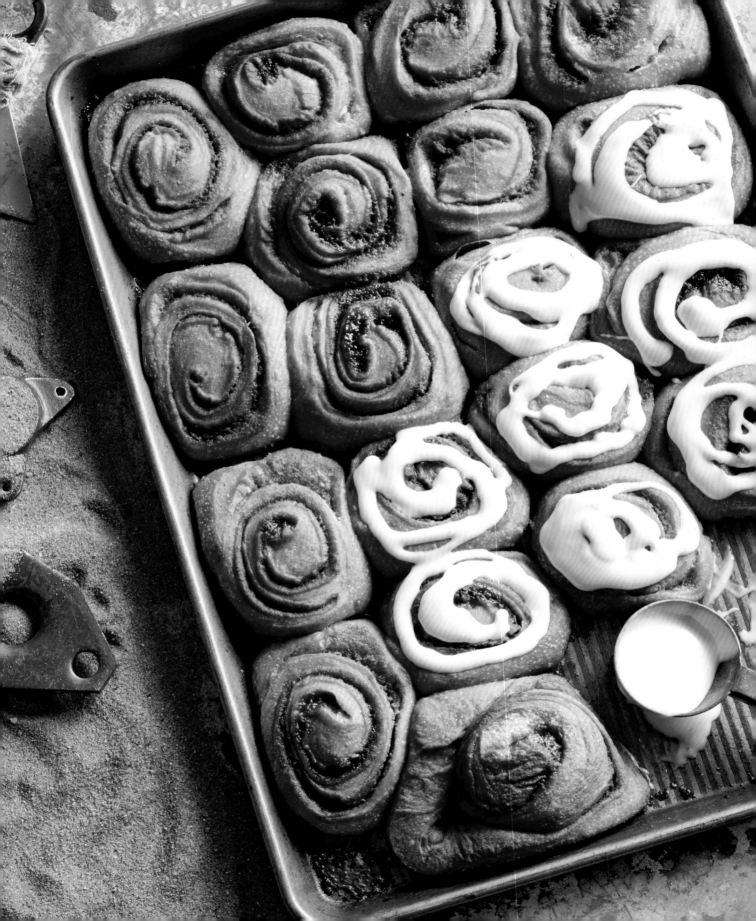

KESHIAN SPICE ROLLS

My late, great sous-chef, Robbs Ely, liked to keep his recipes to himself, but he was still quick to let you know when your best attempts weren't up to his ridiculous standards. Didn't make him the easiest of fellas to get along with, but I tolerated his attitude if it resulted in better food. And it almost always did. Like this one time, I was whippin' up some basic batter when ol' Robbs ripped the bowl and spoon right outta my hands in disgust. He added a bunch of unexpected spices that turned the batter a vivid pink. I was this close to firin' the guy right then and there—until he opened the oven and presented one of the best Keshian spice rolls I ever tasted. It had hints of citrus and ginger and a delectably spicy fillin', and to this day, when I eat one of these beauties, I think of that miserable moof milker and smile.

INGREDIENTS

ROLLS:

1 MEDIUM BEET, ABOUT ½ POUND

¼ CUP WATER

½ CUP GRANULATED SUGAR

1 EGG, LIGHTLY BEATEN

1 CUP BUTTERMILK

2 TABLESPOONS MELTED BUTTER

2 TEASPOONS INSTANT DRY YEAST

1 TEASPOON SALT

4½ CUPS ALL-PURPOSE FLOUR, PLUS MORE FOR DUSTING

COOKING SPRAY OR BUTTER, FOR GREASING

FILLING:

¾ CUP PACKED BROWN SUGAR

1 TABLESPOON GROUND CINNAMON

1 TEASPOON GROUND GINGER

½ TEASPOON GROUND CARDAMOM

1 TABLESPOON ALL-PURPOSE FLOUR

5 TABLESPOONS BUTTER, SOFTENED

ICING:

½ CUP POWDERED SUGAR

½ TEASPOON ORANGE EXTRACT

¼ CUP HEAVY CREAM, OR AS NEEDED

PREP TIME: 1½ HOURS

RISING TIME: 1½ HOURS

BAKING TIME: 20 MINUTES

YIELD: ABOUT 2 DOZEN

DIFFICULTY: MEDIUM

1. To make the rolls: Preheat the oven to 375°F. Wrap the beet in aluminum foil and roast for about 1 hour, until very soft. Peel and roughly mash in a large bowl. To the same bowl, add the water, sugar, egg, buttermilk, and melted butter. Puree with an immersion blender until no large pieces of beet remain. Add the yeast and salt, then gradually work in the flour a cup at a time until you have a dough that isn't too sticky. Turn the dough out onto a lightly floured surface and knead for a couple of minutes, until it is soft and pliable. Place the dough in a clean, lightly greased bowl, cover with plastic, and set somewhere warm to rise for about 1 hour, or until doubled in size.

2. To make the filling: While the dough is rising, mix together the brown sugar, cinnamon, ginger, cardamom, and flour in a small bowl and set aside.

Lightly butter a large rimmed baking sheet. When the dough is ready, roll it out into a rectangle shape roughly 12 by 24 inches. Spread the softened butter over the dough, then sprinkle the filling mixture evenly over top. Working from one end, roll up the dough lengthwise into a long tube. Cut into 1-inch-wide slices and place these on the prepared baking sheet. Allow to rise for about 30 minutes more, until puffy and soft. Preheat the oven to 375°F, then bake for about 20 minutes, until golden brown on top. Let the rolls cool for at least 20 minutes while you make the icing.

3. To make the icing: In a small bowl, stir together the powdered sugar, orange extract, and just enough heavy cream to make a thick icing that can still be drizzled. Drizzle over the cooled spice rolls just before serving.

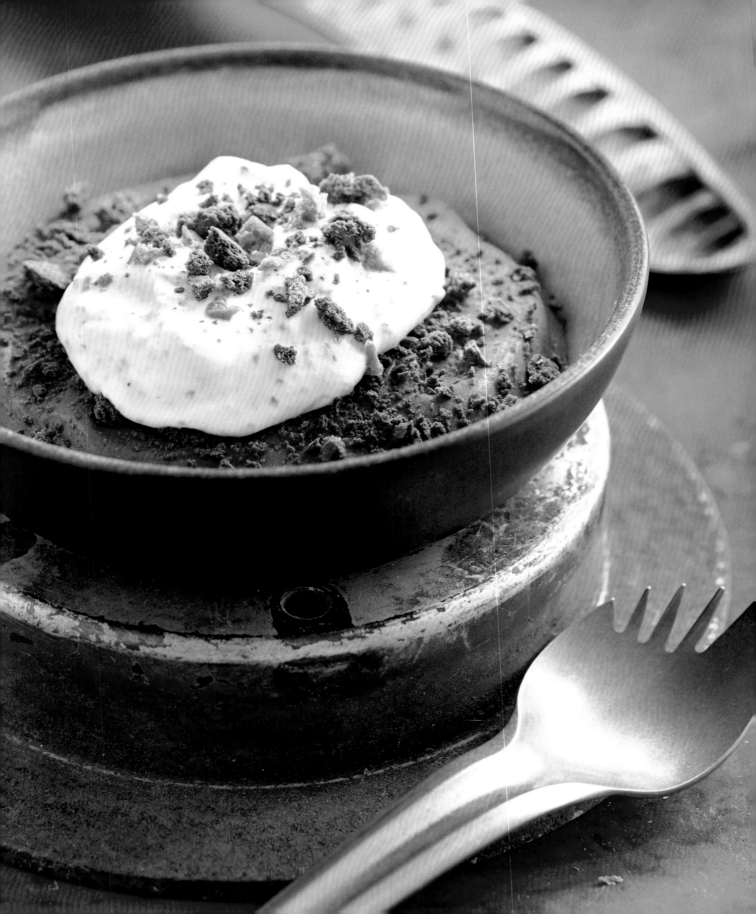

MIMBANESE MUDSLIDE

Went to Mimban once, and once was enough for me. Frankly, it's a world that ain't got much to offer other than a whole lotta mud. And while mud ain't typically an ingredient that inspires the appetite, it did serve as the inspiration for this rich, creamy puddin'. Yeah, I know puddin' ain't exactly gourmet dinin'—but I promise this ain't the same overprocessed sugary glop that they pack in with the cheap rations you find at your local trade depot. This homemade puddin' is all-natural and combines some unusual ingredients to give it a velvety smoothness and just a hint of deep, fertile flavor that would please even the Mimbanese. Still don't got much of a reason to go back to this dish's namesake world, but if I ever found a planet covered with mud like this, you can bet I'd never leave.

INGREDIENTS

2 CUPS MILK, DIVIDED
1 EARL GREY TEA BAG
¼ CUP GRANULATED SUGAR
¼ CUP PACKED BROWN SUGAR
⅓ CUP DARK COCOA POWDER
¼ TEASPOON KOSHER SALT
½ TEASPOON GROUND CINNAMON
½ TEASPOON VANILLA EXTRACT
2 TABLESPOONS CORNSTARCH
WHIPPED CREAM FOR TOPPING
½ CUP CRUMBLED CHOCOLATE COOKIES
 FOR TOPPING
NECTROSE CRYSTALS (PAGE 39) FOR
 TOPPING

COOKING TIME:
15 MINUTES

COOLING TIME: 1 HOUR
(OPTIONAL)

YIELD: 4 SERVINGS

DIFFICULTY: EASY

1. Combine 1 cup of the milk with the tea bag, granulated sugar, and brown sugar in a small saucepan over medium heat.

2. Bring to just under a simmer, until the milk is steaming, then remove from heat and let steep for 5 minutes.

3. Remove the tea bag, then whisk in the cocoa, salt, cinnamon, and vanilla.

4. In a small bowl, whisk together the remaining 1 cup milk and the cornstarch. Pour this mixture into the hot milk while whisking. Return to heat and continue to cook for another minute or so, until noticeably thickened.

5. Remove from the heat and pour into a clean bowl.

6. Enjoy warn or cover with plastic and refrigerate to cool. Add whipped cream to taste and top with the crumbled chocolate cookies and Nectrose Crystals just before serving.

NECTROSE FREEZE

Believe it or not, a lot of folks beyond the Core Worlds have never tried ice cream before. Guess it's a luxury item in a galaxy that ain't been luxurious for a long time. So when I take my food freighter to new worlds, I like to make sure I bring along a few extra gallons of the stuff in my deep freezer pod so that I can watch the locals' faces as they try their first bites. I've made a wide variety of flavors over the years, usin' everythin' from bantha milk to numina cream as a base. But these days, I prefer to whip up a simple no-churn variety that I flavor with Nectrose Crystals (page 39) for a bit of extra pop. It's so tasty, I even managed to sell a batch of the stuff to a scientific expedition party on Vandor. (And when it comes to cold, those guys are the experts.)

INGREDIENTS

ONE 14-OUNCE CAN SWEETENED
 CONDENSED MILK
1 TEASPOON VANILLA EXTRACT
⅓ CUP OLIVE OIL
2 CUPS HEAVY WHIPPING CREAM
GOLDEN LICHEN TUILE (PAGE 37)
 FOR TOPPING (OPTIONAL)
NECTROSE CRYSTALS (PAGE 39)
 FOR TOPPING

PREP TIME: 10 MINUTES
FREEZING TIME:
6 HOURS
YIELD: 6 GENEROUS
SERVINGS
DIFFICULTY: EASY

1. Combine the sweetened condensed milk, vanilla extract, and olive oil in a medium bowl.

2. In a large bowl, whip the heavy cream until it forms stiff peaks. Stir a little under half of the whipped cream into the condensed milk mixture, then fold all of that back into the remaining whipped cream. Freeze for at least 6 hours.

3. Serve with Golden Lichen Tuile and your choice of Nectrose Crystals.

KOWAKIAN CRUMB CAKE

There's only one thing that can mess up a kitchen worse than a homicidal droid: a Kowakian monkey-lizard. If one of those little monsters gets loose in your galley, not only will it ravage your prep area, it'll laugh in your face the entire time. For some reason, a bunch of the pirates who frequented Maz's castle kept those blasted things as pets. When they got off their leashes—which they always did—chaos was sure to follow. Luckily, during one particular devastatin' rampage, I discovered that Kowakians are drawn to the blend of spices in my crumb cake. Or maybe it was the berry swirl. I dunno. All that matters is that I was able to trap one of these tiny terrors under a soup pot when it stopped to gobble up an entire cake. When I ain't usin' this classic confection as monkey-lizard bait, it does a fine job lurin' in less destructive diners.

INGREDIENTS

TOPPING:

⅓ CUP GRANULATED SUGAR

⅓ CUP PACKED BROWN SUGAR

1 TEASPOON GROUND CINNAMON

½ TEASPOON GROUND GINGER

½ CUP (1 STICK) BUTTER, MELTED, PLUS MORE FOR GREASING

BURGUNDY GEL FOOD COLORING

1¼ CUPS ALL-PURPOSE FLOUR

CAKE:

6 TABLESPOONS BUTTER, SOFTENED

½ CUP GRANULATED SUGAR

1 EGG

1 TEASPOON VANILLA EXTRACT

½ CUP BUTTERMILK

¼ TEASPOON BAKING SODA

¼ TEASPOON SALT

1½ CUPS ALL-PURPOSE FLOUR

1 CUP FRESH BLUEBERRIES

PREP TIME: 15 MINUTES

BAKING TIME: 35 MINUTES

YIELD: 1 CAKE, ABOUT 8 SERVINGS

DIFFICULTY: MEDIUM

ICING:

½ CUP POWDERED SUGAR

DASH OF ORANGE EXTRACT

1-2 TABLESPOONS HEAVY CREAM

1. To make the topping: Combine the granulated sugar, dark brown sugar, cinnamon, ginger, melted butter, and food coloring in a medium bowl. Add the flour and mix until you have a consistency like breadcrumbs. Set aside to cool.

2. To make the cake: Preheat the oven to 325°F and lightly butter an 8-inch square baking pan and line with parchment paper.

3. In a large bowl, beat together the butter, sugar, egg, and vanilla until smooth. Add the buttermilk, then the baking soda and salt. Finish by adding the flour and mixing until you have a thick batter. Stir in the blueberries, then transfer the batter to the pan. Sprinkle the crumble topping on top, and bake for about 35 minutes, until a toothpick inserted into the middle comes out clean. Let cool completely.

4. To make the icing: While the cake cools, stir together the powdered sugar, orange extract, and just enough cream to give it a thick runny consistency. Drizzle the cool cake with the icing.

ZOOCHBERRY SURPRISE

Zoochberries used to be a pretty popular ingredient, grown on a number of worlds and used in countless recipes. But over the years, this former staple lost some of its luster as hyperspace tradin' routes made hundreds of varieties of rare and exotic berries available to planets across the Outer Rim. Suddenly, the ol' zoochberry didn't seem so special anymore, and folks stopped growin' and harvestin' 'em. The result was a steep hike in price for what was once one of the cheapest berries on the market. Nowadays, when somebody with a fondness for zoochberries wants to take their taste buds on a walk down memory lane, I serve 'em this creamy confection. It's sweet, juicy, and burstin' with so much flavor that most folks never even realize there ain't a single zoochberry in it. Surprise!

INGREDIENTS

CRUST:

- 1½ CUPS CHOCOLATE GRAHAM CRACKER CRUMBS
- 2 TABLESPOONS BROWN SUGAR
- ½ CUP (1 STICK) BUTTER, MELTED

SAUCE:

- 10 OUNCES MIXED BERRIES, SUCH AS BLUEBERRIES, STRAWBERRIES, AND RASPBERRIES, PLUS MORE FOR GARNISHING
- ¼ CUP GRANULATED SUGAR
- 1 TEASPOON LEMON JUICE
- 1 TABLESPOON BALSAMIC VINEGAR
- ½ TEASPOON GROUND GINGER

FILLING:

- 1 CUP HEAVY CREAM
- 1 POUND CREAM CHEESE, SOFTENED
- ½ CUP POWDERED SUGAR
- DASH OF VANILLA EXTRACT
- ½ TEASPOON LEMON JUICE

PREP TIME: 15 MINUTES

COOKING TIME: 15 MINUTES

CHILLING TIME: 2 HOURS

YIELD: SERVINGS VARY

DIFFICULTY: HARD

1. Line an 8-inch square baking pan with aluminum foil, leaving enough overhang to help pull the dessert out of the pan when you are ready to serve.

2. To make the crust: In a medium bowl, combine the ingredients for the crust. The mixture should be a little wet, and hold its shape when squished. Press this layer into the bottom of the pan.

3. To make the sauce: Combine all the ingredients in a medium saucepan over medium heat and cook until the berries have broken apart, about 15 minutes. Strain into a small bowl and refrigerate to chill.

4. To make the filling: In a small bowl, beat the heavy cream until it forms stiff peaks, then set aside. In a medium bowl, beat together the cream cheese, powdered sugar, vanilla, and lemon juice. To this mixture, stir in one-third of the whipped cream, then gently fold in the remaining whipped cream. Pour this mix over the crust in the pan, then set aside. Once the berry sauce is cool, gently pour it over the cream layer. Using a bamboo skewer or a butter knife, make swirled designs in the top of the dessert. Refrigerate for at least two hours. When ready to serve, gently lift out of the pan and cut into squares. Garnish with berries.

TEPASI TAFFY

Workin' at Maz's castle for as many years as I did, I met some of the most skilled smugglers and prodigious pirates to ever soar through the spaceways. Oh, and I also met Hondo Ohnaka. This Weequay pirate might not have been quite the legendary rogue he always claimed to be, but he did have his brief moments of glory now and then. Like this one time, Hondo described how, when Maz yelled at him, she stretched out each syllable of his name "like it was Tepasi taffy." Couldn't stop laughin' for a week! From then on, I made sure to put a bowl of these sticky sweets out on the bar whenever Hondo docked on Takodana. Figured the busier I could keep the guy's mouth, the less trouble it'd get him into with Maz.

INGREDIENTS

⅔ CUP BOILING WATER

1 BLUE BUTTERFLY PEA TEA BAG

1 CUP SUGAR

3 TABLESPOONS HONEY

½ TEASPOON GROUND GINGER

½ TEASPOON ORANGE EXTRACT

½ TEASPOON VANILLA EXTRACT

2 TABLESPOONS BUTTER, PLUS MORE FOR STRETCHING

½ TEASPOON BLACK SALT

COOKING TIME: 10 MINUTES

STRETCHING TIME: 15 MINUTES

YIELD: SERVINGS VARY

DIFFICULTY: MEDIUM

1. Pour the boiling water over the tea bag in a mug and allow to steep for around 5 minutes, until you have a nice dark blue tea. Discard the tea bag. Line a baking sheet with a silicone mat or a well-buttered piece of parchment paper.

2. Combine the tea, sugar, honey, ginger, orange and vanilla extracts, and butter to a medium saucepan. Place over medium-high heat and cook until the mixture reaches 255°F.

3. Pour the mixture onto the prepared baking sheet and sprinkle with the black salt. Move the hot mixture around the pan carefully to start cooling it down.

4. When it is cool enough to handle, cover your hands in butter to prevent the taffy from sticking. Begin stretching it between your hands, twisting it as you stretch. After around 10 minutes or so, the taffy should have lightened in color and become stiffer.

5. When it's a consistency that holds its shape, cut into bite-size pieces using a buttered knife or scissors.

6. Enjoy straightaway, or wrap in candy paper and store in an airtight container for up to a week.

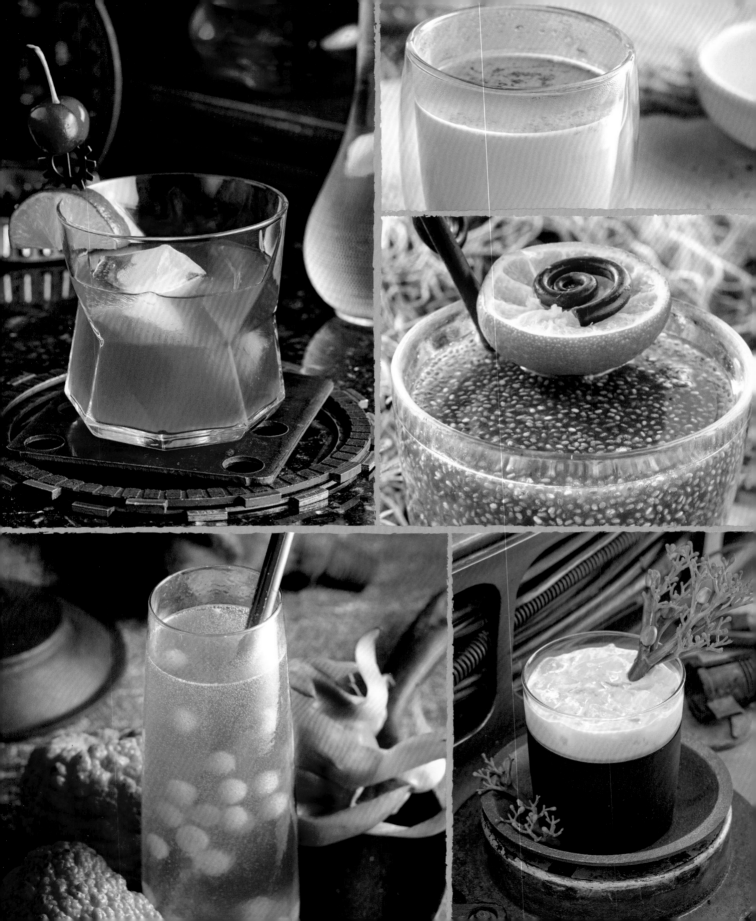

DRINKS

I may have spent a century cookin' meals in Maz's kitchen on Takodana, but I never really spent much time behind the castle's bar. I left that distinct pleasure to guys like my old buddy Bragthap, who had the unlimited patience required to deal with our regular clientele of ne'er-do-wells. Even though I wasn't mixin' the drinks myself, any good chef understands that even the perfect plate don't amount to much without a quality beverage to pair it with.

When I started travelin' the Outer Rim in my food freighter, I realized quick that folks were gonna depend on me to provide 'em both food and drink, so I had to add a few crowd-pleasin' concoctions to my menu. I'm a lot better with meat than, mead, so if you are eager for somethin' with a bit more flair, try a local cantina. I always make sure to dock my truck as close as possible to the nearest waterin' hole and, as a show of thanks for the extra traffic, some of the barkeeps on the worlds I've visited have passed along a few of their favorite recipes. So feel free to save some credits and avoid the cantina crowds by makin' these in the comfort of your own home.

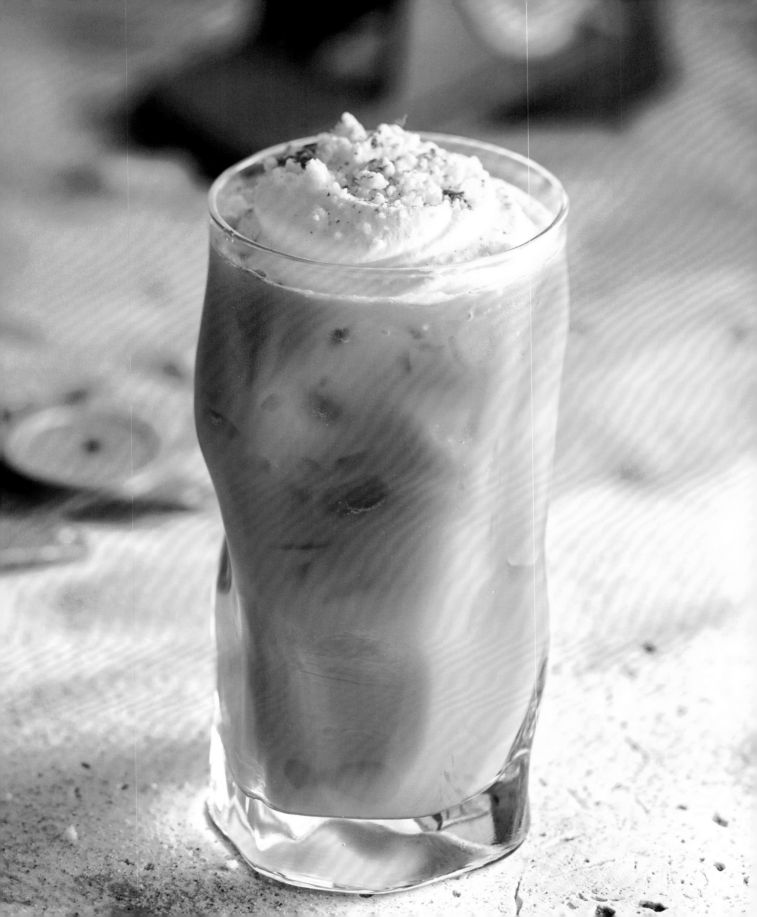

MOOGAN TEA

Don't let the fancy corporate brandin' fool you: Moogan Tea was around long before the Ardees Beverage Company trademarked the recipe and tried to claim the "galaxy's favorite" drink as its own. These days, it's almost too easy to grab a bottle—or a can, if you like the fizzy variety—on the go for just a couple of credits. But if you wanna get a taste of real Moogan Tea, the kind we used to drink back before big business dipped its filthy fingers into the concentrate, just ask any respectable barkeep. But try to keep it quiet. As long as there aren't any corporate surveillance droids around, they'll be glad to brew you up a nice frothy mug the way it was originally intended. Sure, you might be walkin' a dangerous line when it comes to galactic trademark laws just by havin' a sip, but taste like this is probably worth it.

INGREDIENTS

1¼ CUPS PREPARED UNSWEETENED ICED TEA

1 CUP CHOCOLATE MILK

¼ CUP MOOGAN SPICE SYRUP (PAGE 33)

½ CUP HEAVY CREAM

1 OUNCE FALERNUM

1 TABLESPOON CHRISTOPHSIAN SUGAR (PAGE 38), MIXED WITH ½ TEASPOON GROUND CINNAMON, FOR SPRINKLING

PREP TIME: 5 MINUTES
YIELD: 2 SERVINGS
DIFFICULTY: MEDIUM

1. Combine the iced tea, chocolate milk, and Moogan Spice Syrup in a small pitcher and refrigerate until ready to serve.

2. In a small bowl, beat the cream until it forms stiff peaks, then add the Falernum and beat until just mixed in.

3. To serve, fill two tall glasses half full with ice and divide the tea mixture between them.

4. Top with the flavored whipped cream, and sprinkle a little of the Christophsian Sugar on top.

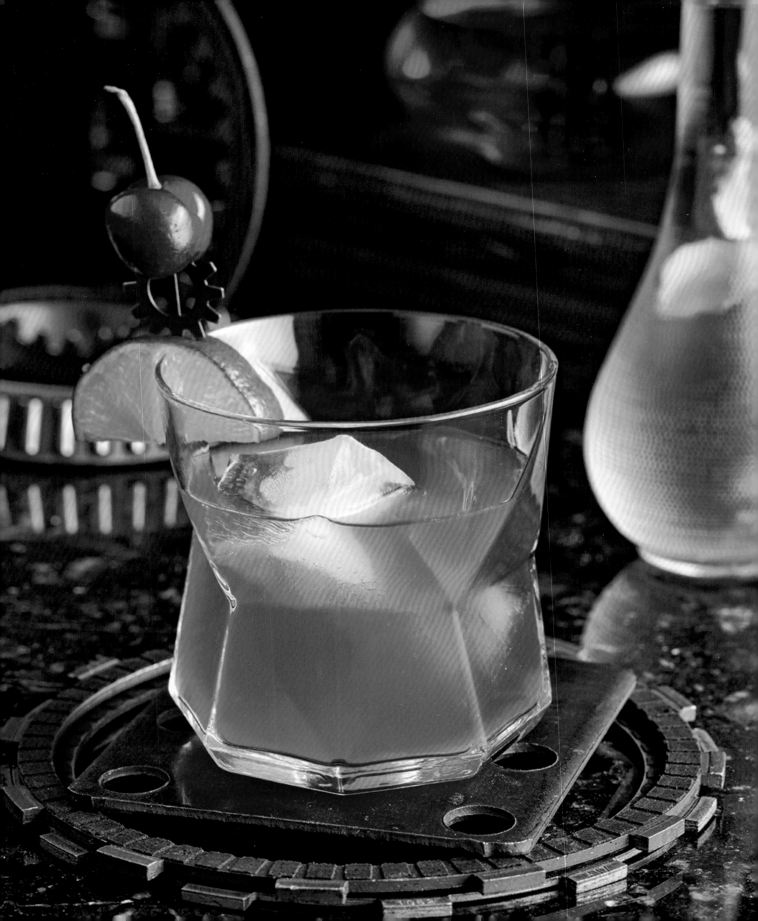

CORUSCANT COOLER

Back before the days of the Empire, the enormous sprawlin' city coverin' the surface of Coruscant was seen as the cultural center of the galaxy. Nearly a trillion residents spannin' every species from the Core to the Rim called it home, mixin' and minglin' their cultures and customs. That big-city intermixture is reflected in the sophisticated flavors of the planet's famed Coruscant Cooler, a fruity twist on a classic cocktail. It's no wonder this timeless tipple found its way beyond the infinite skyline of its home planet.

PREP TIME: 5 MINUTES
YIELD: 1 SERVING
DIFFICULTY: EASY

INGREDIENTS

3 OUNCES CRANBERRY JUICE
2 OUNCES BOURBON
1 OUNCE LIME JUICE
½ OUNCE SWEET VERMOUTH
SPLASH OF DARK CHERRY PUREE
LIME WEDGE FOR GARNISHING

1. Shake the cranberry juice, bourbon, lime juice, vermouth, and cherry puree together in a shaker, then pour into a short glass with a single large ice cube.

2. Garnish with a wedge of lime.

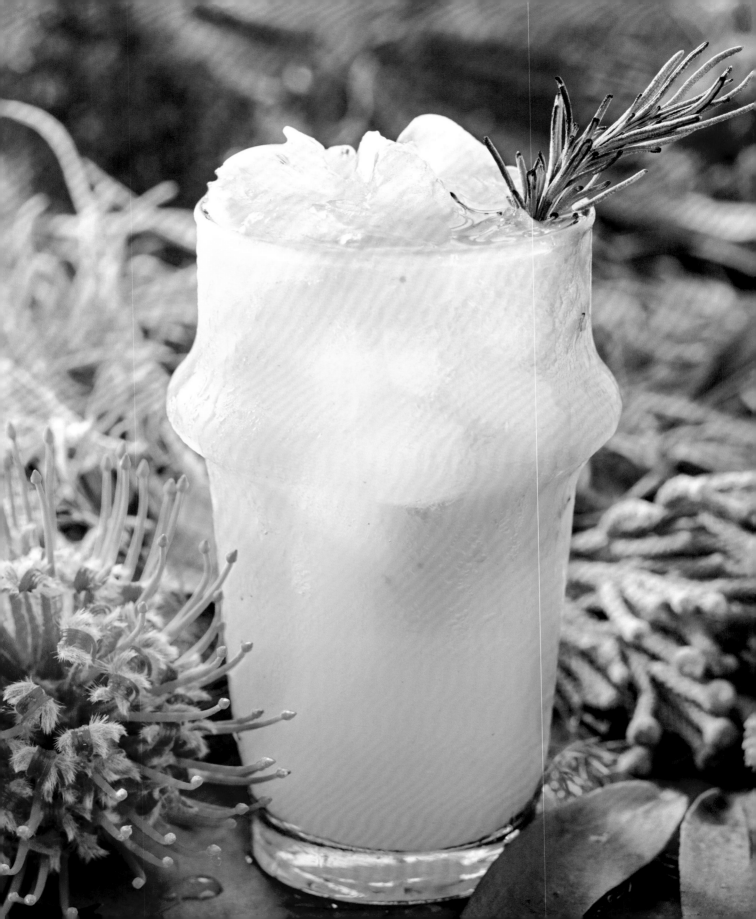

DAGOBAH SLUG SLINGER

As you probably guessed from its name, this particular cocktail derives its inimitable herbal nip from the sticky slime of the Dagobah swamp slug—or, at least, from the substitute Dagobah Slug Syrup (page 33) in this book's first batch of recipes. Despite its decidedly floral notes, the Dagobah Slug Slinger isn't nearly as swampy as you might expect from a drink that originated on Dagobah. That's because it's got a tart citrus base that provides the ideal balance to the slug's sweet, herbaceous ooze. The strong flavors also do a nice job of smoothin' out the equally strong portion of booze it contains. But don't be fooled—this one has more kick to it than a master of Teräs Käsi!

INGREDIENTS

½ OUNCE LIME JUICE

2 OUNCES ORANGE JUICE

1 OUNCE DAGOBAH SLUG SYRUP (PAGE 33)

½ TEASPOON BLUE CURAÇAO

2 OUNCES TEQUILA

1 OUNCE WATER

SPRIG OF ROSEMARY FOR GARNISHING

PREP TIME: 5 MINUTES
YIELD: 1 SERVING
DIFFICULTY: MEDIUM

1. Combine the lime juice, orange juice, Dagobah Slug Syrup, curaçao, tequila, and water in a shaker and give it a few good shakes to combine.

2. Pour into a tall glass with a few ice cubes and garnish with a sprig of rosemary.

3. For added flair, light part of the rosemary sprig on fire, then blow out and let smolder.

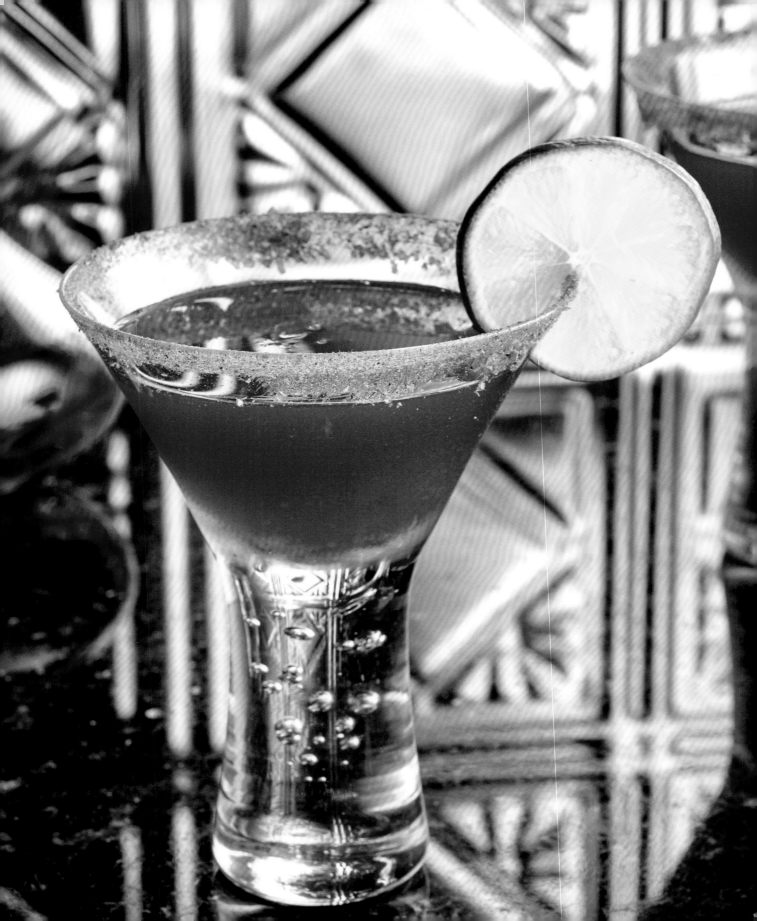

BLURRGFIRE

Ain't no other fruit in the galaxy quite like a citrom. Not only is its juice somehow sour and sweet simultaneously, but the taste is chased by a powerful burst of heat that'll leave your throat just beggin' to be cooled down—preferably by more delicious citrom juice. Citrom are only good fresh, and they don't stay fresh long, so if you ain't got much squeezin' time in your schedule, there's another option: One of the bartenders at Oga's Cantina in Batuu's Black Spire Outpost came up with this secret mix of juices and spices that perfectly mimics the citrom's refreshin' burn. Had to try it to believe it, but even my refined palate couldn't tell the difference.

INGREDIENTS

LIME
RED SALT
2 OUNCES POMEGRANATE JUICE
½ OUNCE HABANERO LIME SYRUP
4 OUNCES PREPARED LEMONADE

PREP TIME: 5 MINUTES
YIELD: 1 SERVING
DIFFICULTY: EASY

1. Run a slice of lime around the rim of a tall glass, then dip the glass in red sea salt.

2. Fill the glass half full of ice, then pour the remaining ingredients over the top.

3. Give the drink a quick stir to combine everything.

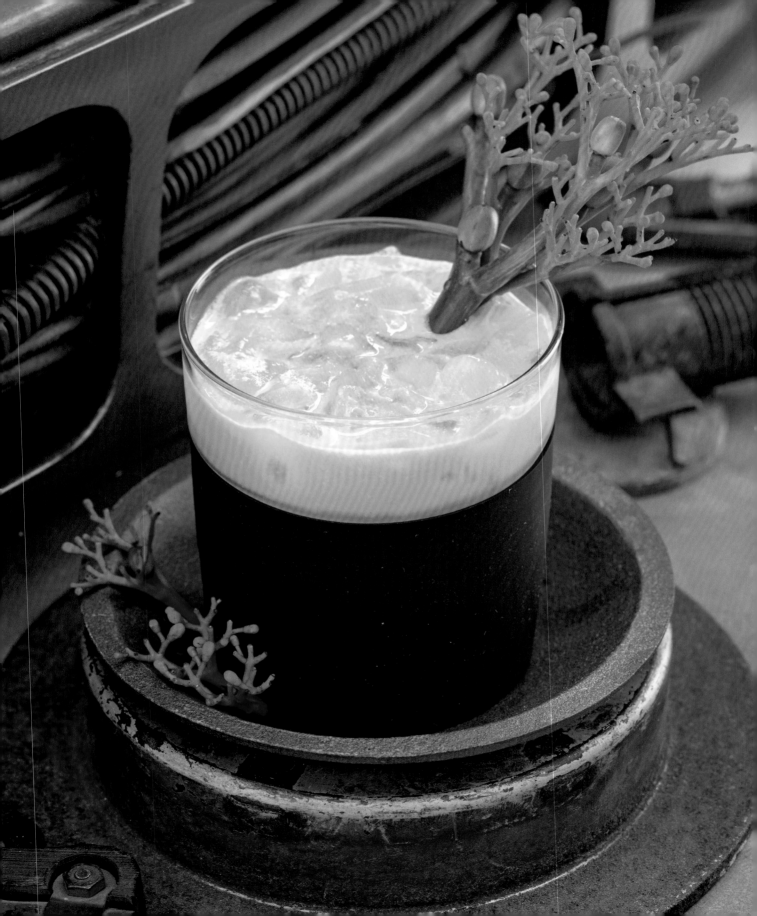

CLIFF DWELLER

Ahch-To is mostly one big ocean, with a few craggy islands juttin' up outta the water here and there. I imagine any folks who make their homes high up in those jagged cliffs ain't lookin' to be found. Even on a remote world like that, though, there's always the chance unexpected company could show up, so it's a good idea to know how to mix up a delicious drink to make guests feel welcome. The Cliff Dweller does just that, incorporatin' simple ingredients that can easily be found on Ahch-To's archipelagos. Its surprisingly tropical flair manages to make Ahch-To's rocky shores seem like paradise.

PREP TIME: 5 MINUTES
YIELD: 1 SERVING
DIFFICULTY: EASY

INGREDIENTS

2 OUNCES ORANGE JUICE
½ OUNCE PINEAPPLE JUICE
1 OUNCE LIME JUICE
1 OUNCE GRENADINE
1 OUNCE COCONUT CREAM
1 OUNCE GINGER ALE

1. Half-fill a tall glass with chipped ice.

2. In a cocktail shaker, shake together the orange juice, pineapple juice, lime juice, grenadine, and coconut cream.

3. Pour into the glass, then top with the ginger ale.

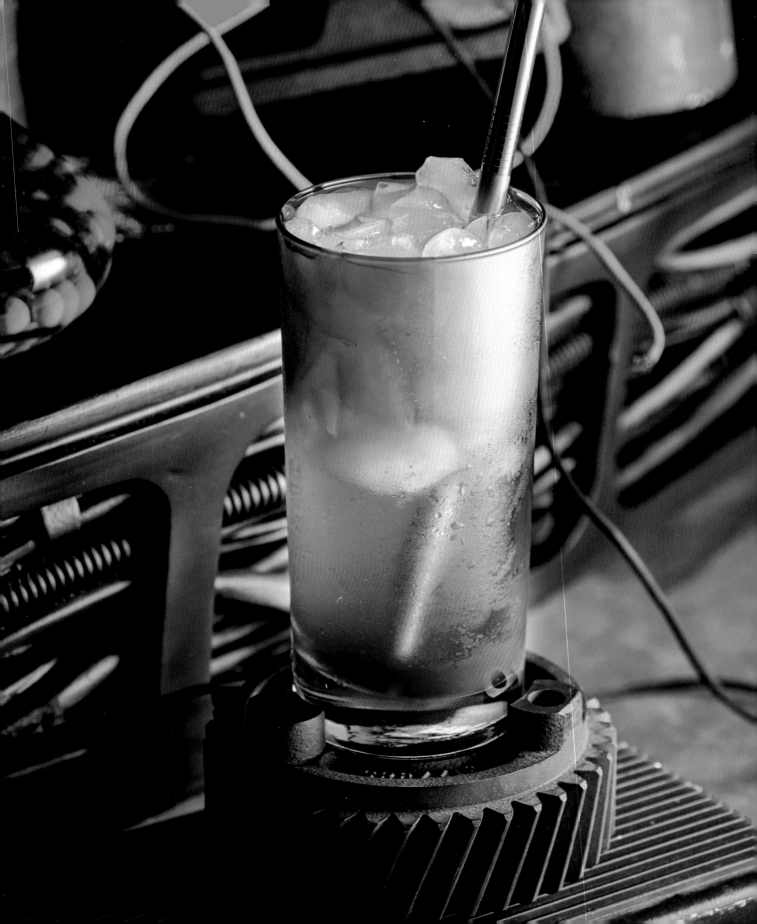

HYPERDRIVE

Every once in a while, you come across a drink that takes your taste buds to a whole new galaxy. I always find the bold, fruity flavors of the Hyperdrive propel me into pure beverage bliss every time. This powerful punch was a big winner in the casinos of Canto Bight, givin' patrons the amplified blast they needed to stay up all night and gamble away all their credits. Until they figure out how to make a digestible form of coaxium, this is probably the next best thing. Believe me, after one little sip, you're gonna wanna *punch it*!

PREP TIME: 5 MINUTES
YIELD: 1 SERVING
DIFFICULTY: EASY

INGREDIENTS

1½ OUNCES WHITE CRANBERRY JUICE OR WHITE GRAPE JUICE

3 OUNCES BLUE BERRY-FLAVORED SPORTS DRINK

1 OUNCE LEMON-LIME SODA

1 OUNCE BLACK CHERRY PUREE

1. Half-fill a tall glass with crushed ice, then pour in the juice and sports drink.

2. Top off with the soda, then drizzle the cherry puree over the top.

3. Serve with a straw.

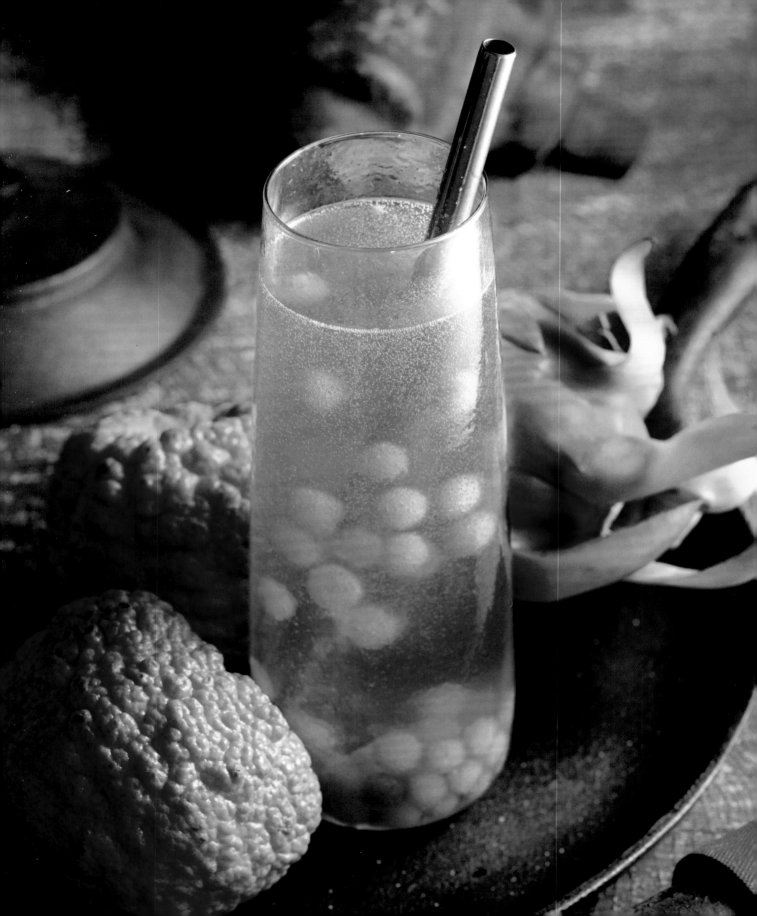

PHOTON FIZZLE

You ain't gonna find a Photon Fizzle bein' served on a fancy yacht on Vandor, but even though this popular beverage ain't quite as sophisticated as some of the other cocktails on the list, it'll get the job done just the same. This carbonated concoction was commonly found at diners on Core Worlds, like Coruscant, back in the days of the Galactic Republic. It was usually premixed in large vats so WA-7 waitress droids could keep the good times flowin'. The Fizzle is most commonly recognized for the edible green orbs floatin' in it. Burstin' with fruity flavor, they give the drink a unique texture that you won't forget, even after a few too many rounds.

INGREDIENTS

¼ CUP UNCOOKED LARGE BOBA PEARLS

ONE BATCH DAGOBAH SLUG SYRUP
 (PAGE 33)

GREEN GEL FOOD COLORING

3 OUNCES GIN

JUICE OF ½ FRESH LIME

4 OUNCES GINGER BEER

PREP TIME: 5 MINUTES
STEEPING TIME:
20 MINUTES
YIELD: 1 SERVING
DIFFICULTY: EASY

1. Cook the boba according to package directions, then set to steep for at least an hour in the Slug Syrup and enough food coloring to achieve a color you like.

2. Place the now-green boba at the bottom of a tall glass. Combine ½ ounce of the Slug Syrup used to steep the boba, the gin, and the lime juice in a shaker with some ice.

3. Give a few good shakes to chill everything, then strain into the glass. Top up with ginger beer, and enjoy!

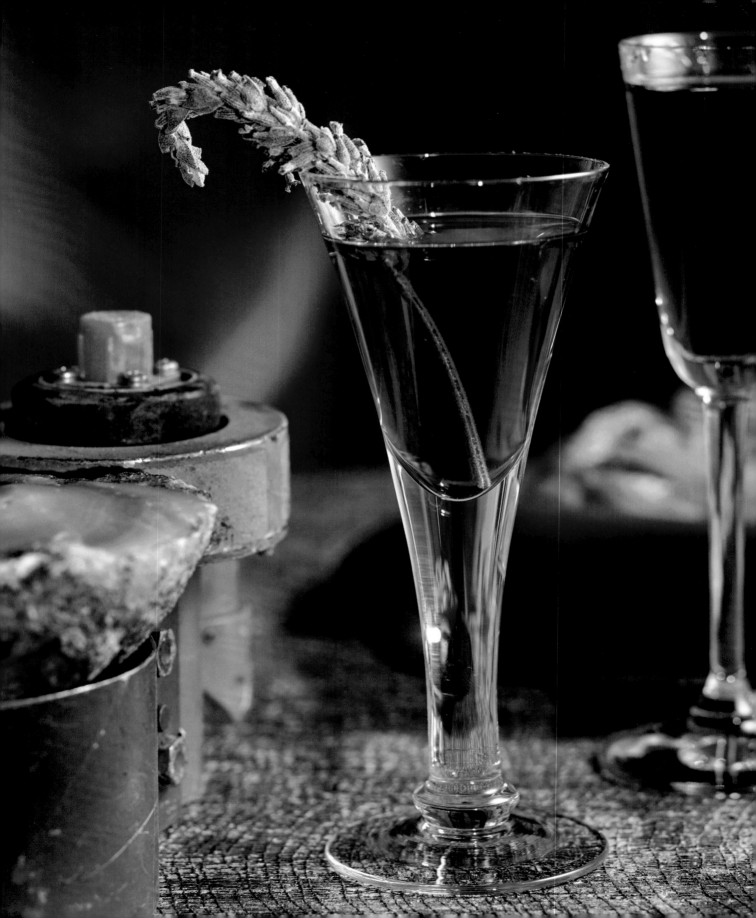

AKIVAN LIQUEUR

I don't use a lot of honey in my recipes these days 'cause it goes for a premium price at most Outer Rim outposts. And since I ain't willin' to go to Vashka myself to fight past a swarm of giant apidactyls to steal the liquid gold from their hive, I try to find other ways to sweeten my dishes. But there's one honey that I'll cough up the dough for every time—it comes in the form of a rare liqueur that my Ithorian associate Dok-Ondar acquired from the planet Akiva. Its syrupy sweetness lingers on the lips before givin' way to a flourish of floral notes—and even a hint of pepper. But since scrapin' together enough credits to buy another bottle of this luxurious liquid from Dok always lands me in a sticky situation, I came up with this suitable substitute instead.

INGREDIENTS

¼ CUP SUGAR
½ CUP HONEY
1 CUP WATER
¼ CUP DRIED CULINARY LAVENDER FLOWERS
3 WHOLE CLOVES
1 TEASPOON GRATED ORANGE ZEST
1 TEASPOON GRAINS OF PARADISE, CRACKED
1½ CUPS VODKA
LAVENDER GEL FOOD COLORING

PREP TIME: 10 MINUTES
STEEPING TIME: 5 DAYS
YIELD: SERVINGS VARY
DIFFICULTY: EASY

1. Place all ingredients except for the vodka and food coloring in a small saucepan over medium-high heat. Bring to a boil until the sugar and honey have dissolved, then remove from the heat.

2. Let cool for about 1 hour, then add the vodka and food coloring to the desired shade. Transfer to a clean container and refrigerate for 5 days.

3. After it's done steeping, strain into clean bottles and keep chilled until ready to enjoy.

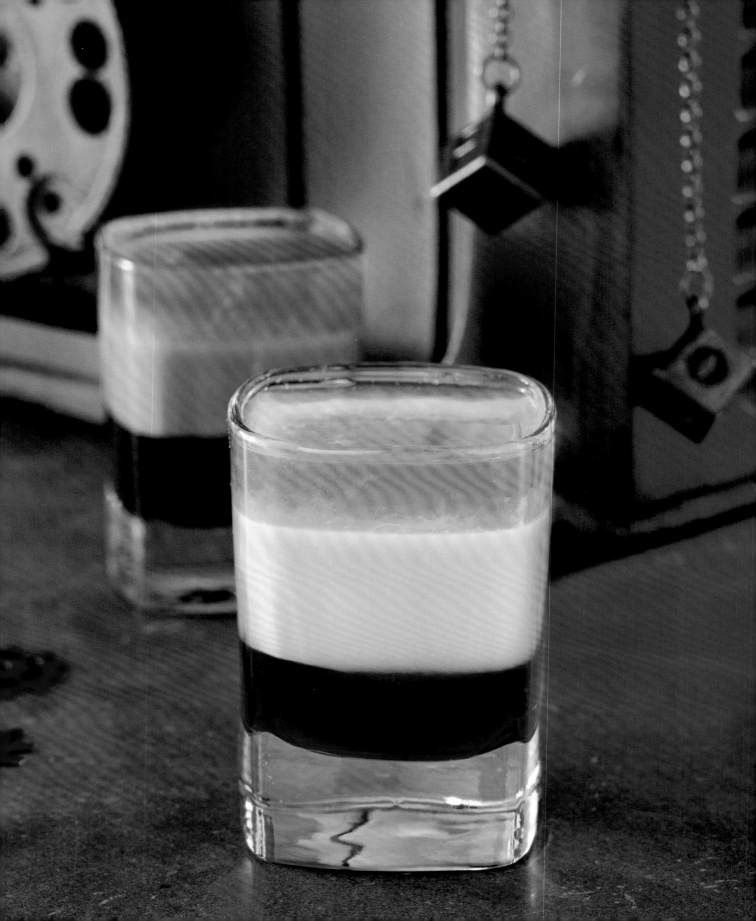

RODIAN SPLICE

When it comes to food and beverages, there ain't many things I'm scared of preparin'. The Rodian Splice is one of the few exceptions. This caustic cocktail is made from a bunch of ingredients that are already extremely toxic on their own. Even worse, if they're not mixed together in exactly the right proportions, the drink becomes lethal to most species. It's the kind of libation ordered by desperate smugglers with somethin' to prove. Despite its deadliness, folks have said the intense flavor of a Rodian Splice is nearly as intoxicatin' as its abundance of alcohol. I'll take their word for it, though, as I prefer a drink that don't make me worry over whether each sip might be my last.

PREP TIME: 5 MINUTES
YIELD: 1 SERVING
DIFFICULTY: MEDIUM

INGREDIENTS

½ OUNCE COFFEE LIQUEUR
½ OUNCE IRISH CREAM LIQUEUR
½ OUNCE BOURBON OR WHISKEY

1. Pour the coffee liqueur into the bottom of a shot glass.

2. Set a spoon over the glass, back side up, so the tip of the spoon is just touching the coffee layer.

3. Pour the Irish cream liqueur over the back of the spoon so it pools on top of the coffee layer.

4. Do the same with the bourbon, then down the hatch!

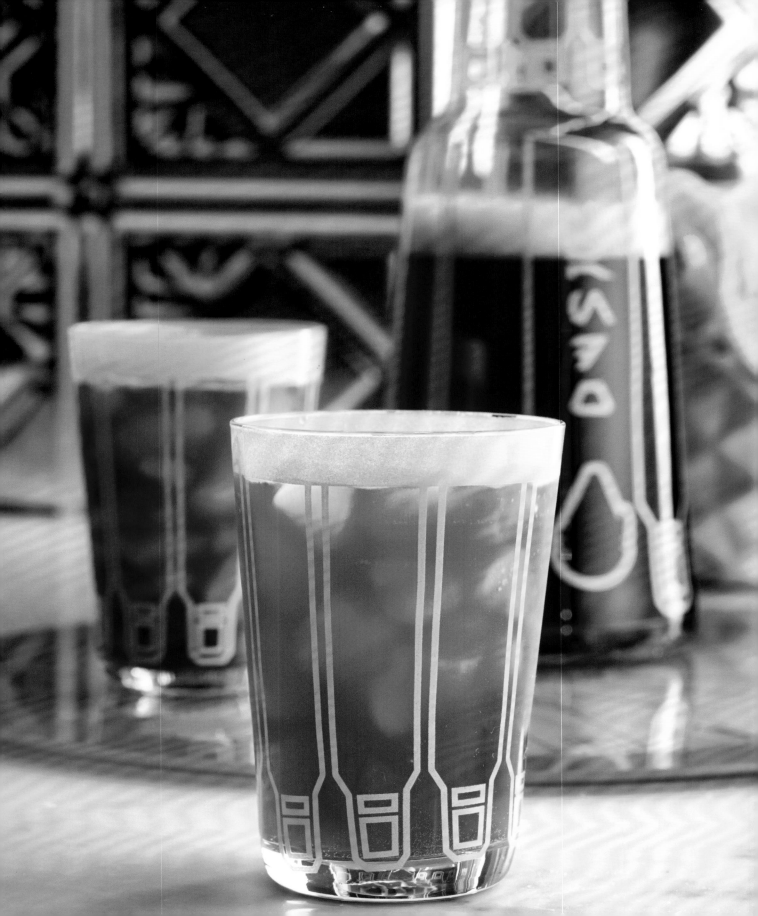

PORT IN A STORM

Anyone who's piloted their way through a cosmic maelstrom knows that danger lies behind every cloud of interstellar gas. Whether you're dodgin' carbonbergs, avoidin' giant vacuum-dwellin' monsters, or tryin' to escape the pull of a star-size gravity well, the whole process ain't exactly great for the nerves. Most regular folks ain't never gonna find themselves navigatin' the Akkadese Maelstrom, but some still wanna experience somethin' akin to the euphoric relief that follows a harrowin' escape. This sparklin' mixture of spirits will do the trick, warmin' the body while coolin' the nerves. And if you *are* lucky enough to survive the Kessel Run, you're gonna wanna pour yourself a few of these the second you reach the nearest outpost.

PREP TIME: 5 MINUTES
YIELD: 1 SERVING
DIFFICULTY: EASY

INGREDIENTS

1 OUNCE SPICED RUM
1 OUNCE RUBY PORT
½ OUNCE GINGER LIQUEUR
1 TEASPOON LIME JUICE
2 OUNCES STRONG GINGER BEER
LIME WEDGE, FOR GARNISHING

1. Combine the rum, port, ginger liqueur, and lime juice in a tall glass filled with chipped ice.

2. Pour the ginger beer over the top and garnish with a lime wedge.

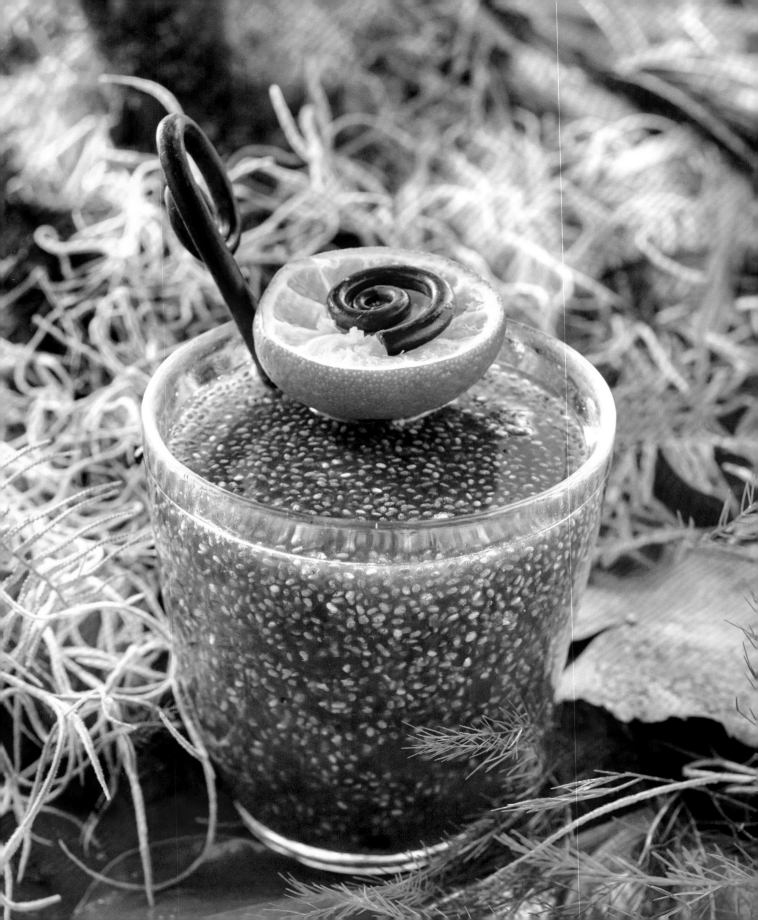

PAONGA FRESCA

I accidentally discovered this refreshin' beverage way back when I was still fishin' for my own yobshrimp on Naboo. See, I made the rookie mistake of castin' my traps in Lake Paonga without gettin' permission from the local Gungan Boss. Before long, I found myself bein' escorted straight to the heart of the underwater city Otoh Gunga. But once the Gungans realized I wasn't a threat, they sent me back on my way— and even offered me a tall glass of this swampy swill, filled with all sorts of seeds skimmed off the surface of the lake. I didn't wanna risk insultin' my hosts any further, so I reluctantly guzzled it down. To my surprise, the perfect blend of bright flavors and strange textures in this green grog had me wishin' I'd run afoul of the Gungans years sooner.

PREP TIME: 5 MINUTES
INFUSING TIME: 20 MINUTES
YIELD: 1 OR 2 SERVINGS
DIFFICULTY: EASY

INGREDIENTS

1 CUP WATER
2 CUPS PREPARED LIMEADE
¼ CUP CHIA SEEDS
½ TEASPOON SPIRULINA POWDER
½ TEASPOON MATCHA TEA POWDER

1. Combine all the ingredients in a jar with a lid, and shake a few times to mix fully.

2. Let sit at least 20 minutes to let the chia seeds jell, then enjoy either chilled or at room temperature.

BANTHA CHAI

Runnin' a kitchen is a round-the-clock job, so I've usually got a big pot of black caf brewin' at all times. While the extra boost it provides might keep me goin' all day and night, its bitter taste leaves a bit to be desired. If I ever have a real moment to relax, I prefer a steamin' cup of tea brewed usin' local spices. In fact, durin' my recent stay on Batuu, I found myself stirrin' in a bit of fresh bantha milk from Bubo Wamba's milk stand to mellow out the flavors and add a rich thickness to the drink. Each sip is gentle and calmin', but to be honest, the pleasant aroma waftin' up from the mug is almost enough to give me a much-needed moment of peace before I dive back into the hustle and bustle of a busy dinner service. (Since I'm guessin' you ain't got a bantha on hand, this version will have to suffice.)

INGREDIENTS

2 CUPS RICE MILK OR MILK OF YOUR CHOICE

2 TEASPOONS ARROWROOT POWDER

1 BLUE BUTTERFLY PEA TEA BAG

1 INCH FRESH GINGER ROOT, THINLY SLICED

PINCH OF GROUND CARDAMOM

PINCH OF GROUND MACE

1 TO 2 TABLESPOONS SUGAR, TO TASTE

COOKING TIME: 15 MINUTES
YIELD: 1 SERVING
DIFFICULTY: EASY

1. Whisk together the milk and arrowroot powder in a small saucepan, then place over medium-low heat.

2. Add the remaining ingredients and allow to heat until steaming, whisking occasionally.

3. Let the mixture steep for about 5 minutes, until it is a rich blue color and smells strongly of spice.

4. Remove from heat. Strain into a clean mug and enjoy straightaway.

SUNRISE CAF

I used to take my caf as black as space itself, but my time on Batuu has inspired me to explore some beverage options that lean a bit more toward the light side. During a recent early-mornin' stroll through Black Spire's market, I acquired an unusual spice blend from Kat Saka's stall. Its sweet aroma was so intoxicatin' that I couldn't wait to give it a try, so I stirred a spoonful of the stuff right into my cup—along with a healthy dollop of fresh cream provided by my pal Bubo Wamba. Needless to say, I was hooked from the first sip. With its rich, warm blend of spices and smooth, creamy finish, the drink I've come to call Sunrise Caf has become the perfect way to start my day. And for those who live on a world that has more than one sun, consider yourselves lucky. You've got the perfect excuse to have an extra cup.

INGREDIENTS

1 CUP PREPARED BLACK COFFEE

½ CUP MILK

1 TABLESPOON COCONUT OIL

½ TEASPOON FIVE-SPICE POWDER

2 TEASPOONS TURMERIC POWDER, DIVIDED

¼ CUP HEAVY CREAM

BROWN SUGAR OR OTHER SWEETENER, TO TASTE

PREP TIME: 10 MINUTES

COOKING TIME: 10 MINUTES

YIELD: 1 SERVING

DIFFICULTY: EASY

1. Combine the coffee, milk, coconut oil, five-spice, and 1 teaspoon of the turmeric in a small saucepan over medium heat. Heat up until steaming but not bubbling, then remove from heat. Continue to let it infuse for about 5 minutes.

2. In a small jar or cocktail shaker, combine the heavy cream and the remaining teaspoon turmeric and shake for about 30 seconds, until somewhat thickened.

3. To serve, pour the coffee mixture into a heatproof mug, sweeten to taste, then top with the thickened cream.

LOTHAL SPICEBREW

On my last visit to Lothal, I docked at a tiny old outpost a few hours from Capital City known to the locals as Jhothal. The place had seen better days, but it was clear that it had plenty of history. And in my world, history and flavor tend to go hand in hand. After a bit of diggin'—and a couple pieces of Loth-rat pie—I learned that this pit stop used to be run by an Ithorian named Old Jho. That is, until the Empire decided to execute him for helpin' out some local rebels. Jho was remembered for havin' a sympathetic ear and a helpin' hand, but it was his signature spicebrew that really elevated him to legendary status. He might not have survived the Empire's occupation, but the recipe for his potent spiced beverage did, so now you can raise a tall mug of it in Old Jho's honor.

PREP TIME: 5 MINUTES
YIELD: 1 SERVING
DIFFICULTY: EASY

INGREDIENTS

12 OUNCES CREAMY STOUT BEER
½ CUP CONDENSED MILK
¼ TEASPOON CINNAMON
¼ TEASPOON GROUND NUTMEG
1 OUNCE BRANDY (OPTIONAL)

1. Combine all ingredients in a blender and blend together until pale and smooth.

2. Pour into a tall glass filled with ice and add a pinch of nutmeg to the top to serve.

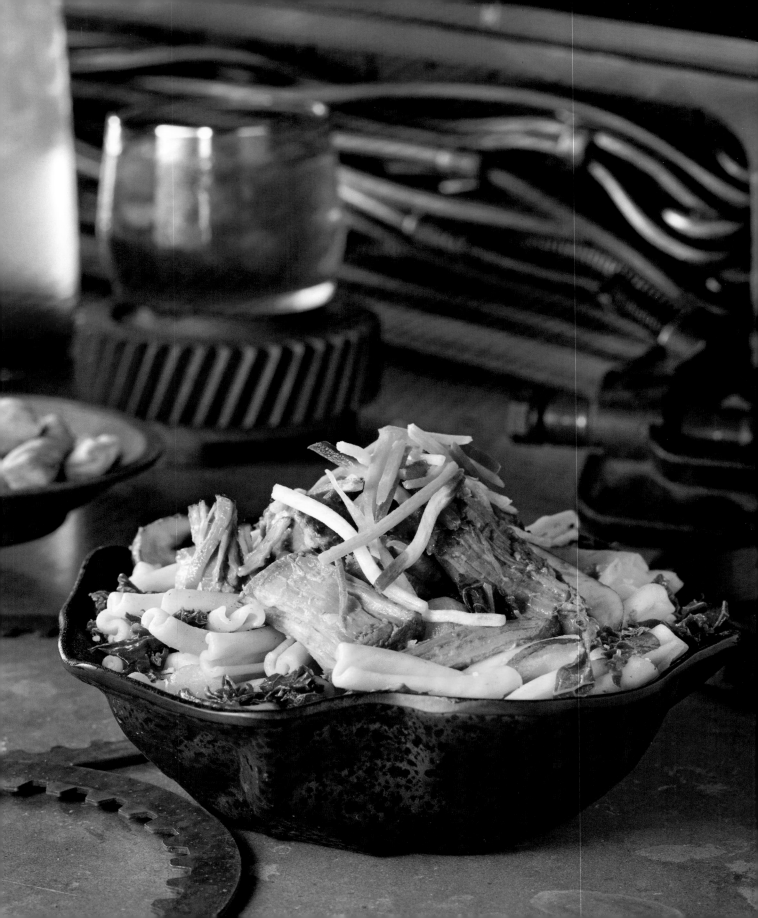

DIETARY CONSIDERATIONS

V = Vegetarian V+ = Vegan
GF = Gluten-free V*, V+* & GF* = Easily made vegetarian, vegan, or gluten-free with simple alterations

CONDIMENTS, SAUCES + GARNISHES

Nerfsteak Seasoning	GF	V	V+
Saka Salt	GF	V	V+
Gurreck Gravy	GF	V*	
Emulsauce	GF	V	
Moogan Spice Syrup	GF	V	V+
Dagobah Slug Syrup	GF	V	V+
Chadian Dressing	GF	V	
Golden Lichen Tuile	GF*	V	V+*
Christophsian Sugar	GF	V	V+
Nectrose Crystals	GF	V	

SIDES, STARTERS + SNACKS

Kat's Kettle Corn	GF	V	V+
Pitmaster's Choice			
Rings of Hudalla	GF		
Roasted Kajaka Root	GF	V	
Xizor Salad	GF	V*	
Roasted Chando Peppers	GF	V	
Moss Chips	GF	V	
Fritzle Fries	GF	V	
Mon Cala Sardine Fritters	GF*		
Devaronian Soufflé	GF	V	
Fried Zuchii		V	
Deviled Pikobi Eggs	GF	V	
Mashed Chokeroot	GF	V	
Constable's Caps		V	

SOUPS AND STEWS

Rootleaf Stew	GF	V	V+
Topato Soup	GF	V*	
Tatooine Terrine	GF	V*	
Spicy Mandalorian Stew			

BREADS

Ronto Wrappers	V	V+
Polystarch Portion Bread	V	V+
Five-Blossom Bread	V	
Mustafarian Lava Buns	V	
Munch-Fungus Loaf	V	

MAIN COURSES

Yobshrimp Noodle Salad		V*	
Braised Shaak Roast			
Fried Tip-Yip	GF*		
Ronto Wrap			
Felucian Garden Spread	GF*	V	V+
Gormaanda's Glowblue Noodles	GF	V	
Nerf Kebabs			
Stuffed Puffer Pig	GF		
Parwan Nutricakes	GF*	V	
Huttese Slime Pods		V	
Gruuvan Shaal Kebab			

DESSERTS

Wroshyr Tree Cake		V
Bespin Cloud Drops	GF	V
Cavaellin Spice Creams		V
Mandalorian Uj Cake		V
Sweet-Sand Cookies	GF*	V
Corellian Ryshcate		V
Keshian Spice Rolls		V
Mimbanese Mudslide	GF	V
Nectrose Freeze	GF	V
Kowakian Crumb Cake		V
Zoochberry Surprise		V
Tepasi Taffy	GF	V

DRINKS

Moogan Tea	GF	V	
Coruscant Cooler		V	V+
Dagobah Slug Slinger	GF	V	V+
Blurrgfire	GF	V	V+
Cliff Dweller	GF	V	V+
Hyperdrive	GF	V	V+
Photon Fizzle		V	V+
Akivan Liqueur		V	
Rodian Splice	GF	V	
Port in a Storm	GF	V	V+
Paonga Fresca	GF	V	V+
Bantha Chai	GF	V	V+
Sunrise Caf	GF	V	V+*
Lothal Spicebrew		V	

Consuming raw or undercooked eggs may increase your risk of foodborne illness.

ABOUT THE AUTHORS

CHELSEA MONROE-CASSEL is the coauthor of the best seller *A Feast of Ice and Fire: The Official Game of Thrones Companion Cookbook* and the author of *World of Warcraft: The Official Cookbook, Hearthstone: Innkeeper's Tavern Cookbook, The Elder Scrolls: The Official Cookbook, Overwatch: The Official Cookbook,* and *Firefly: The Big Damn Cookbook.* Her work is a synthesis of imagination and historical research. This passion has led her to a career of transforming imaginary foods into reality. She greatly enjoys foreign languages, treasure hunting, history, and all things related to honey.

MARC SUMERAK is an Eisner- and Harvey Award–nominated writer and editor whose work over the past two decades has been featured in comics, books, and video games showcasing some of pop culture's most beloved franchises—Marvel, Star Wars, Harry Potter, Firefly, Ghostbusters, and many more. His other books from a galaxy far, far away include *Star Wars: Droidography* and *Star Wars: The Secrets of the Jedi.* He would like to assure readers that no porgs were harmed in the making of this book.

ACKNOWLEDGMENTS

Chelsea Monroe-Cassel would like to thank Marc Sumerak, Elena Pons Craig, and Ted Thomas, plus the teams at Insight Editions, Lucasfilm, and Disney, whose amazing collaboration made this possible. For B, in a galaxy near or far: I know.

Marc Sumerak would like to thank Chelsea Monroe-Cassel, Chris Prince, Landry Q. Walker, Robert Simpson, and the team at Lucasfilm Publishing, Lucasfilm Story Group, Scott Trowbridge, Margaret Kerrison, and the Galaxy's Edge team at Walt Disney Imagineering, and, of course, George Lucas. For Jess, Charlie, and Lincoln, without whom I'd be lost in Wild Space.